Vas Prabhu

PEM

June 2005

Origins of Thai Art

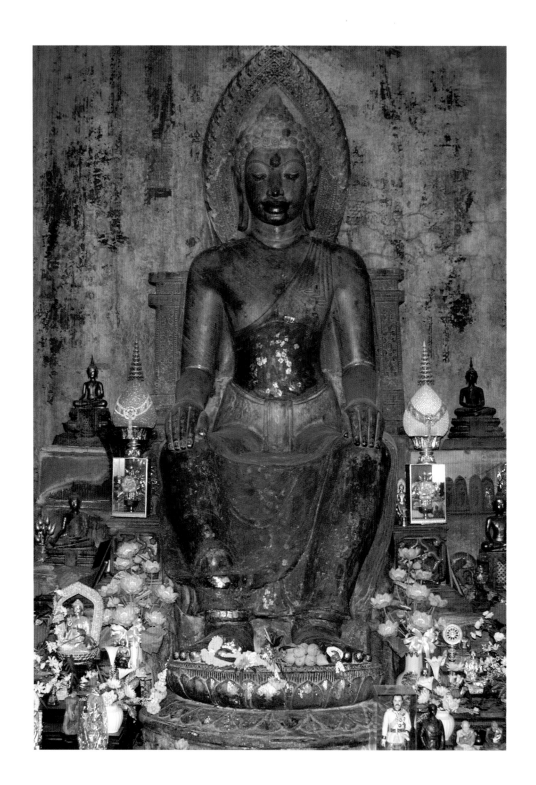

Betty Gosling

Origins of Thai Art

Weatherhill

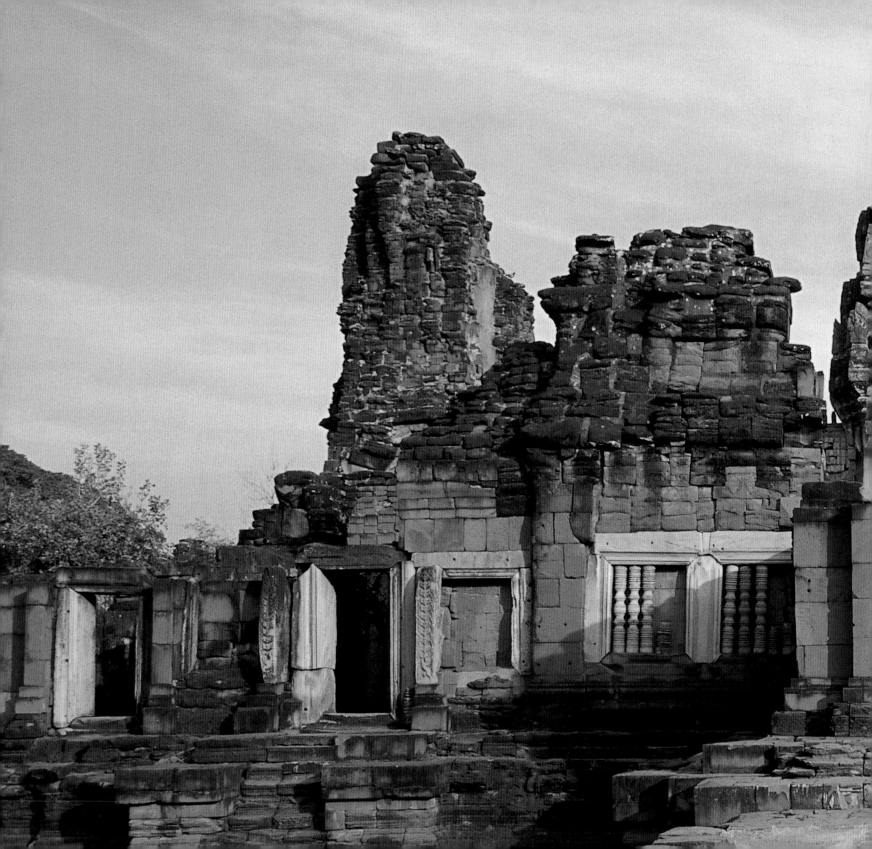

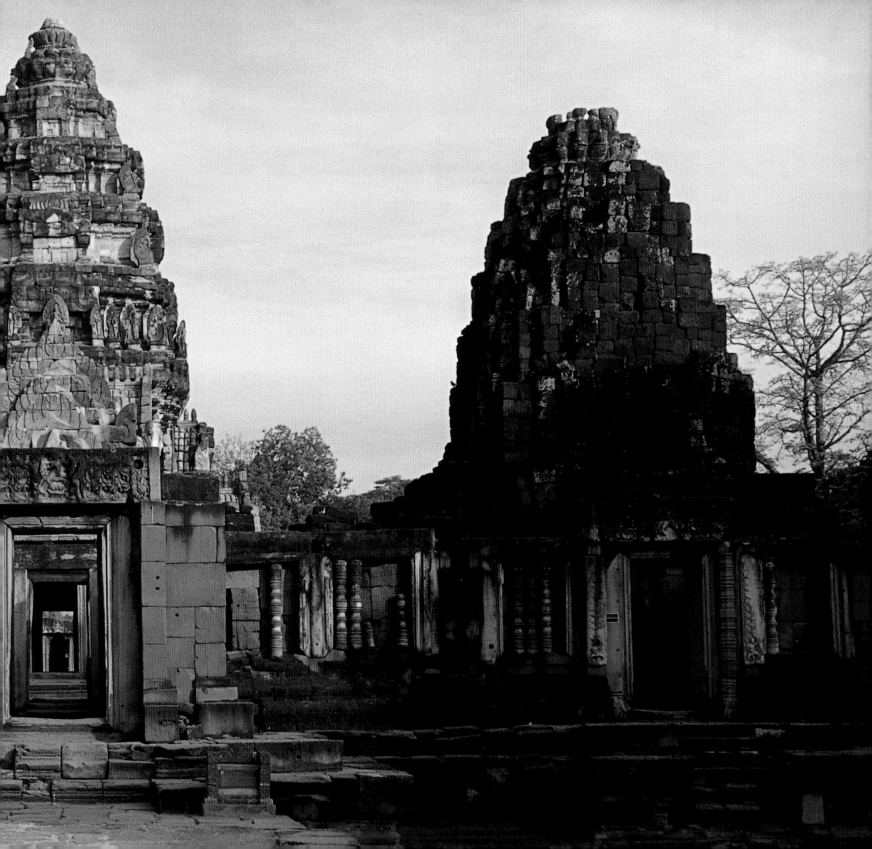

To Barbara, Forrest, and Sara.

First published and distributed in the USA and Canada by
Weatherhill Inc.
41 Monroe Turnpike
Trumbull, CT 06611

A River Books Production.

British Library Cataloguing-in-Publication Data.
A catalogue record for this book is available from the British Library.

ISBN 0 8348 0541 3

Editor: Narisa Chakrabongse
Photography: Paisarn Piemmettawat and Pattana Decha
Design: NaPaHa
Production Supervision: Paisarn Piemmettawat

Frontispiece: *Seated Buddha image in Dvaravati style at Wat Na Phra Men in Ayutthaya.*

Previous pages: *The tower and buildings of the outer enclosure from the east, Phimai.*

Printed and bound in Thailand by
Amarin Printing and Publishing (Public) Co., Ltd.

Acknowledgements

The study of early Thai art history is an ongoing process, and this book relies heavily on recently published research by noted Southeast Asian scholars who have opened new windows on Thailand's far-distant past. Essential sources were Charles Higham's achaeological explorations of Thailand's prehistoric period; Robert L. Brown's investigations into the Dvaravati period; Hiram W. Woodward's intensive studies of Khmer art; and Piriya Krairiksh's insights into the art of the Thai Peninsula. Without these works, my book would have taken a very different course. It should go without saying, however, that the conclusions I have drawn from piecing together the complexly related information derived from these diverse works are my own and that I alone am responsible for any flawed inferences, analyses, and deductions.

In many ways I am indebted to others who have generously given their time and help. I am especially grateful to John Whitmore, who read my manuscript, and with his fine editorial skills and exceptional knowledge of Southeast Asian history, offered many critical suggestions. And I am grateful to Robert Brown, who read several chapters. His corrections and enlightening remarks are much appreciated. Thanks go also to Victor Lieberman for reading an earlier, now revised introductory chapter, and to Walter Spink and Hiram Woodward, who answered some puzzling questions. Susan Go and her staff at the University of Michigan Library graciously tracked down missing publications and kept me apprised of new library acquisitions, while Cindy Middleton, at the University of Michigan Center for Southeast Asian Studies, arranged for the best possible Library privileges. As always, thanks to Judith Becker, Southeast Asia Center Director, for her continuing encouragement and support and to the Association for Asian Studies, who provided funding for a fieldtrip to Thailand. And last, but certainly not least, I want to thank Peter Blair Gosling, without whose computer skills my manuscript might never have reached the publisher.

Contents

CHRONOLOGY

2300 BC	Neolithic period in Thailand. Permanent settlements emerge.
1500 BC	Bronze is introduced in Thailand, perhaps from Vietnam.
6th Century BC	The Buddha is born in India.
500-400 BC	The use of iron in Thailand allows larger permanent settlements.
4th Century BC	Assorted items from India, China, and Vietnam appear in Thailand.
1st Century AD	Buddhist sculpture is made in India.
2nd-3rd Century AD	Buddhism is introduced in Thailand.
400 AD	Brahmanical sculpture appears in Thailand.
5th Century AD	Statues of Vishnu become common.
6-7th Century AD	Mon chiefdom networks develop in Central Thailand. Dvaravati emerges.
7th Century AD	Dvaravati Buddhists are thought to visit India. Vast amounts of Buddhist sculpture are produced in Thailand. Khmer begin to settle in Thailand.
9th Century AD	Srivijaya introduces Indo-Javanese art.
11th Century AD	Local Khmers establish Phimai as political center. Local Khmer art tradition is established.
12th Century AD	Northern Mon arrive from Myanmar and settle in northern Thailand.
12th-13th Century AD	Angkorean (Cambodian) Khmer establish a provincial capital at Lopburi. Period of Angkorean domination engenders period of art historical confusion.
13th Century AD	Tai-speakers establish permanent communities at Sukhothai, Chiang Mai, and elsewhere in Thailand. A new art tradition established.
1350	Ayutthaya becomes the country's major political center.
1782	Thailand's capital is moved to Bangkok.

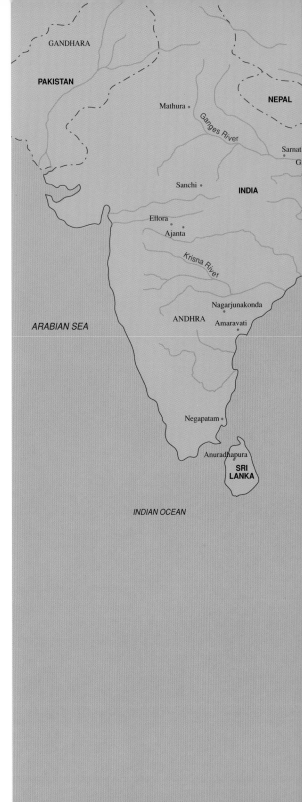

Map showing Thailand in relation to South and Southeast Asian countries that have contributed to the formation of Thai art.

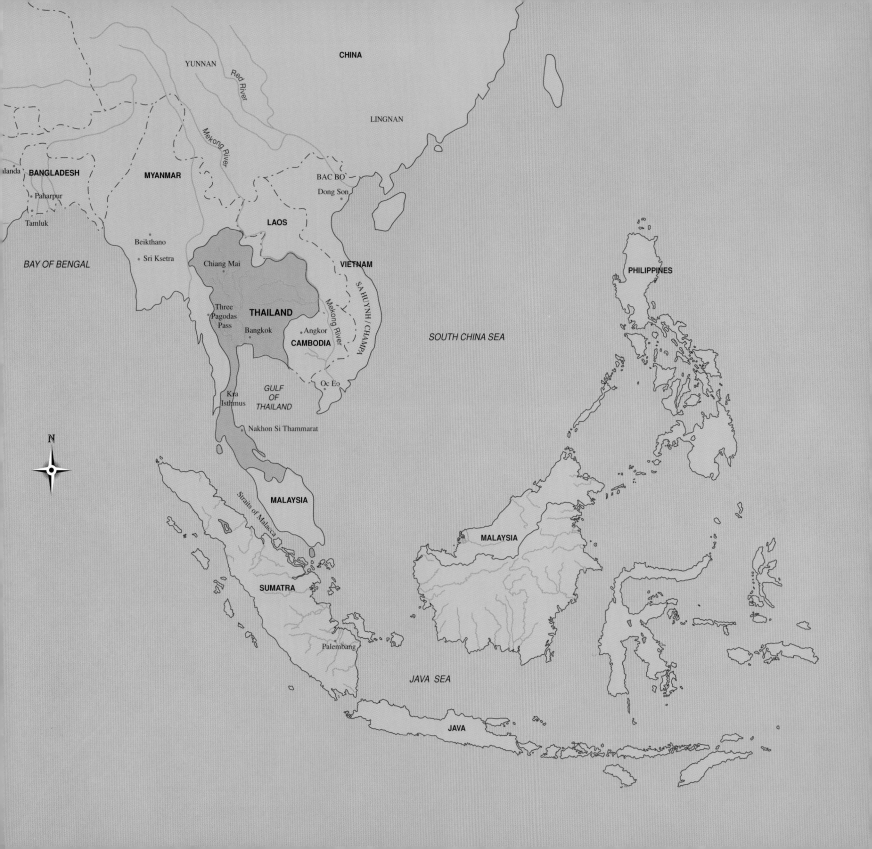

CHAPTER ONE

The Complexities of Thai Art

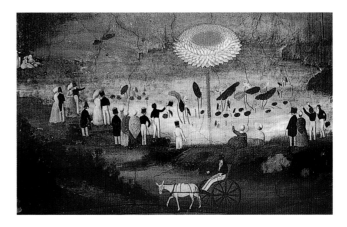

Detail of a painting by the nineteenth-century Bangkok artist Khrua In-Khong showing Europeans gazing at a long-stemmed lotus that represents the dharma, or Buddhist doctrine. While artistic styles changed dramatically over the centuries, many iconographic features retained their original significance. (Wat Boromniwat, Bangkok)

Thai art is an ambiguous term which (according to the cultural orientation of the speaker or the context in which it is used) may refer to very different, sometimes contradictory things. In common parlance and according to some art historical classifications, Thai art refers to the very remarkable sculpture and architecture that a predominantly Tai-speaking population who lived in what would one day become Thailand began to create in the late thirteenth century AD (Piriya, 1977). Those thirteenth-century Tai initiatives are often considered to have produced a cultural watershed that clearly separated them from the artistic traditions that preceded them.

But Thai art, that is, the art that is part of Thailand's cultural heritage, is much more than the product of Tai initiatives: it is also the outgrowth of ethnically diverse peoples who had lived in the land that would become Thailand several millennia before the Tai began their prodigious undertakings. Not only is pre-Tai art part and parcel of the country's cultural landscape, but a case can be made that a break between the arts of the pre-Tai and Tai periods was not as divisive as is sometimes suggested. Just as modern-day citizens of Thailand, that is, the Thai, may claim descent not only from the Tai but also from Mon, Khmer or Chinese ancestry, Thai art reflects an ancient, richly diverse, multicultural heritage. The identification of 'Tai' a linguistic group) with 'Thai' (an inhabitant of Thailand) has resulted in artistic confusion and a misunderstanding of the country's cultural and artistic traditions that

are difficult to untangle. Equally confusing is the common assumption that Khmer peoples who had lived in what are now Thai territories for many centuries during the pre-Tai era were culturally synonymous with those with political ties to the Mekong region of what is now Cambodia.

A distinction between Thailand's Tai and pre-Tai traditions is understandable, for the Tai's contributions to the country that would one day include a variation of their name were enormous. The Tai had begun to migrate from southern China and settle in their new homeland in the late first millennium AD, and although for several centuries following their arrival they appear to have made little cultural impact, by the thirteenth century they had begun to establish political and religious institutions that brought unity to their multicultural surroundings, a cohesion that resulted from the selection and adaptation of cultural elements, both local and foreign. The Tai adopted the strictest and most conservative form of Buddhism, Theravada, as their state religion, and Brahmanical rites supported a newly established monarchy. They also produced vast amounts of sculpture and architecture that reflected their political and religious fervor. Their early works established art styles that would endure until the present day. Tai dialects became widespread throughout the area and Tai scripts were increasingly used to document religious and political events. What is now considered Thailand's cultural heartland came to be

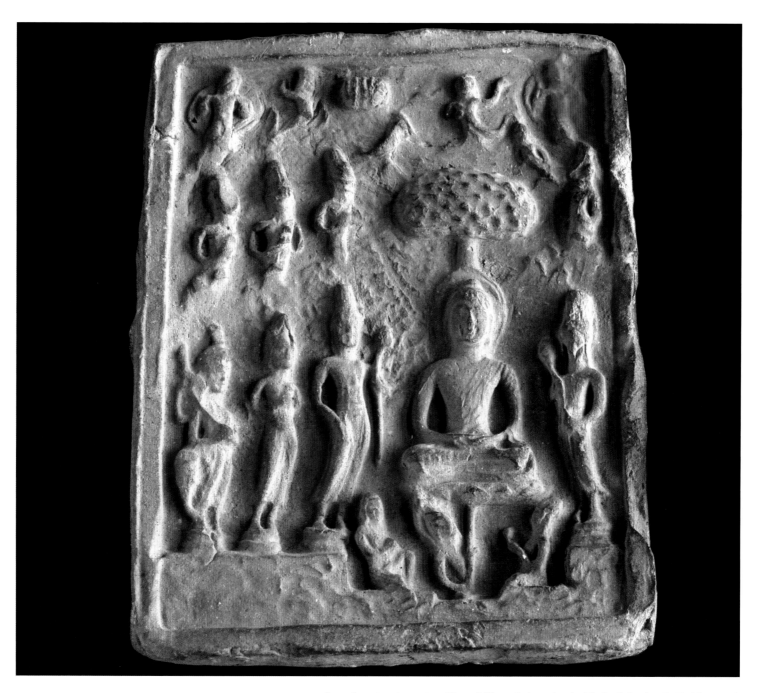

Seventh-century terracotta tablet probably made in peninsular Thailand showing the Buddha seated on a huge lotus that rises above the water. Although the lotus is a common iconographic symbol in Buddhist art, the long-stemmed variety is distinctive. (Ratburi National Museum)

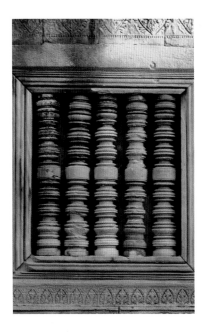

known as Siam, the name by which the 'Central Tai' who settled there were once known. And in 1939, a millennium after the Tai's arrival, Siam became Thailand, a broader term that referred not only to the Central Tai but to Tai who lived farther afield. A national identity, one that had been in the making for many centuries, was established, and *khwam pen thai* – a sense of what constitutes the essence of Thai art and culture was cast (Reynolds, 1991).

Still, links between Thailand's pre-Tai and Tai periods and the role that the pre-Tai peoples – Mon, Khmer, Indian, Malay – played in the formation of the Thai ethos was vital to its development, and it is those connections that we will consider in the following chapters. To understand the true meaning of Thai art, one must begin in the pre-Tai period when the roots of Thai art and culture took hold and – in a variety of unforeseeable and unexpected ways – contributed to their growth.

The links between old and new and the ways in which both the pre-Tai and Tai legacies found their way into modern Thai sensibilities are not always apparent. Over the centuries many contributions of the country's pre-Tai peoples were forgotten, only to reemerge in the late nineteenth and twentieth centuries when epigraphic, archaeological, and art historical research began in earnest. Some aspects of pre-Tai culture had been previously rejected or ignored. Others had been buried within the outer casings of newer ideologies and given new meanings to fit more recent religious and political attitudes. Some gaps between pre-Tai and more recent traditions may never be filled, while others have been invented to bridge past and present. Although attempts have been made to link the designs of Thailand's Neolithic pottery of the first millennium BC (Chapter 2) to that of the Tai speakers who were producing fine ceramics in the fourteenth century AD, corroborative evidence is lacking. And while it is interesting to draw comparisons between the lively scenes of daily life that appear in

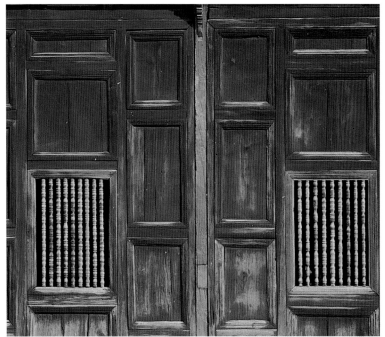

Balustered windows constructed of wood at Chiang Mai, in Thailand's heavily forested north.

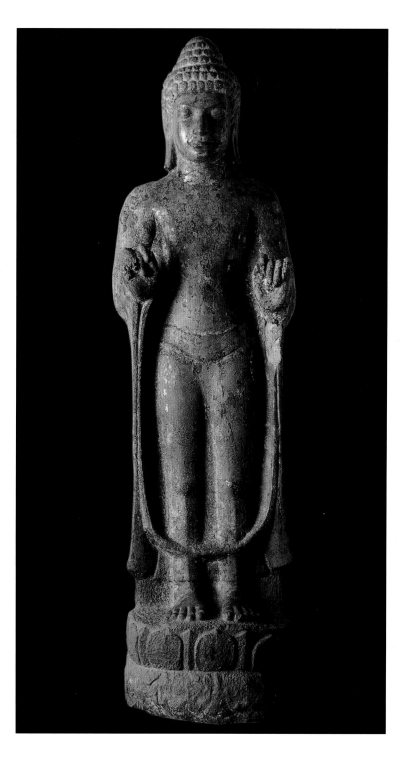

Seventh-eighth-century AD image of the Buddha from central Thailand. Buddha images, which originated in India around the beginning of the first millennium, supplied prototypes for Buddhist art in all parts of Asia. But standing images such as this one with both hands raised in identical iconographic gestures are not found in India. They have been common in Thailand since the seventh century AD. (Nakhon Pathom National Museum)

hundreds of Thailand's prehistoric cave paintings and the folksy genre scenes that became common in Buddhist paintings centuries later, there are no evolutionary bridges to connect them. In determining the elements that link old and new, much more than stylistic or thematic similarities must be considered. Complex and sometimes elusive historical and cultural connections must also be sought, scrutinized, and carefully evaluated.

In contrast to its painting and ceramics, much of Thailand's sculpture and architecture is easily relatable to pre-Tai antecedents. Early Mon and Khmer-style sculpture provide undisputed links with sculpture of later periods. Mon speakers had inhabited what is now Thailand since prehistoric times, but as early as the mid-first millennium AD, the population was perhaps already ethnically diverse (Wyatt, 2001: 7). Certainly, by the early second millennium AD there were many local Khmers. Their contributions throughout the ages are ubiquitous. Balustered window designs that were common in pre-Tai Khmer buildings survive in twentieth-century buildings. And the designs of some of the country's most renowned and arguably its most `Thai' architectural monuments, scattered throughout the country or conspicuously positioned in its modern-day capital, Bangkok, derive from pre-Tai prototypes and are still revered as landmarks central to Thailand's cultural identity. Some major twenty-first century landmarks, even though they bear no physical resemblance to those of the past, are nonetheless identified historically – if not architecturally – with pre-Tai monuments that occupied religious and political sites of special importance in ancient times.

It was the geographical areas where such monuments were built that provide the most fundamental nexus between the pre-Tai and Tai periods, for it was there that Thai art took root, grew, and flowered. The land that is now Thailand (like the diverse cultures it supported) was (and is) heterogeneous, and it engendered complexity. But it also

Angkor Wat, in Cambodia, built in the early twelfth century AD. Here, Angkorean architectural design is considered to have reached its peak. Because of its complexity, beauty, and political significance, Angkor Wat is often thought to have influenced many features of Thai religious architecture. In fact, Angkor Wat derived many of its stylistic and iconographic features from Thailand.

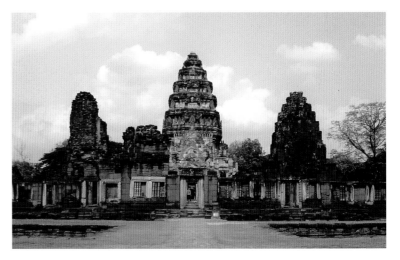

Prasat Phimai, built in the late eleventh century AD. Located in the Upper Mun area of Thailand's western Khorat Plateau, an area that had a long history of economic prosperity and political significance, Prasat Phimai was the most important Buddhist temple in Thailand around 1100 AD. Many of its iconographic and stylistic features were incorporated at Angkor Wat and in royal temples in Thailand.

provided continuity and permanence. For most of its history Thailand was defined not by political boundaries, which were not devised until the late nineteenth and early twentieth centuries, but by ecological regions, each distinguished by distinctive climates, natural resources, means of access with one another, and links with the outside world. From earliest times these geographically diverse areas encouraged different and enduring art styles, each of which would make its own unique contribution to the formation and growth of the more widespread but unified styles that evolved in later centuries. Still, while peoples, cultures, and art styles mixed and blurred, the land and the architectural monuments it supported provided geographical identity and a sense of place that linked past and present in ways that the ever evolving, ethnically diverse population has sometimes confused.

The country's largest region, known today as the Khorat Plateau (in Northeast Thailand) encompasses an area of about 155,000 square kilometers, in non-Asian terms about the combined size of England and Wales. The Plateau then, as now, was characterized by poor soil, extreme heat, variable rainfall, and alternating periods of drought and flooding. But the harsh conditions provoked innovations that overcame the area's environmental shortcomings and those initiatives would play a major role in Thailand's cultural history. The Plateau was enriched by

Thailand's most extensive river systems. At its eastern rim the Mekong flowed south from what is now China, and the Mun River, which crossed the area from east to west enabled the transmission of art styles between the Mekong regions and western Thailand. In prehistoric times the Mun River appears to have provided transmission of art forms that originated as far away as the Philippines. For several centuries, long before the fertile area to the west became the country's heartland, an area near the headwaters of the Upper Mun River was the most important political and religious center in all the lands that would one day become Thailand.

The western portion of present-day Thailand, now known as Central Thailand, was the Central Plains, a somewhat smaller area than the Plateau. The Plains lay east and west of the Chao Phraya River as it flowed from its northern source into the Gulf of Thailand. In sharp contrast to the arid but accessible Plateau, much of the Central Plains, especially in the lower region of the Chao Phraya, was composed of swamplands that made transportation between north and south difficult. But although the Gulf of Thailand extended much farther north than it does today, fine alluvial soils and plentiful rainfall provided the Plains with good agricultural lands that led to exceptional prosperity. And though internal transportation was difficult, the Central

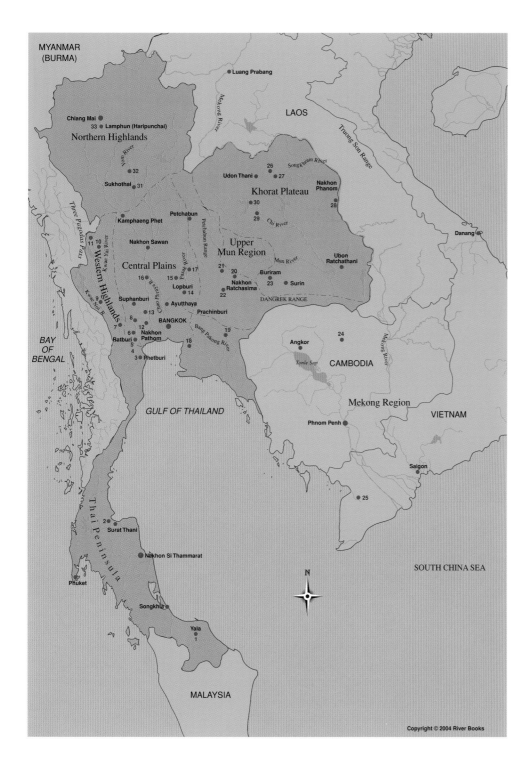

Map of Thailand showing present-day political boundaries, river systems, natural geographic regions, major sites mentioned in the text, and modern cities. For most of Thailand's history, political boundaries did not exist, and natural regions (as today) were not well delineated. Political, cultural, and art historical developments have been determined, not by borders, but by the communities that had best access to the resources the various regions had to offer.

1. Yala
2. Chaiya
3. Phetburi
4. Khu Bua
5. Ratburi
6. Phong Tuk
7. Ban Kao
8. Ban Don Ta Phet
9. Muang Singh
10. Ongbah
11. Three Pagodas Pass
12. Nakhon Pathom
13. U Thong
14. Lopburi
15. Chansen
16. Muang Bon
17. Si Thep
18. Khok Phanom Di
19. Dong Si Mahaphot
20. Phimai
21. Noen U-Loke
22. Muang Sima
23. Phnom Rung
24. Koh Ker
25. Oc Eo
26. Ban Chiang
27. Ban Na Di
28. Phra That Phanom
29. Muang Fa Daed
30. Kantarawichai
31. Sukhothai
32. Si Satchanalai
33. Lamphun

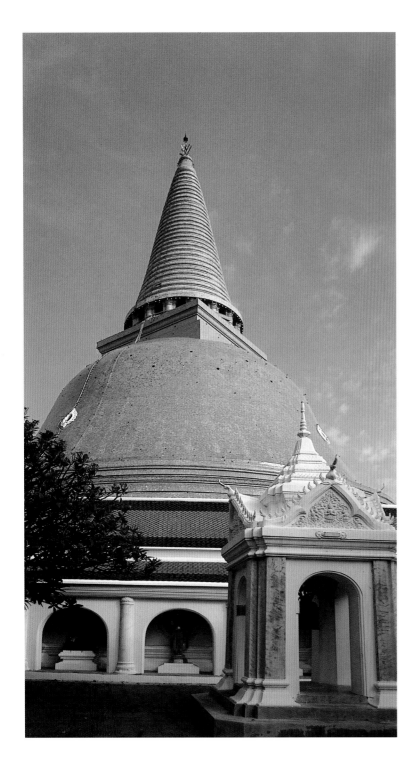

Plains, like the Plateau, had access to the outside world – lands in the east by way of the Plateau, and more significantly, overseas, to those in the west. The Kwae Noi River and the Three Pagodas Pass led from the Lower Central Plains through the Western Highlands that separated the Plains from the Bay of Bengal, beyond which lay India.

The two regions north and south of the Central Plains were also geographically well positioned to play significant roles in Thailand's history. The Northern Highlands, composed of mountains one to two thousand meters high with narrow river valleys, was ill suited to agriculture and early permanent settlement, but there was easy communication with Mon peoples who lived in what is now Myanmar. South of the Central Plains and the Western Highlands lay the long Peninsula, a land of mangrove swamps, nipa palms, and sandy beaches that reached as far south as what is now Malaysia and generated cultural and historical contacts with present-day Indonesia. The Peninsula also separated the Bay of Bengal from the Gulf of Thailand while at the same time its narrowest area, the Kra Isthmus, forty kilometers wide, provided a stepping stone between India and China.

Thus, Thailand was located at the very heart of countries whose recorded histories were more ancient than its own and undisputedly played vital roles in the formation of Thai art. For this reason it is understandable that past histories of pre-Tai art have often begun with the arts and cultures of neighboring lands. In those histories, Thai art is perceived primarily as a reflection of foreign attributes. And that perspective has become deeply ingrained in the minds of historians, art historians, and lay people alike. Still today, in the early twenty-first century, Thai scholars, ignoring the fact that by the late eleventh century AD the western Khorat Plateau was ruled by a firmly established local Khmer population that was producing its own distinctive art objects, classify Plateau art styles according to (undisputed) similarities with art produced in neighboring Cambodia. And, according to many twentieth-century historians, Indian influences

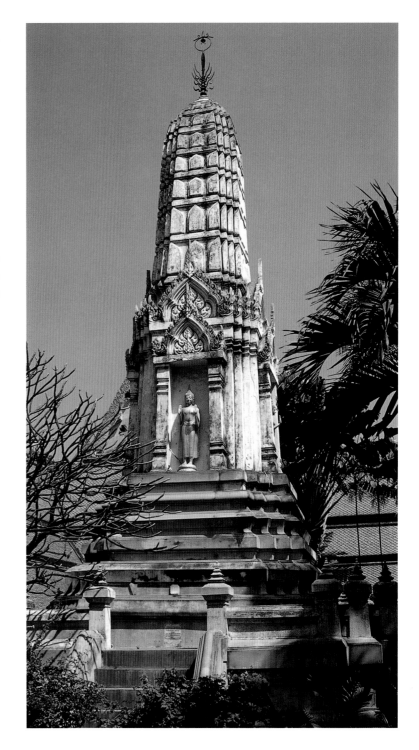

Stupa in the form of a prang *at Wat Mahathat, Bangkok, nineteenth century. The* prang *is a modified version of Khmer towers* (sikhara) *that surmount temples in Cambodia and Thailand. Such temples were usually dedicated to the Hindu gods Vishnu and Shiva, but the* prang, *which originated at Phimai, on Thailand's Khorat Plateau, are invariably Buddhist. Nonetheless, the royal symbolism of the Hindu temples has been retained. (Betty Gosling Photo)*

in the early centuries AD were felt to have been so strong that the 'Indianization' of Southeast Asia has remained a catchword to describe what is believed to have been the major process by which Thai art and culture were created. 'Pre-Indianized' Thailand, it was thought, was a barren land that provided neither local resistance nor encouragement to the seeds of change that foreign immigrants planted on Southeast Asian soils as they arrived 'in waves' from their native lands. It has been some time since Southeast Asia was referred to as 'Farther India' or 'Greater India', but debates as to what is 'Indian' and what is 'local' persist'.*

The vital role that foreign cultures have played in the formation of Thai art and culture in both pre-Tai and later periods is unmistakable and deserves major attention in any art historical work. In recent decades, however, archaeological, linguistic, and art historical research has begun to unearth ancient cultures in Thailand that predate the introduction of Indian or Khmer cultural concepts, and a case can be made that it was local peoples rather than foreign visitors who determined the course of Thailand's artistic history. No longer must pre-Indian Thailand be perceived as the passive recipient of foreign influence but as a land of thriving communities that determined which foreign elements they would adopt and in what ways they would put them to use. Major influences – the compelling forces that produced significant cultural and artistic innovation – were local, not foreign.

While the seeds of change often arrived from distant lands, their selection, cultivation, and cross-fertilization were the products of local endeavors. The seeds that were left untended failed to root; those that landed on fertile soil and were encouraged survived. It was this internal process, by means of which Thai art developed, that is central to an understanding of Thai art as we know it today. It is this course of development that will be considered in the pages below.

* See, for instance, Wales (1960) and Coedès (1964). For more enlightened views, see Brown (1992, 1994, 1996); Schastok (1994); Aasen (1998) and specific chapter references.

CHAPTER TWO

Neolithic, Bronze, and Iron Period Art

To unravel the complexities of Thai art, we start at the beginning, in prehistoric times around 2300 BC, when (three millennia before the arrival of the Tai), agricultural peoples were beginning to form permanent communities in the land that four millennia later would become Thailand. The early settlers were Austroasiatic speakers, perhaps descendants of earlier migrants who over many centuries had spread into Southeast Asia from the Yangtze region of what would later become southern China (Higham and Rachanie, 1998: 72-4). The Austroasiatic people who settled in Southeast Asia would eventually split into two of its most widespread linguistic groups – Mon-speakers, clustered in Thailand's Central Plains and Khmer-speakers in the east, in the southern regions of the Mekong River. Each group would play distinctive roles in Thailand's cultural and artistic history. At first, however, this ethnic dichotomy did not exist (Vickery, 1998: 63-5), and the art objects that the early Southeast Asian settlers produced bore no stylistic relation to Thailand's art in historic times.

Still, less obvious links between the arts of the prehistoric and historic periods are essential to our story and need to be examined. As early as the Neolithic Period (c. 2300-1500 BC), the country's diverse geographic regions had begun to play unique roles in the country's artistic development, the inhabitants of different regions interacting with their surroundings in unlike ways. In the area's Bronze Period (c. 1500-400 BC), new technologies would enable innovative art styles, and in the latter half of the first millennium BC, iron would play a major role in the Plateau's cultural development. In the latter centuries of the first millennium, new contacts with India and China would engender an awareness of unfamiliar art styles that were arriving from opposite directions of the outside world. At the same time, well-established lines of internal communication along Thailand's rivers allowed increasing local dissemination. The communities that were located along the well-traveled routes would later become important political and artistic centers. While most of these communities would vanish, only to reemerge as twentieth-century archaeological sites, the areas in which they were located would retain their importance well into the historic period. If the roots of Thai art did not take hold in prehistoric times, the country's soil, inadvertently, was being tilled.

Life in Thailand's earliest settled communities can be vaguely conjectured from rock paintings that have been found throughout most of the country (Higham and Rachanie, 1998: 131-33). It is not known when these paintings were made and a wide variety of dates has been suggested, some as late as the first century AD. The paintings reflect, however, a way of life that must have existed in much earlier times, enduring only in Thailand's more remote areas. The paintings depict hunting scenes with both bows and arrows and blowpipes, and domesticated animals include oxen, dogs, and cattle, the latter superimposed upon one another as they might appear in herds. Fish appear to have been a major source of food. Rendered in red, black, and ocher, the figures, both human and animal, are primitive, sometimes nothing more than silhouettes, and the significance of the geometric patterns interspersed among them cannot be explained. It was only with the advent of archaeological work in the twentieth century that a picture of Thailand's prehistoric past and the art that it produced began to emerge with any clarity.

In the beginning (according to archaeological research), Thailand's early settlers, like Neolithic peoples the world over, manufactured goods that were primarily utilitarian – axe heads, choppers, and knives made of polished stone, bone, or bamboo. And as elsewhere, there were vast amounts of pottery. There was a conformity in both the appearance and manufacture of Southeast Asia's early ceramic pieces that suggests that an ubiquitous pottery style had spread throughout Southeast Asia as culturally similar peoples dispersed from northern areas. There were a few designs that found farflung but only scattered use. At a site known today as Ban Kao, located in the Kwae River valley west of the Lower Central Plains, cord-marked globular vessels that were supported on three legs facilitated their placement over an open fire. But while there were no counterparts in neighboring areas, similar pots have been found as far away as the Malay Peninsula and suggest the style was disseminated by movement of settlers as they migrated into more southerly regions (Watson, 1979: 60-1; Higham, 1996: 264-5).

Much more common, however, were globular, unglazed, and thick-walled vessels without legs, which, like the tripod pieces, were constructed by tapping the exterior walls with cord-covered paddles while the inner walls were supported by doorknob-like clay anvils. The corded paddles left distinctive markings that were often delineated by incised, curvilinear lines (White, 1982: 29-31; Watson, 1979: 61-2). Gradually over time, those markings would evolve into what might be considered the country's earliest art.

Thailand's first Neolithic, pottery-producing villages were few, small, self reliant, and autonomous, and the pottery designs that they had once shared with villages throughout Southeast Asia began to

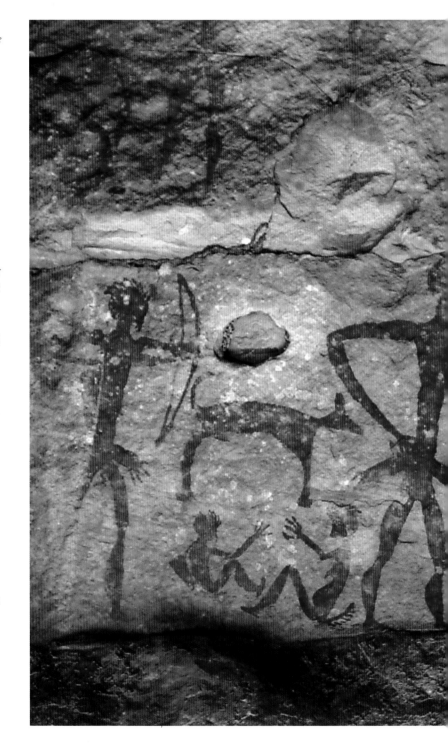

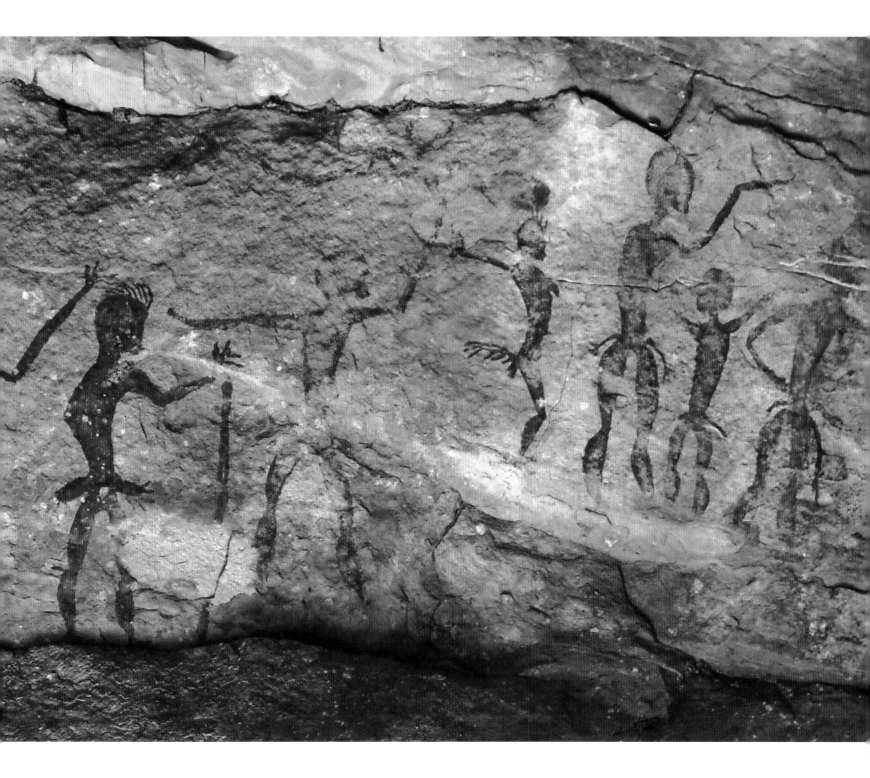

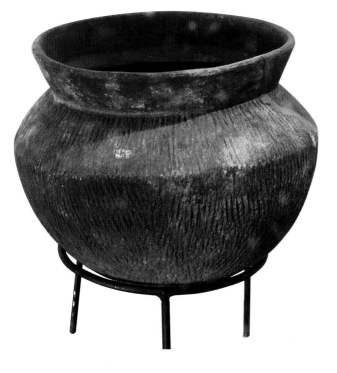

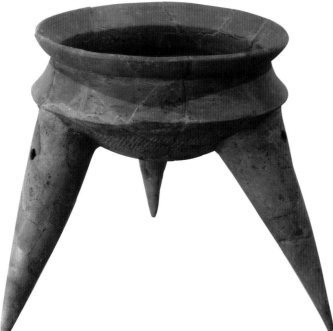

Left, opposite and next overleaf: *Four cord-marked vessels from Khok Phnom Di, on the coast of Thailand. These pots illustrate variations in pottery design that evolved from generic globular pots as transient peoples began to settle in autonomous, semi-isolated villages in Thailand around 2300 BC. Lips, pedestals, and more carefully arranged cord marks were early innovations.*
(Prachinburi and Ban Kao National Museums)

Below: *A tripod vessel from Ban Kao, in the Western Highlands. This type of cooking pot appears to have been disseminated wildly throughout Southeast Asia by migrations of peoples from the north.*
(Ban Kao National Museum, Kanchanaburi)

acquire local variations. Some of these idiosyncratic pieces displayed an artistry heretofore unknown. The old traditional cord marks that were common to most of Southeast Asia became more distinctively arranged, and dissimilar aesthetic variations in the delineating lines emerged. This was particularly true in the favorable environments of the Lower Central Plains where a few Neolithic communities flourished and there was leisure time for the production of objects of uncommon artistic value. Some of these cord-marked vessels were burnished with smooth pebbles to produce a fine luster, and pedestals, which had appeared only sporadically in earlier pieces became more prominent.

The largest and most prosperous of the Lower Central Plains settlements between 2000 and 1500 BC so far discovered was a community known today as Khok Phnom Di, located near a swampy estuary of the Bang Pakong River where it flowed into the Gulf of Thailand (Higham, 1996: 251-8; Higham and Rachanie, 1998: 44-63). The site was blessed with an abundance of maritime products and good potting soils, and at times when the sea level was low, there were good agricultural lands. Its pottery was exceptional. Over time, cord-marked and incised wares became increasingly sophisticated and the shapes more varied while other pieces broke with tradition altogether. There were distinctively pedestaled, brightly polished, incised black wares, and unlike the traditional cord-marked pots, which continued to be mass-produced, the finer pieces with their stylistic variations appear to have been manufactured by individuals or small groups of specialists.

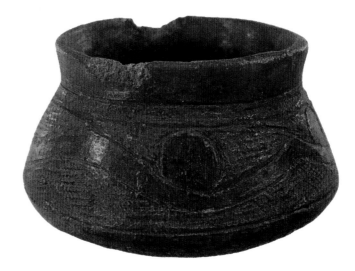

Along with more refined ceramic wares, Khok Phnom Di, like other affluent communities in the Lower Central Plains, produced a profusion of ornamental beads, bangles, and earrings. There were also ornamental flat rings with beveled inner rims, similar to ones found in Neolithic China, peninsular Malaysia, as well as various other sites in Southeast Asia (Sørensen 1988: 65) and whose designs, like that of the Ban Kao pots, must have been disseminated by migrations of peoples moving southward. But more notable were unique ceramic forms that were beginning to emerge. Both jewelry and ceramics must have provided prestige to their owners and distinction to their communities, and there was special status accorded the artisans who were now producing unique works of art. While prized objects were interred with their owners in elaborate graves, artisans were buried not only with their finer works but also the tools they used to fashion them. Artisans appear to have been mostly women, and one woman potter was buried in a large grave along with more than 120,000 shell beads and examples of her finest ceramics and working tools.

At about the same time that villages were beginning to take pride in creating unique art forms, there was also an interest in the exotic – a dichotomy of interests that would characterize Thai art throughout the ages. Neolithic `imports' would not be considered foreign today, for they were acquired from nearby communities, which, however, in Neolithic times were distinctive. In the beginning, a preference for local craftsmanship appears to have overridden a desire for new designs.

Importation consisted primarily of raw materials rather than finished wares (Hall, 1985: 1-2). In the highland areas that bordered the Plains there were agate, marble, and other fine stones that were not found elsewhere, and the highlanders, who subsisted primarily by hunting and gathering, exchanged their wares for rice grown in the Plains. Khok Phnom Di exchanged large amounts of sea products for stone. But local designs appear to have persisted even as they were rendered in new, 'imported' raw materials. The stone that Khok Phnom Di imported was used to manufacture bracelets that like those previously manufactured from shell. And Ban Kao, which was especially well situated for trade with both the mountains and the coastal areas, produced an abundance of shell and stone bracelets and beads like those that they had previously made of bone (Higham, 1996: 263). In a later period, after new technologies had been introduced, the same designs would be rendered in bronze.

Not surprisingly, trade was most developed among communities with the most to barter – notably between Khok Phnom Di and villages in the Lopburi (or Khao Wong Prachan) area, in the Lower Central Plains 150 kilometers north of Khok Phnom Di (Higham and Rachanie, 1998: 79-81; Ciarla, 1992: 126). The Lopburi area enjoyed an especially fertile area of the Plains, which allowed for the abundant production of rice, and the rice was exported to Khok Phnom Di in exchange for large amounts of shell that was used to manufacture beads, bangles, and earrings. Like Khok Phnom Di, the Lopburi area was also a

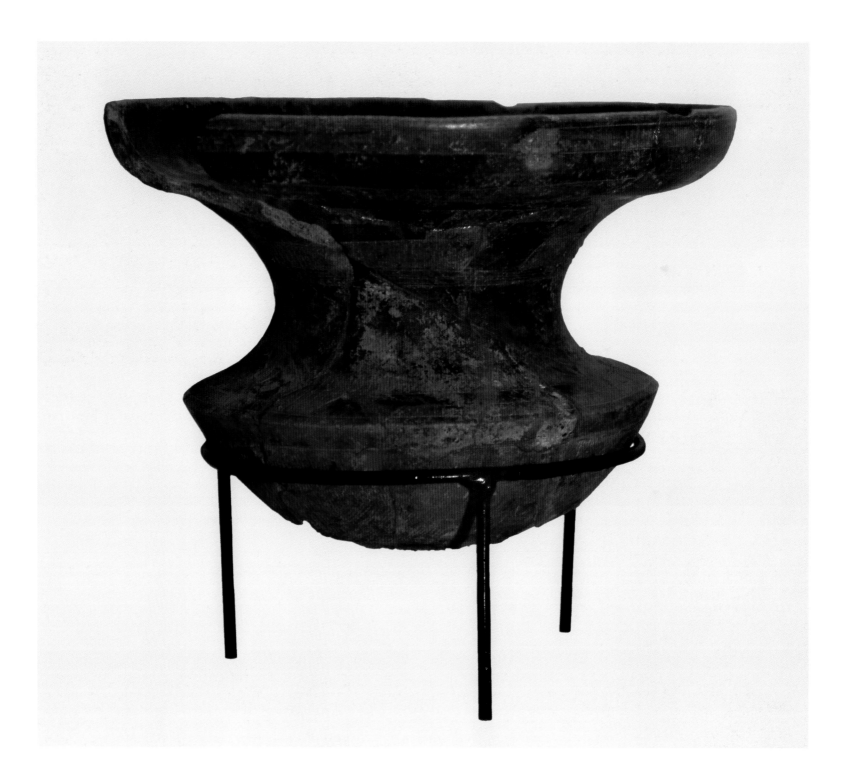

Right: *Beads and bracelets made of bone, shell, and stone. Such objects were highly prized among Thailand's Neolithic settlers. Some objects, such as the flanged bracelet, appear to have been spread by migrations of peoples over large parts of Asia while other types were traded within much more limited areas.*

Below: *Necklace made of bone beads. The shape of the beads was sometimes replicated in stone.*

Below right: *Glass beads dating perhaps from the third century BC. When contacts were made with India, glass beads began to supplement those made of natural materials. Many beads such as these were soon produced locally.*

(Prachinburi National Museum)

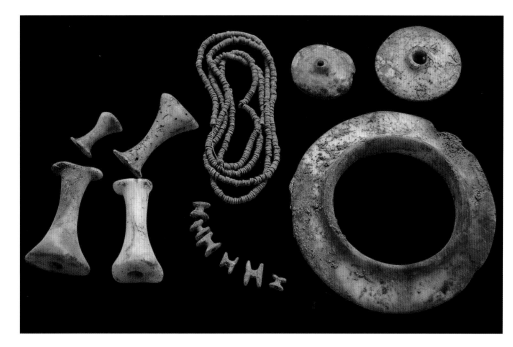

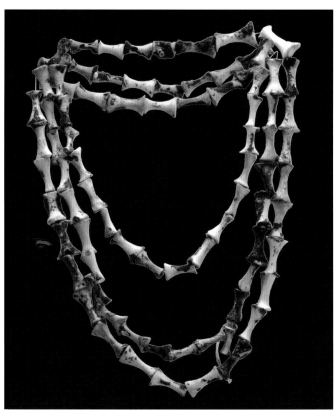

Right: *Early Ban Chiang vessels from the early second millennium BC. Pots such as these, like other ceramics in Thailand, evolved from generic cord-marked pots. But the Ban Chiang designs are notable for their well-executed, diverse shapes and meandering designs, which were often applied with red paint. (Ban Chiang National Museum)*

Below: *A pot typical of Ban Chiang's middle period, c. 1000 BC. The design is unique and its origins are unknown. (Ban Chiang National Museum)*

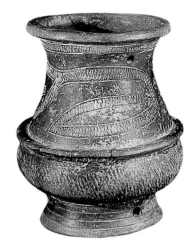

producer of exceptionally fine pottery and a stylistic resemblance among some of the designs of the two areas suggest an exchange of finished wares. It is possible, however, that the refined swirls of the cord-marked pieces reflect parallel developments form earlier designs. Certainly, what exchange of art motifs there might have been was limited. Three and a half millennia later, in the thirteenth century AD, Lopburi would become a melting pot of multicultural and artistic attributes acquired from farflung area and would provide the geographic and cultural nexus between Thailand's Tai and pre-Tai eras (Chapter 9). In Neolithic times, however, even its most distinctive pottery designs did not spread very far. Unusual vessels in the shape of a cow made in the Lopburi area remained local, and the remarkable turtle shell ornaments that were a Khok Phnom Di specialty did not find their way outside the coastal area.

In contrast to the Lower Central Plains' fine agricultural lands, which fostered flourishing Neolithic settlements, the inhospitable environment of the Khorat Plateau made early settlement difficult. Early arrivals from southern China seem to have bypassed the Plateau for the Plains' more productive lands, and Neolithic settlements were rare. The greater part of the Plateau would not develop culturally until the emergence of iron around 500 BC. There was one notable exception, however: a small area located in the far northeast of the Plateau where the Chi and the Songkhram rivers provided some arable soil. For several centuries, that area would outshine even the Lower Central Plains in its artistic achievements.

Sometime around 2100 BC the Songkhram area gave birth to more than one hundred culturally related sites that would later become

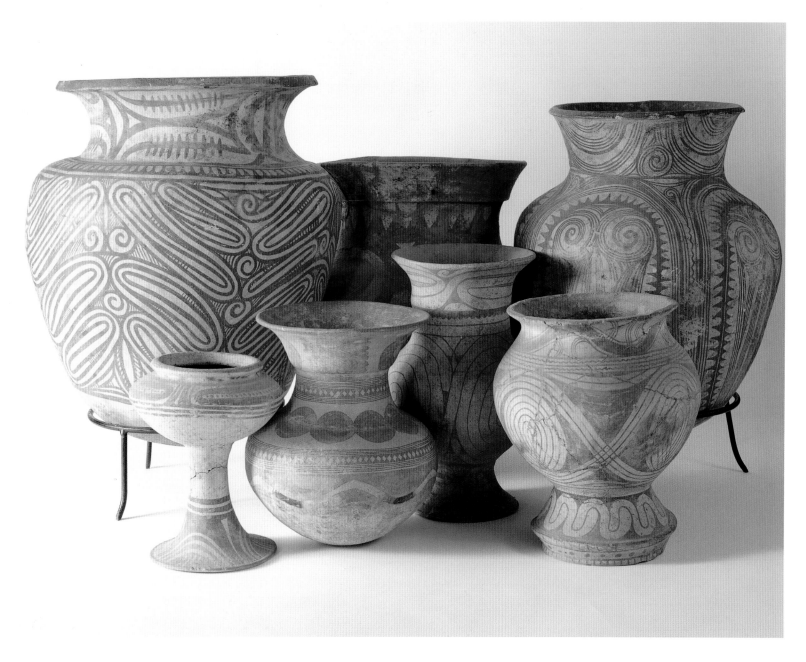

A group of late-period Ban Chiang-area vessels dating from the last few centuries AD. Although such vessels were made a millennium and a half after Ban Chiang's early pieces, a stylistic continuity is evident. The late designs display an artistic expertise unknown elsewhere in Southeast Asia. The pot at front center is probably a twentieth-century reconstruction and is indicative of the interest Ban Chiang has generated in recent decades.
(Ban Chiang National Museum)

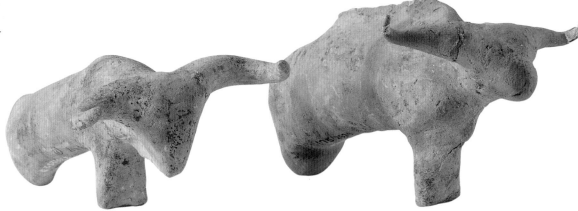

Small pottery animals from the Ban Chiang area. Like Thailand's rock paintings, these figures display an interest in the local rather than the exotic.
(Bangkok National Museum)

Archaeological site at Wat Pho Sri, one of many in the Ban Chiang area. Since Ban Chiang was discovered in the 1960s, archaeological research has been prolific.

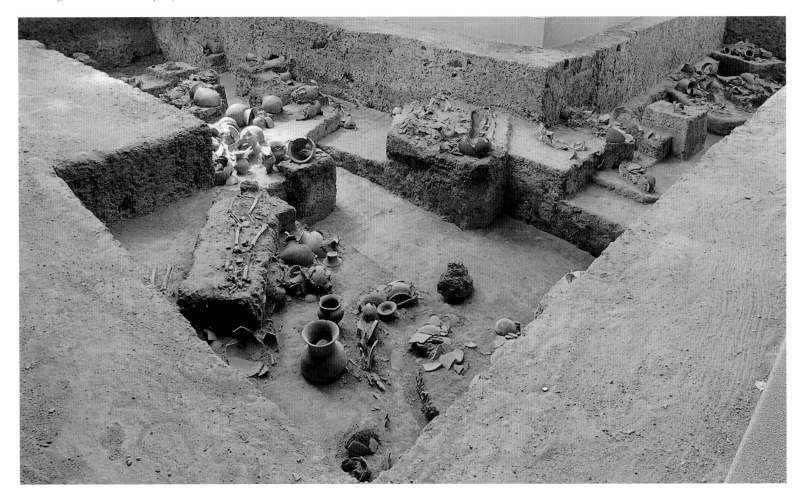

Bronze objects from Ban Chiang. A variety of innovations in Ban Chiang's bronze jewelry appear to have resulted from access to new technologies rather than from foreign artistic connections. (Ban Chiang National Museum)

known collectively by the name of its most prominent community, Ban Chiang.* During the early stages of its development, trade seems to have been little developed in this relatively isolated area. Shell and stone beads and bracelets evidence some contact with both the sea coasts and the mountains, but a preponderance of objects made from bone and ivory suggests a heavy reliance on local resources. Graves were less richly furnished than on the Plains and were fewer in number. In spite of its slow beginnings, however, Ban Chiang and some of the surrounding Songkhram area communities would eventually produce the finest artifacts that Thailand's Neolithic and Bronze Periods would know (Higham, 1996: 188-204).

Like that of other Neolithic communities, Ban Chiang's earliest pottery consisted of thick, unglazed, cord-marked globular bowls, but even in the beginning the vessels displayed exceptional artistic skills. The cord markings and delineating lines were especially assured, and in some cases additional motifs were applied by cord-wrapped rollers. A number of the Ban Chiang pots were footed and lipped, and lively, free-hand engraved lines and meandering designs painted in red sometimes encircled the rim. Distinctive flanges surrounding the bowls were common. These Neolithic designs initiated a long and remarkable pottery tradition that culminated with Ban Chiang's finest masterpieces nearly two millennia later (White, 1982).

As on the Plains, foreign intrusions into Ban Chiang's art had been in the form of novel raw materials that were used in traditional ways. By 1500 BC, however, there was a dramatic new technology as well: both utilitarian objects and jewelry that had been made of stone, shell, or bone began to be replicated in bronze and the new technology also

led to new designs. It has not been ascertained how bronze first came to be manufactured on the Plateau. Tin and lead could be imported from the highlands that surrounded the area, and some scholars consider that their amalgamation into bronze was due largely to the Plateau people's 'exploiting local rich resources' (Glover, 1999: 126). A few others see influence arriving from the west (White, 2000: 1093-4). There was also a flourishing bronze casting industry in the lower Red River region (Bac Bo) in what is now northern Vietnam, which in turn, was in contact with Lingnan, in southeast China, where magnificent Chinese Shang Dynasty bronzes were being produced in the mid-second millennium BC. According to archaeological research, bronze casting at Ban Chiang began at about the same time (Higham, 1996: 9-12, 134, 240-6, 311-12). Thus, the introduction of bronze technology on the Plateau from the north is also a possibility.

By whatever means bronze casting reached Ban Chiang, local aesthetic preferences (as on the Plains) were to persist. No contemporary bronzes from China, northern Vietnam, or the west have been found in the Songkhram area, and there is nothing to suggest foreign artistic (as opposed to technological) influences. Small clay figurines from Ban Chiang as well as nearby Ban Na Di that include representations of humans, deer, elephants, cattle, and perhaps water buffalo reflect an interest in the local. As on the Plains, Ban Chiang appears to have celebrated its own craftsmanship and artistry. Remains of furnaces, bivalve molds, and ingots all indicate local production, while tools of the trade were sometimes buried with the artisans.

What artistic innovation there was in the Songkhram area derived not from the outside but from new possibilities that bronze casting

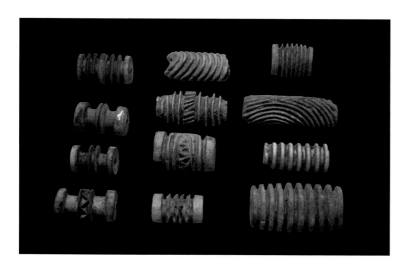

Clay rollers probably used at Ban Chiang for printing cloth. Fragments of silk have been found at Ban Chiang sites, but nothing is known of the weaving techniques or where they originated. (Ban Chiang National Museum)

provided. Rather than adopt whatever foreign designs they may have had access to, artisans elaborated upon the old. Bangles whose designs derived from traditional bone and ivory examples were now embellished with decorative flanges, small nodules, and scallops. The larger surfaces that bronze made possible provided flat surfaces that could be embellished with linear designs of local origin. Bronze casting also played a role in the formulation of a new pottery design. For a short time during Ban Chiang's middle years, large unadorned, carinated ceramic vessels with very thin walls and a sleek sculptural elegance made their appearance. There are no known prototypes for these vessels; rather, they appear to have been made in segments that were pieced together in a procedure that is more typical of metal work than potting.

What is considered the best of Ban Chiang's pottery and bronzes was produced during the latter three centuries of the first millennium BC. A continuity with the distant past can be seen in the pottery's elegant free-hand abstract designs, whose origins can be traced back to similar Neolithic cord-marked vessels (White, 1982). The typical swirls, spirals, and meanders display the vitality and verve that had typified much earlier pieces, but now the motifs were more complex and despite their apparent spontaneity, were combined in novel, complex, precisely controlled arrangements. The pieces were also larger, the pedestals taller, the lips wider, the shapes more diverse. The decorative motifs were typically rendered wholly in red over a buff or red-slipped background rather than over incised patterns, and occasionally there were stylized human and animal representations.

Sometime around 300 BC, just when Ban Chiang's finest ceramics were being produced, there were also signs that its ancient traditions were being disrupted. While old pottery styles persisted in more elaborated forms, a different source of potting clay is evident at both Ban Na Di and Ban Chiang, and there were different methods of tempering the clay. Some iron tools appeared alongside bronze jewelry, and there were a few glass beads of foreign manufacture. Innovative bronze technologies that required intense heat and a high tin content were now used to produce nontraditional, highly ornamented bronzes such as toe and finger rings, wire-like necklaces, and bells. Surprisingly, however, these cultural intrusions into the Songkhram area seem to have engendered not an increase in artistic production, as one might have expected, but, rather, Ban Chiang's demise.

Just what happened during the latter centuries of the first millenium BC is not known, and one can only speculate as to the events that brought about the end of Ban Chiang's centuries of artistic production. Perhaps there were infiltrations of peoples from the southern Plateau, where major cultural changes were taking place. There, change was dramatic. Glass beads and iron tools, found only sparingly at Ban Chiang, were becoming ubiquitous, and high-tin bronze jewelry was abundant (Higham, 1989, 1996; Higham and Rachanie, 1998). Most remarkable, settlement was progressing at a rapid pace and large villages were being constructed. Slow to develop, the Plateau was now meeting its environmental deficiencies head on, and development would soon come in ways heretofore unseen.

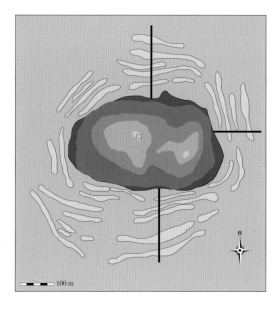

Plan of Noen U-Loke, located in the Upper Mun River area. Noen U-Loke was one of the largest of many hundreds of concentrically moated settlements that began to dot the Khorat Plateau in the late first millennium BC.

Despite the intrusive designs of some of Ban Chiang's new artifacts, however, the Songkhram communities failed to follow the cultural innovations that were taking hold farther to the south. While settlements in the southern Plateau multiplied, grew and flourished, the Ban Chiang communities remained small and provincial. Located in a more isolated, favorable environment, they had neither the incentive to change nor the easy access to distant lands that the Mun River afforded. The northern and southern areas of the Plateau, in spite of their proximity, were cultural strangers, and while the south was launched into a new cultural era, Ban Chiang was left in the murky backwaters to gradually expire.

While Ban Chiang's pottery and bronzes made little impact on art styles beyond the Songkhram valley, by the latter half of the second millenium BC bronze casting had been disseminated throughout the Plateau (Higham, 1989, 1996). It was not bronze, however, but iron, that would change the face of the area and the way of life it provided. With the southern region's ever-present problems of drought and flooding, there was a dire need for water management, and iron tools provided the means of making the land habitable.

Both China and India have been suggested as possible sources for the iron working on the Plateau, or perhaps, as sometimes suggested, it evolved from local copper and bronze technologies (Higham, 1989). Whatever its source, iron was used in ways that were unique to the area and was put to use to meet its own particular needs. By the fourth century BC, primarily in the valleys of the Mun River, and to a lesser extent in the Chi area, there were hundreds of villages that were able to

withstand the inhospitable environment. Typically, towns were built on elevated areas that were surrounded by one or more concentric moats interspersed with earthen ramparts. Water sources were controled by dams, canals, and large tanks that fed into the moats (Williams Hunt, 1950; Moore, 1988). What had once been a hostile landscape now supported communities of considerable size and affluence. One of the largest of the moated sites, Noen U-Loke, was conspicuous for what may have been five concentric moats. Houses were small but substantial and, unlike the wooden, stilted houses that would be the norm in later times, were constructed of clay-covered wooden frames that were erected above slightly excavated rectangular pits.

The Plateau's Iron Period is notable not only for Thailand's first planned cities, but for what might be considered its earliest monumental art – crudely shaped upright megaliths, or menhirs, some several meters high. The stones were erected in a variety of configurations – in circles, in pairs, or in straight lines, some of which were several kilometers long. Most of the stones that have been discovered so far – and many are still to be excavated – have been moved from their original sites and their exact function is not known. Muang Sima, a moated site in the Upper Mun region not far from Noen U-Loke, would later become an important Buddhist and Hindu center, and the stones would be overshadowed by more sophisticated monuments. At Muang Fa Daed, in the Chi valley, the roughly hewn stones would later be carved with scenes that depicted *jataka*, or former lives of the Buddha (Chapter 7). Originally, however, like similar prehistoric monuments found the world over, the Plateau's menhirs may have been erected to track the

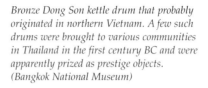

Vessel exemplifying the 'Phimai Black' burnished pottery typical of the Upper Mun River area in the latter centuries BC. This type of pottery was much traded throughout the area and must have contributed to a prosperity that led to the area's unrivaled political, religious, and artistic dominance in the tenth and eleventh century AD. (Phimai National Museum)

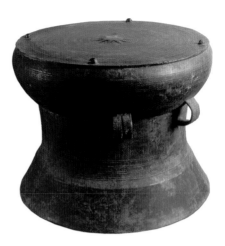

Bronze Dong Son kettle drum that probably originated in northern Vietnam. A few such drums were brought to various communities in Thailand in the first century BC and were apparently prized as prestige objects. (Bangkok National Museum)

astronomical and seasonal changes on which agricultural peoples depended for their sustenance. Or perhaps they marked now vanished shrines where earth gods were propitiated (Wales, 1969: 109; Manit, 1962: 13; No Na Paknam, 1981: 60).

In the arid areas, which Neolithic peoples had once bypassed in favor of more benign environments, prosperity allowed for other non-essential activities. Large moated communities such as Noen U-Loke, by 500 BC were making large, richly decorated high-tin bronze bracelets, head ornaments, belts, bells, and a multitude of finger, toe, and earrings, some of which were made by the lost-wax method, some manufactured in batches in ceramic molds. The most affluent communities were located on the far western part of the Plateau, the area of the Upper Mun River, where passes led through the Petchabun mountains into the Lower Central Plains. The Upper Mun region held a pivotal position on major trade routes, and it would long remain one of the country's major cultural and political centers. Its bronze casting would become the most sophisticated in all Mainland Southeast Asia.

As early as the Bronze Period, the Plateau's new technologies and unprecedented population explosion resulted in a previously unknown interaction along the old communication routes that linked eastern and western parts of Mainland Southeast Asia. In diverse areas, red-slipped, red-painted ceramic wares replaced some of the old generic cord-marked wares, and regionally-distinct pottery spread over an increasingly wide range. An area of some 100 kilometers in diameter in the Upper Mun region that centered around Noen U-Loke and Muang Sima was distinguished by a pottery style fired in an enclosed environment that produced a black finish. Decorated with clearly defined burnished strokes, the ware is known today as 'Phimai Black'

and sometime found its way into the Lower Central Plains (Welch and McNeil, 1991; Bronson, 1979). Communities in the Central Plains began to produce bronze versions of artifacts which had originally been made of stone or shell.

It was during the Plateau's Iron Period, in the fourth century BC, that foreign objects from both India and China began to find their way into what would one day become Thailand. At Ban Kan Luang, located near the junction of the Mun and Mekong rivers, there was a variety of profusely decorated bracelets and rings, and a bronze figurine of a human forty-five millimeters high is thought to have been made in Yunnan, in what is now southwest China. And at Don Tan on the right bank of the Mekong, there were Chinese coins. Although these objects were apparently isolated, other items found wider distribution, spreading across the Plateau, via the Mun River and across the Petchabun Range into the Lower Central Plains. A number of large, elaborately decorated bronze kettle drums known as Dong Son drums, which between 500 and 100 BC were being produced in Yunnan and the lower Red River region of Vietnam, were deposited at Pak Thong Chai in the Upper Mun River region. Six such drums found their way to Ongbah cave, located in the area not far from Ban Kao (Sørensen, 1988, 1990). At Ban Don Ta Phet, a fourth century BC community located in the Kwae River area, there were jade and glass slit earrings like ones found in the Philippines, as well as jade pendants with double-headed animal designs that had counterparts in the Sa Huynh region of coastal

Opposite: Detail of the top surface of the Dong Son kettle drum illustrated above. In spite of the complexity and beauty of Dong Son drum designs, they were not copied locally.

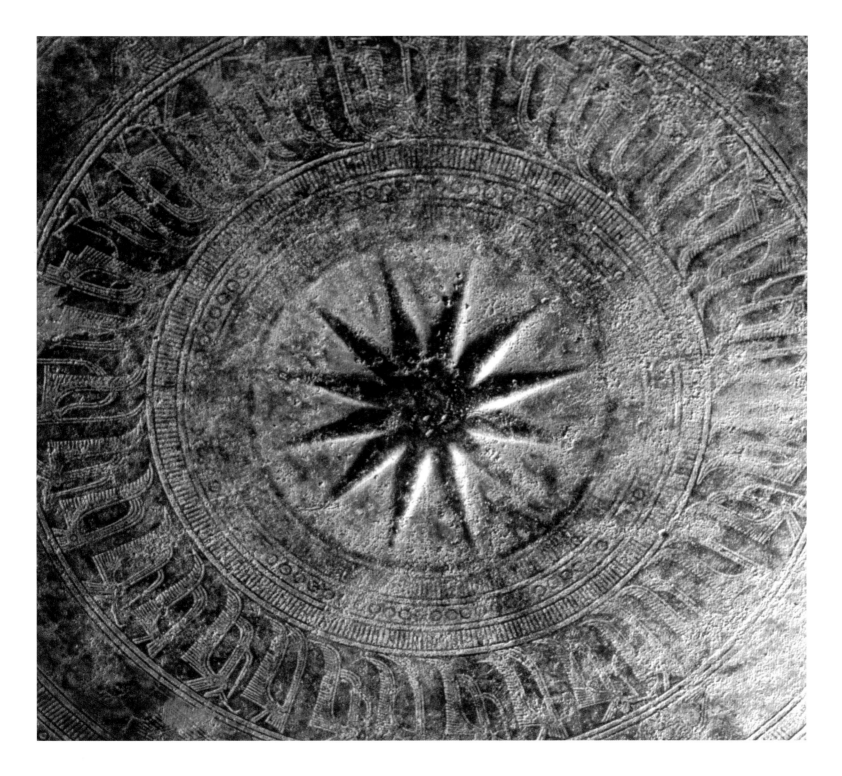

Two examples of foreign objects that were reaching Thailand in the latter centuries BC. The two-headed earring found at Ban Don Ta Phet is like those found on the coast of Vietnam and in the Philippines. The fragment of a high-tin bronze bowl from Khao Jamook is probably from India. Like Dong Son kettle drums, neither the two-headed earring design nor the style of the figures on the bowl had any effect on Thai artistic traditions. While high-tin bronze bowls may have been made locally, the pictorial designs remained foreign.

Vietnam (Higham, 1996). A double-headed pendant also found its way to U Thong, a site located in the Lower Central Plains that would become the area's most important religious and political site a millenium later.

More significant for the Plains, and ultimately for all of Thailand, than imports from the east were those that by the fourth century BC were beginning to arrive from India. Indian travelers could reach the Lower Central Plains by skirting the northern rim of the Bay of Bengal and following the Kwae Noi River, which cut through the Western Highlands by way of what would much later be called the Three Pagodas Pass. From there the Pasak River led to the Mun River and the Plateau. Glass beads manufactured in India soon became ubiquitous in the Kwae River area, on the Lower Central Plains, and the Plateau (Glover and Henderson, 1995).

Ban Don Ta Phet was the recipient, along with its Sa Huynh double-headed and slit earrings, of an unusually large number of Indian glass beads. And there was also a carnelian pendant in the form of a leaping lion, as well as small bronze figurines depicting a fighting cock, a peacock, and a cockerel standing in its cage, all, it has been suggested of Indian origin.[**] Fabrics woven from cotton and hemp appear to have been introduced from India. Most intriguing are bronze bowls with a very high tin content decorated with deeply incised motifs: floral and geometric designs, representations of water buffalo, horses, elephants, and a woman, elaborately coiffured, dressed, and bejewelled in the Indian manner. Several similar bowls were found at neighboring Khao Jamook, near what appears to have been a significant source of tin for the Kwae River area. Although the bowls appear to have been produced locally, they were decorated with incised designs that evidence Indian contacts (Glover, 1990; Bennett and Glover, 1992; Higham, 1996).

The precise nature of the connections between India and Mainland Southeast Asia in these early times is still under investigation, and there are many unanswered questions. But, whatever the links, what is clear at this point is that exotic objects, some of which were interred with their owners in elaborate graves, were highly valued. Foreign finished products, it appears, were now being prized along with the novel raw materials and technologies that had been sought in earlier centuries. But in spite of obvious intrigue with the exotic designs that prompted a few local copies, the unfamiliar pictures and curious three-dimensional objects that were occasionally making their way into Thailand in the late first millennium BC inspired no long-lasting artistic traditions. While some traditional stone and shell ornaments were now replicated in bronze, older materials remained popular (Bennett, 1990: 118; Ciarla, 1992: 126; Higham, 1996: 292). And although glass beads, which clearly fell within the ancient bead and bangle tradition, appear to have instigated widespread glass bead manufacture throughout Mainland Southeast Asia (Basa 1992: 85-102), the Kwae River figurines and drawings never found their way into any widespread artistic vocabulary. The ornate, Indian-related bowls must have lent especial prestige to both their owners and communities, but valued as exotica, they remained just that.

Eventually, Indian imports would make dramatic changes in both the cultural and artistic structure of the Lower Central Plains, and, in fact, of all Thailand. These foreign styles would spread throughout the region as local ones had never done, but this was still a millennium in the future. For imported art styles to make a lasting impression, there had to be new ways of thinking: new ideological as well as technological developments that could provide a meaningful structure with which these imports could mix culturally. And for these new

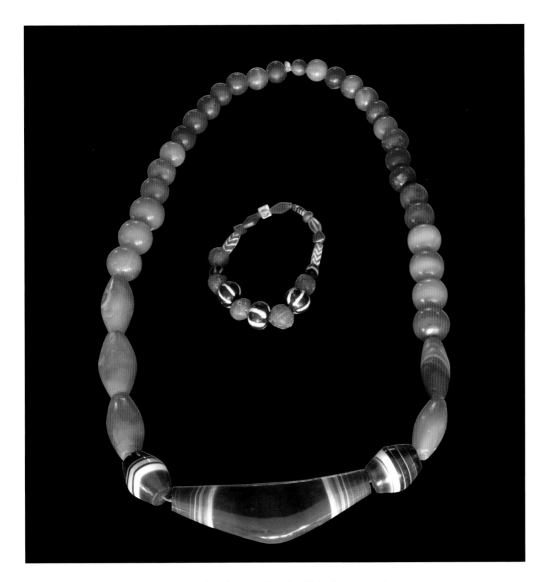

Polished agate, carnelian, and glass beads similar to many found throughout Thailand in the latter centuries BC. The technique and design of such beads were Indian, but they fit well into the local bead-and-bangle traditions and inspired numerous local renditions. (Ban Kao National Museum)

ideologies to be adopted, there had to be new local political centers that promoted dissemination of cultural traits farther afield than the Plains' early settlements could manage. Later, in the first half of the first millennium AD, these conditions would be met. Foreign art styles would be imported for cultivation in a local landscape and their blossoming would be local, not foreign. Then, in a dramatic turnaround, Thailand's art would evolve in novel and dramatic ways that the mere importation of prestigious raw materials, sophisticated technologies, artistic motifs and exotic luxury items alone would never inspire.

* When Ban Chiang's bronzes were first investigated in the 1960s, they were thought to be a local invention of the fourth millennium BC, older than any bronzes crafted in either China or the Middle East. Subsequent, more refined archaeological techniques suggested a much later date, however, and equally importantly, there was no indication of political or social organization in the third or fourth millennium BC that could have supported a local bronze industry.

** There is a wide disagreement concerning the Ban Don Ta Phet material. Glover sees the lion as Buddhist, although iconographic details that normally distinguish religious objects in India are absent. Brown thinks that the lion dates from the fifth or sixth century and perhaps was made in Sri Lanka. It is also his opinion that the cock is from Dong Son (personal communication, 2000).

The Introduction of Buddhist Art in the Central Plains

During the early centuries of the first millennium AD the variety of imported objects that had begun to arrive in the Lower Central Plains in the last centuries BC increased substantially. A third of the world away, the Roman Empire was seeking Asian silks and spices, and systematic long-distance trade routes were beginning to connect Europe, Persia, India, and China. In order for the European, Indian, and Chinese traders to reach their destinations, they had to cross or circumnavigate the land that one day would become Thailand (Hall, 1985: 26-38).

The old Southeast Asian travel routes that had been in place for centuries were still there to be used. The Bay of Bengal and the Three Pagodas Pass provided access through the Western Highlands to the Lower Central Plains and continued by way of the Mun River on the Khorat Plateau and the Mekong River to China. And now the Mun River route appears to have branched southward by way of the Pasak and the Bang Pakong Rivers to the Gulf of Thailand, where new trade routes were developing. Since the first century AD there had been port cities located on the southeast coast of India that were serving as entrepôts for Chinese, Roman, and Middle Eastern goods, and ships crossed the Gulf of Thailand by porting their goods across the Kra Isthmus, the narrowest part of the Thai Peninsula. Eventually, there would be affluent cites on the Peninsula (Chapter 6), and even in the early centuries AD, the port city of Oc Eo, located on the Gulf's eastern shores in what is now Vietnam, rivaled the Indian ports as an entrepôt for the exchange of foreign goods (Hall, 1985: 48-9).

One particularly thriving community in the Lower Central Plains in the early centuries AD that was well situated for both overland and maritime trade was Chansen. Located not far from the headwaters of the Mun River, Chansen also had access to the Pasak River and the Gulf. By the second century AD, Chansen was the recipient of a variety of exotic objects from both east and west. A few Roman coins found their way there by way of India, along with shiny Indian burnished ceramic pieces. There were also metallic-looking black pots thought to have been exported from the island kingdom of Sri Lanka, or perhaps from Beikthano, in what is now Myanmar (Burma), at the northern tip of the Bay of Bengal. Similar pieces have been found in all three areas. Stoneware bowls with a brownish green glaze, thought to be the earliest examples of glazed stoneware in Thailand, appear to have been exported from China (Bronson, 1979: 324-5, 329-30).

Along with the expansion of foreign exchange, local trade within Southeast Asia also increased. As foreign travelers passed across the mainland, they may have exchanged exotic artifacts for lodging, services, and provisions; communities along these trade routes with goods to barter flourished, and new trade routes emerged. Communities closest to the Gulf benefited the most (Hall, 1985: 27). Centuries earlier, U Thong had received items from the South China Sea area by way of the Plateau (Chapter 2); now there was also a variety of foreign objects that arrived by way of the Gulf. There were distinctive torque-like rings, small bronze bells, beads with filigree spirals, gold jewelry, coins, and medals. These items bore no resemblance to previously made local products, but some were identical to those found at Oc Eo, Chansen, and Beikthano, as well as another Lower Central Plains community, Nakhon Pathom, which would play a major role in Thailand's history in later centuries. Some

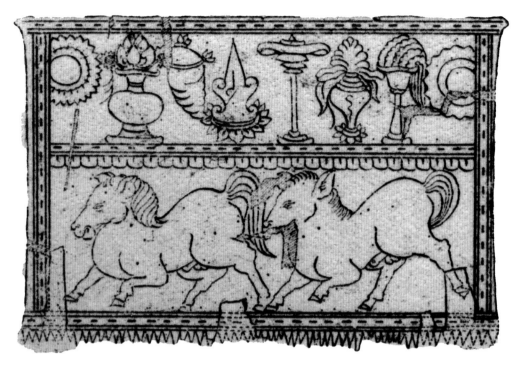

Left: *Ivory comb found at Chansen, in Thailand's Central Plains, probably from the Amaravati area of southeast India. The comb has been dated to the third century AD. (Bangkok National Museum)*

Buddhist symbols engraved on the Chansen comb are indicative of Thailand's early exposure to Buddhism. The upper panel depicts the sun, a ritual parasol, a conch shell, or horn of plenty, and one of Buddhism's most popular images, the purnaghata, *or auspicious ever-blossoming flower pot. The significance of the horses is uncertain, while the* hamsa, *or goose, below, was once associated with fertility.*

Medal found at U Thong, in Thailand's Lower Central Plains, similar to ones found at Beikthano, in Myanmar, and Oc Eo, on the southwest coast of Vietnam. There were many small objects common to the three areas, but it was flourishing trade routes (rather than political ties, as is sometimes suggested) that explain the similarities. (Nakhon Pathom National Museum)

An earring in the shape of a kinnari that arrived at U Thong from India sometime in the early centuries AD. Kinnari (part bird, part female figures) were popular pre-Buddhist Indian deities that were incorporated into the iconography of Buddhism. (U Thong National Museum)

jewelry and decorative items began to be copied locally. Identical stone bivalve molds for making such items, as well as earthenware stamps for printing designs on textiles, have been found at Oc Eo, Chansen, U Thong, and at Tra Kieu, in the Sa Huynh area of the Vietnamese coast (Chira and Woodward, 1966: 16; Bronson and Dales, 1970: 42-4; Bronson, 1979: 323-6; Loofs, 1979: 350-1; Higham 1989: 279). Now, it appears, foreign imports were becoming common enough to exist side by side with the indigenous, and while local craftsmanship seems to have still been valued, traditional designs were being partially replaced by newly imported ones.

There were other items that arrived in the Lower Central Plains that did not immediately inspire local copies but which portended unprecedented social and artistic change. One unique object that arrived at Chansen was an ivory comb engraved with Buddhist symbols. The comb's depictions of *cakra* (wheels), lotuses, conch shells, *hamsa* (geese), *chattra* (parasols), and *purnaghata* (auspicious, forever-blossoming pots of flowers) were all images that had begun to be incorporated into a complex Buddhist iconography formulated in India centuries earlier. Although a variety of dates and manufacture have been suggested for the comb,* an Indian provenance is undisputed. Basing his opinion on reliable archaeological evidence, Bronson has dated the comb to the first to third centuries AD (1979: 331). At about the same time that the comb arrived, U Thong received an Indian gold earring in the shape of a *kinnari*, a mythological part-bird, part woman, that was often depicted in Buddhist art (Chira and Woodward, 1966: 22).

It is not known who brought these items with Buddhist symbols to Thailand's Central Plains – fortune-seekers, commercial traders, and Buddhist monks have all been suggested. However that may be, it is unlikely that the *purnaghata*, *kinnari*, and other Buddhist icons initially had any more significance to the peoples of the Lower Central Plains than they would to uninitiated Westerners in the twenty-first century. It was not until the seventh century that the production of Buddhist art in Thailand began to take shape. Then it would not be isolated imported pieces that inspired a new art, but more likely, a concerted effort on the part of Buddhists in the Central Plains to find a new means of expressing what were now deeply ingrained religious tenets. By this time there must have been a well-established, thriving Buddhist community and a political organization that actively supported it. Buddhist art would serve both and would become as commonplace as the beads and bangles that has preceeded it.

The great majority of Thai art as we know it today stems from the Buddhist tradition. The process by which Thai art and Buddhist art became almost inseparable was a slow and tortuous one, however. Before the production of Buddhist art became ingrained there had to be a Buddhist ideology to provide the foreign religious symbols with local significance. And for Buddhist thought to gain widespread acceptance there had to be a local infrastructure for its dissemination. As we shall see, the spread of Buddhism in the Central Plains and the formulation of widespread links of communication went hand in hand, one dependent upon the other.

There are no written records that document the introduction or establishment of Buddhist practices in Thailand, and the means by which they came to be embraced in a land that previously accepted exotic intrusions with some degree of selectivity poses some of the most fascinating and challenging questions in all Thai history. When Buddhism reached the Central Plains it had already undergone almost a millennium of growth and development in India that was unrelated to the Southeast Asian experience, and the complexities of the Buddhist

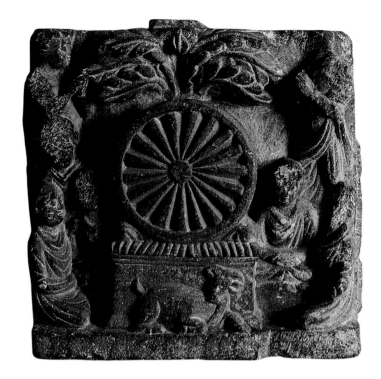

Two reliefs picturing dharmacakra, *or 'wheels of the law', from Gandhara and Sanchi. In India, such wheels symbolized the Buddha's first sermon, that is, the turning point, or founding, of a new religion in the sixth century BC. Before anthropomorphic images began to be made in the early centuries AD, the* dharmacakra *was venerated as the Buddha himself.*

religion were enormous. In spite of differences between India and the Central Plains, however, Buddhism's elaborate foreign concepts would be adopted wholeheartedly. Apparently meeting needs that the existing religions did not accommodate, Buddhism would soon become part of the local culture.

To understand the process by which Buddhism was transported and adopted in the Central Plains (and later, in all of Thailand), one must scrutinize not only the Southeast Asian cultural milieu in which it found a home but also its original source. And there, we must begin almost a millennium earlier, in sixth-century BC India.

India in the sixth century BC was a vastly different place from Southeast Asia, ethnically, linguistically, politically, and artistically. Sanskrit (unrelated to either Mon or Khmer, spoken in Mainland Southeast Asia) would later become India's foremost official and literary language, while a variety of other dialects known today as Prakrit had local use. The land was ruled by several rich and powerful kings, and innumerable merchant caravans traveled from one section of the country to another along well-built roads to exchange goods not only through barter but with coin. India was also a country of diverse religious cults, and the roads, rivers, and cities accommodated thousands of ascetics and mystics who sought followers as they traveled along the highways (Basham, 1954: 217, 220, 223).

It was into this vibrant atmosphere that Gautama, a Nepalese prince, strove to find perfection and inspired the formation of the Buddhist religion. According to Buddhist texts, which were compiled during the first few centuries after his death, Gautama's work began as a personal quest to discover the source of man's suffering and the means to eradicate it. Searching for the truth, he wandered the forests as an ascetic for six years, a spiritual journey that culminated with the

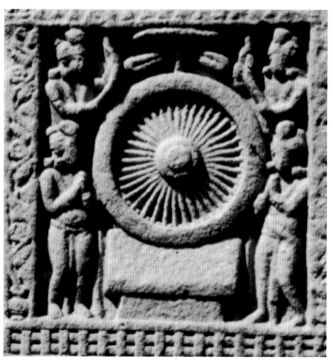

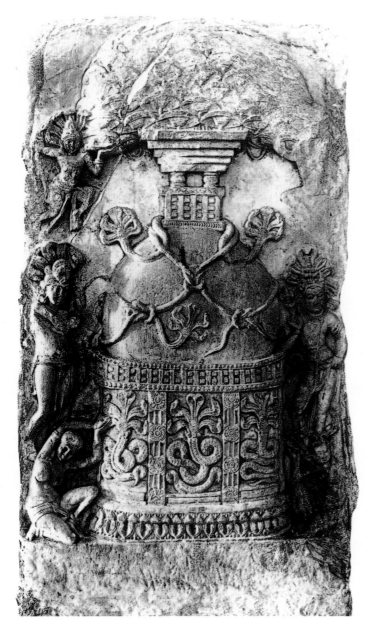

Stone relief from Amaravati depicting a fanciful stupa, second-third century AD. The dome is encircled by snakes, or naga, *pre-Buddhist deities that were incorporated into Buddhist iconography. Here,* naga *also pay homage to the stupa, which like the* dharmacakra, *represented the Buddha. (India Office Photo)*

First century relief from Sanchi, in India, in which the Buddha is represented, not in human form, but by an empty seat beneath the bodhi *tree under which he meditated. (Courtesy of Prapassorn Posrithong)*

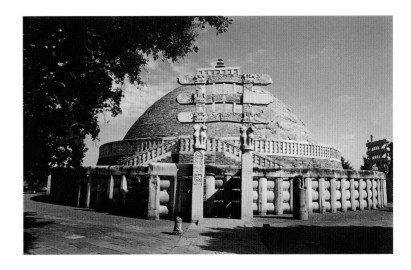

The Great Stupa, Sanchi In the latter centuries of the first millennium BC large stupas were being built in India to commemorate the Buddha. Although Sanchi played an important role in the dissemination of Buddhist practices in southern India, it was north India that had the large role in determining Thailand's early architectural traditions. (Courtesy of Prapassorn Posrithong)

realization that man's suffering was the result of worldly attachment. Gautama firmly renounced all the pleasures of mundane existence. Touching his right hand to the ground, he called the earth to witness his resolve to live a holy life, and thus became the Enlightened One, or Buddha. After meditating beneath a pipal tree near the Ganges River in the city of Gaya, he preached his initial sermon at a deer park near Sarnath (modern Banares, or Varanasi). Speaking in Magadhi, a widely used Prakrit dialect commonly used in western India, he outlined Buddhism's fundamental tenets. Buddhists the world over memorialize the 'First Sermon' at the Deer Park as the 'turning-point', or founding, of a new religion (Rhys Davids 1881: 140-3; Basham, 1954: 256-61, 391).

The sermon in the Deer Park is said to have attracted a large following of Indian disciples, and bound together by vows of poverty, monks traveled the countryside preaching the Buddha's doctrines. During the rainy season , they settled temporarily in spots once sanctified by earlier religious cults. Sometimes they stopped in shady groves of trees thought to be the abode of nature spirits: *naga* (snakes), *makara* (crocodiles), *garuda* (birds), *yaksa* (ogres), and *kinnari* (half bird-half female creatures), all of which were considered minor deities long before the Buddha's lifetime. At other times the resting places were venerated spots where small earthen tumuli had been constructed to contain the ashes of local rulers (Basham, 1954: 261-3).

Despite their dedication to poverty and the rejection of worldly desires, the monks and their teachings attracted the interest of wealthy lay followers, government officials as well as members of the country's thriving commercial guilds. The monks and prosperous laymen each had something to offer the other, and a mutually supportive relationship ensued. In return for their spiritual support and their promotion of a law-abiding life, the monks could receive official protection and the necessities of life that their vows of poverty prohibited them from obtaining themselves.

Aside from providing food and clothing, wealthy lay supporters built permanent monastery buildings, some of which were furnished with elaborate works of art. Events in the Buddha's life were memorialized in sculptural form: the Buddha's meditation beneath the pipal tree, his enlightenment, and `The First Sermon', or 'Turning of the Wheel of the Law' were visually preserved in stone for the first time in the late second century BC. Some iconography derived from the old pre-Buddhist cults. Depictions of *makara*, *kinnari*, and *yaksa* became part of Buddhism's artistic vocabulary, and some were provided a new identity. *Naga* were immortalized as the *naga* king, Mucalinda, under whose hood the Buddha was said to have been protected while meditating after his enlightenment. Trees in the groves that were once sanctified as the abodes of earth spirits now became identified with the pipal, or *bodhi,* tree under which the Buddha meditated. Small tumuli that once commemorated the country's political leaders were reinterpreted as memorials of the Buddha and led eventually to the building of huge architectural stupas of stone or brick. Preserving the rounded, piled-up shape of their small earthen prototypes, the monumental stupas encased not ashes of local rulers but relics of the Buddha, said to have been divided and subdivided innumerable times after his death.

Buddhist art in India had been slow to emerge. The earliest Buddhist art in India dates to the third century BC (three centuries after the Buddha's death), and anthropomorphic representations of the Buddha, which would in later times become the most ubiquitous of all Buddhist icons, were even later. Until the first century AD the Buddha's presence was represented symbolically, sometimes by engravings of his footprints, or, more specifically, by iconographic symbols that indicated the major events in his life. Reliefs depicting the *bodhi* tree recalled the Buddha's meditation and enlightenment, while a wheel, or *dharmacakra*, sometimes accompanied by deer, signified the Turning of the Wheel of the Law, the founding of a new religion at Sarnath's Deer Park. India's most notable lay supporter, the third-century BC emperor Asoka, erected huge sandstone monuments, so-called 'Asokan pillars', some over fifteen meters tall along the trade routes that crisscrossed the land. At least one of these pillars was surmounted by a *cakra* and many bore inscriptions celebrating the Buddhist religion. Some marked important Buddhist pilgrimage sites, where they proclaimed both the strength of the Mauryan Empire and the Buddhist religion with which it was firmly bound (Rowland, 1953: 43-4).

India's first anthropomorphic images of the Buddha appeared in northern India in the first century AD and derived from diverse artistic sources. Some of the earliest images were in the style of earlier *yaksa* figures that had been made in the Mathura region of northern India, but the most influential sculptural tradition derived not from local prototypes but from Western sources (Rowland, 1953: 75-91; Snellgrove, 1978: 47-76). In the fourth century BC, following Alexander the Great's invasion in 327, a region located in what is now Pakistan and Afghanistan had come under the influence of Greek culture. The area was also located at the juncture of caravan routes that connected the Roman Empire and Asia, and by the first century AD it had become a major trading center and was receiving a few Roman works of art. Images of the Buddha, referred to as 'Gandharan' after a major polity in the region, began to be created, and their appearance, not surprisingly, was more European than Indian. The images were shown with Greco-Roman headdress, hair piled in waves at the top of the head and were draped in voluminous rippled Greco-Roman style robes.

Stylistically, Gandharan images of the Buddha were so Roman-like in their appearance that they are sometimes considered a provincial form of Roman art. If the style was Western, however, the images were essentially Indian, for their significance was expressed by iconographic features devised in India and denoted specifics of the Buddhist doctrine that owed nothing to foreign prototypes. Various body positions (*asana*) and hand positions (*mudra*) were used to designate different events in the Buddha's life. While many images were standing, more often they were seated with legs crossed in the traditional meditation pose of the Indian *yogi*. An *usnisa*, or large protuberance at the top of the Buddha's head symbolized his superhuman wisdom; and an *urna*, or mole or beauty spot positioned between the eyes, signified his excellence. Long extended earlobes were reminders of the heavy earrings that the Buddha wore before he began his quest, and lines that sometimes encircled the neck of the image suggested his beauty. The *dhyana*, or meditating *mudra*, in which the hands, palms facing upwards, rested on the lap, represented the Buddha's meditation beneath the *bodhi* tree. The *abhaya mudra*, with raised palm facing outward indicated the bestowing of blessings, and the *bhumisparsa mudra*, in which the right hand touched or pointed towards the earth, symbolized the Buddha's calling the earth to witness his renunciation of worldly desires and his enlightenment. The *dharmacakra mudra*, with both hands held at waist level and the fingers curved as if turning the Wheel of the Law, referred to the First Sermon.

By the late first century AD, the basics of a Buddhist iconography had become well established and were beginning to spread to other areas of the Indian subcontinent. By the second and third centuries AD, Amaravati and Nagarjunakonda, the two most important Buddhist centers in the Andhra region of southern India, had adopted many of the Mathura and Gandharan sculptural iconographic conventions

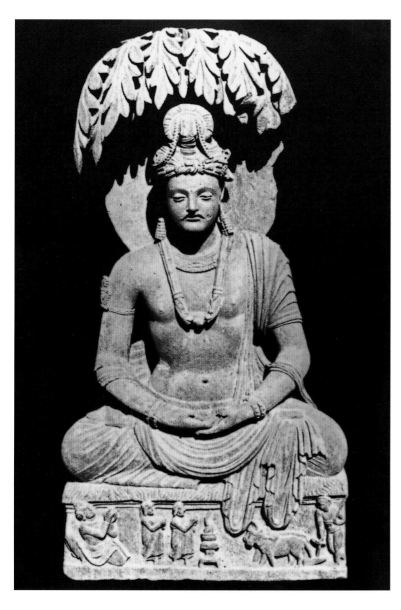

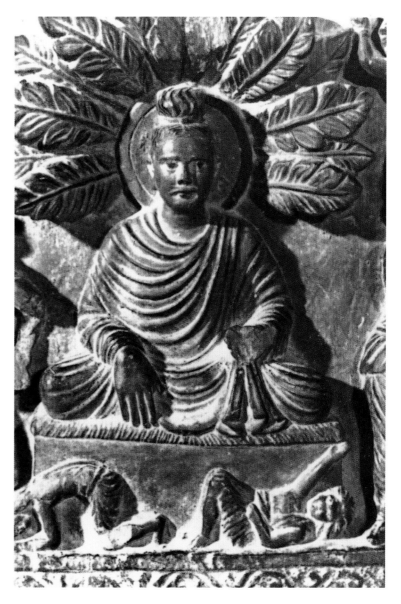

Two Buddha images from Gandhara dating from the early centuries AD. Stylistically, Gandharan images are typified by their toga-like robes, voluminous hair styles, and corpulent bodies, all deriving from Greco-Roman sculpture. But the iconographic hand gestures are purely Buddhist and indicate various episodes in the Buddha's life. Left, a seated image with hands folded in the lap (dhyana mudra) represents the Buddha meditating beneath the bodhi tree before his enlightenment. (SEATO Office of Public Information)

Above, fragment of a Gandhara relief showing the Buddha in bhumisparsa mudra, right hand touching the ground, calling the earth to witness his defeat of the evil king Mara. Two of Mara's defeated troops are shown below. The dhyana mudra is found in seventh-century images in Thailand, but the Mara scene and bhumisparsa mudra did not occur in Thailand until the late eleventh century. (SEATO Office of Public Information)

(Knox, 1992; Stone, 1994). If the transfer of art styles and iconography in India can be traced with some degree of certainty, however, the spread of Buddhism abroad was a much more complex matter. To understand its introduction to the Central Plains, something must be said, not only of its inception, but also its growth and gradual transformation in India. Only through some of the these details can connections between India and Southeast Asia be identified.

Soon after the Buddha's death, multiple schisms had begun to split his followers into a variety of sects with dissimilar beliefs and practices. There were the so-called Mahayana sects, which incorporated metaphysical beliefs that contrasted dramatically with the humanistic teachings of the Buddha, and there were more conservative sects known as Hinayana, whose doctrines remained closer to the Buddha's original teachings. Most conservative of the Hinayana sects were the *sthaviravada*, 'Believers in the Doctrines of the Elders', who as early as the fifth century BC had become the champions of Buddhist orthodoxy, challenging the ever-evolving beliefs of less traditional groups (Basham, 1954: 261; Bareau, 1955: 110; Rahula, 1956: 85).

Unlike less orthodox groups, who elected to preach their doctrines in Sanskrit, India's classical written language, the *sthaviravada* continued to use Magadhi, the local Prakrit dialect in which the Buddha had taught. As Buddhism spread through different areas of western India, however, various other local dialects mixed with Magadhi, and eventually, as a *sthaviravada* canon began to take shape, a composite language made up of several dialects evolved. By the third century BC, it is thought, a rudimentary oral canon, perhaps compiled at the renowned Buddhist site of Sanchi, had taken shape, and under Asoka's patronage, missionaries are said to have spread *sthaviravada* doctrines word-of-mouth to southern India and to neighboring Sri Lanka. By now there appears to have been an artificially contrived language of mixed dialects intended to preserve the earliest Buddhist teachings, and that language would much later be called Pali `the

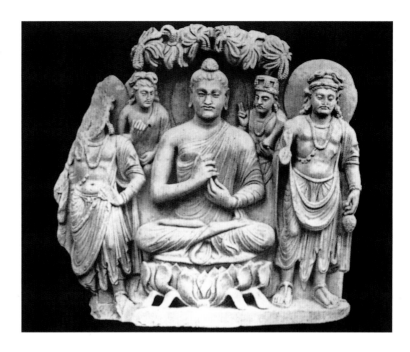

Image in dharmacakra mudra *with the curved fingers of the hands touching as if turning the Wheel of the Law, signifying the Buddha's first sermon. The mudra was especially popular in early Thai Buddha images of the seventh century AD. Later, such images depicted the Great Miracle of Sravasti (Chapter 5) as the example here does. (SEATO Office of Public Information)*

language of the scriptures'. After 400 years of oral transmission, in the first century AD, monks in Sri Lanka transcribed the orally transmitted *sthaviravada* tenets into their own Prakrit language, Sinhalese, and in the fifth century, works were retranscribed back into the traditional Pali (Geiger, 1943: 1-7, 25-8; Basham 1954: 263-4, 266, 391-2; Rahula, 1956: xxv, 82, 98; Hazra, 1994: vii, 1-44).

The Believers in the Doctrines of the Elders, referred to previously only in Sanskrit written texts as *sthaviravada*, were increasingly identified by the Pali equivalent, Theravada. Understandably, *sthaviravada* and 'Theravada' were (and are) often used interchangeably, though more often, today 'Theravada' is used to refer to the Doctrine of the Elders after it had been introduced into Sri Lanka. Here, for convenience, we use *sthaviravada* and 'Theravada' to differentiate the oral and written traditions of the Pali canon. That distinction is crucial to our story.

In the third century AD (as reported in the Sanskrit texts) *sthaviravada* Buddhism was one of the twenty or thirty Buddhist sects that resided at Nagarjunakonda, where they were reported to have been archrivals of the Sanskritic Hinayana *sarvastivada* sect. Conspicuous for their adamant insistence on Buddhist orthodoxy, *sthaviravada* from Sri Lanka boasted also of their zealous missionary work (Bareau, 1955: 8, 207-8; Stone, 1994: 19-20, 107, n. 103), and Amaravati, located on the Krisna River between Nagarjunakonda and the Bay of Bengal, provided access to potential foreign converts. Amaravati was not only the area's most important Buddhist center but also south India's busiest seaport, and contemporary records show that Buddhist missionaries often accompanied Amaravati seamen on their lengthy voyages with destinations as far away as China (Rowland: 1953, 123). Amaravati lay directly west across the Bay of Bengal from Thailand's Three Pagodas Pass and a case can be made that it was South Indian missionaries who arrived in the Central Plains and perhaps brought the Buddhist comb to Chansen. Although we have no

concrete evidence of Andhra missionaries, *sthaviravada* or otherwise, having stopped in Mainland Southeast Asia, piecing together the meager bits of data, it can be suggested that at least as early as the third century AD, *sthaviravada* Buddhism had spread to Thailand's Central Plains.

Relying on evidence from Thailand, archaeologists have suggested that even prior to the third century AD, Buddhism had begun to make its presence felt in the Lower Central Plains. Bronson has noted that by the early first millennium cremation had replaced burial at several Plains sites, suggesting that Buddhist practices were replacing old indigenous ways (1979: 329). Piles of bricks and brick fragments have been found at at U Thong, archaeological sites dated to the early centuries AD evidencing religious architecture rather than houses, which were built of light materials (Loofs, 1979: 341-9). Two third-century Amaravati-style terracotta reliefs found at U Thong and dated archaeologically to second to fourth century AD sites relate more specifically to evidence from the Andhra region. One of the reliefs depicts a *kinnari* while another portrays a row of Buddhist monks dressed in heavy, voluminous Roman-style robes like those found on Amaravati-style Buddha images (Chira and Woodward, 1966: 18-19). A fragment of stucco sculpture in the Amaravati style, also from U Thong, shows the Buddha seated on the coils of a *naga*. Although there

is no evidence that these pieces were made locally, they suggest that Buddhism was becoming firmly implanted, at least in one of the Central Plains' more prosperous communities. The U Thong reliefs, which appear to have been made for architectural embellishment, imply that there were now permanent Buddhist monasteries, where, as the *naga* image suggests, images of the Buddha were housed.

Although there is no epigraphic evidence from the Central Plains dating from the first half of the first millennium AD, short seventh-century inscriptions (Chapter 4) provide some evidence of Buddhist practices. While these inscriptions, written in Pali, are similar to canonical passages in Theravada texts, there are enough variations to suggest that they derive from a tradition that predates the fifth-century written tradition. Woodward has noted that while inscriptions evidence some signs of Theravadin orthodoxy, deviations from the written texts suggest some other Pali-speaking sect (1975: 14-15), and Brown has suggested the possibility that the inscriptions were inscribed from memory (1996: 103). Since no other possible sources have been identified, one might suggest that the inscriptions derive from the *sthaviravada* oral tradition.** If the scenario outlined here is correct, then a case can be made that the super-orthodox *sthaviravada* tenets had become established before the written Pali texts had come into existence.

One can only speculate as to how Buddhism might have been accepted by the early Plains peoples. Having previously practiced a religion that had centered around mortuary offerings of pottery and jewelry to a deceased elite, the Indian religion must have seemed unusual, to say the least. But Buddhism must have had a secular appeal as it had in India, and the presence of Buddhist monks would not have been unwelcome. It has been suggested that a ruler's political success was measured by the allegiance of large numbers of people rather than territories (Hall, 1985: 4), so an influx of law-abiding learned monks would have been a political asset. Major communities that had prospered because of their positions along the old trade routes were in a position to provide the monks with food, clothing, and housing. And the monks would have provided evidence of the cosmopolitan atmosphere that had already begun to distinguish the major trading centers from provincial communities.

If Buddhism was becoming well established, however, its art was yet to be accepted. Examples of Amaravati-style art in the Central Plains are few and far between, and there appears to have been little interest in either the importation of art from India or in local reproduction. While local rulers, well-to-do from their propitious trade route connections, could have provided necessities required by the Buddhist monks, it is possible that they had neither the means nor the interest in adding to or replicating the few unusual looking foreign works that were now occasionally reaching their communities from abroad.

If Buddhist art was slow in catching on in the Central Plains (as it had been in India), however, the roots of the foreign religion itself appear to have been firmly planted, and four centuries later, in the seventh century, its art would proliferate beyond all expectations. While Amaravati would leave no lasting impact on the Plains' locally-produced art, its Buddhist orthodoxy would play a role in the conservative nature of the Central Plains for centuries to come.

* Both Piriya and Brown have suggested a fifth-century date, and Brown suggests manufacture in Sri Lanka. (Piriya, 1977: 53; Brown, personal communicaiton: 2000)

**It is Brown's opinion that the *dharmacakras'* Pali "is certainly from Sri Lanka, and was used from the fifth century on". (Personal communications, 2000)

Terracotta relief showing monks dressed in Gandharan toga-like robes, second or third century AD from U Thong. The Gandharan type images spread from northern India to the Amaravati region of south India, and from there a few examples reached Thailand. (U Thong National Museum)

Below right: *Fragment of a terracotta relief depicting a* kinnari, *second or third century AD from U Thong. (U Thong National Museum)*

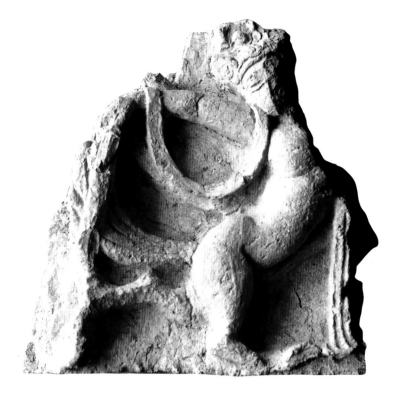

47

CHAPTER FOUR

The Emergence of Dvaravati

By the fourth century AD, dramatic changes were taking place in both India and Southeast Asia that would alter the art histories of both. In India, Andhra rulers, who had politically dominated a large part of the Indian subcontinent for several centuries, were defeated by more powerful rivals; Amaravati and Nagarjunakonda were in decline, and the *sthaviravada* branch of Buddhism was no longer widely practiced (Bareau 1955: 39). Mahayana sects were becoming common, and Hinduism, a sophisticated religion that had developed out of myriad popular cults that had existed long before the Buddha's lifetime, was vying with Buddhism in importance.

In addition to the religious changes in India, there were also commercial alterations. Not long after Buddhism began to weaken, sea connections between India and Thailand's Central Plains also faltered. More seaworthy ships and better navigational methods now enabled shipping farther from shore than had been possible in the past. The old Bay of Bengal route that provided access to the Central Plains by way of the Three Pagodas Pass, though still in place, was undermined by travel through the Straits of Malacca and the Java Sea south of the Peninsula. Ports on the southern coast of Sumatra and in central Java emerged as major entrepôts for the exchange of foreign goods, and Oc Eo and the Central Plains were left in the murky backwaters, secluded from the torrent of multicultural activity that swirled around it (Hall, 1985: 21, 72). The importation of foreign goods into the Central Plains decreased accordingly.

One might suppose that with the growing isolation of the Plains, the old affluent communities that had once functioned as centers of foreign trade and as the destinations of Buddhist missionaries might have fallen on hard times. Nothing, however, could have been farther

from the truth. By now, a local social and political infrastructure must have been in place, free to strengthen internally without further overseas input. Short political inscriptions of the seventh century were written in Sanskrit and Mon, while religious inscriptions were written in Pali, the language of *sthaviravada* Buddhists, and evidence the survival of both the political and religious realms that had been founded much earlier. Ancient Buddhist icons – *purnaghata*, parasols, shells – that had reached the Plains perhaps via Chansen's ivory comb (Chapter 3) were now imprinted on local coins and medals (Wicks, 1999: 8-18). Although Indian missionary efforts in the area may have ceased shortly after their arrival a couple of centuries earlier, a mutually supportive relationship between the Plains tradition-bound monkhood and the lay communities must have encouraged the prosperity of both.

While foreign intercourse decreased, local trade expanded. The once autonomous villages that early on had bartered goods with neighboring communities now traded with more distant areas in both the Plains and the Plateau. And these communities were now becoming more complexly affiliated, politically as well as commercially. There appears to have been a gradual emergence of what is known today as chiefdom societies, conglomerates of communities in which more affluent and proficient ones exerted some political control over less prosperous ones. By the late sixth century there appears to have been a hierarchy of chiefdom centers in which secondary centers, that is, sub-chieftains to a major one, exerted some control over even weaker communities. These chiefdom networks, sometimes referred to as *mandala* (Mabbett, 1978; Wolters, 1982) or by the Thai word *muang* (Charnvit, 1976), were without clear-cut political boundaries, and political control depended not so much on geographical proximity as

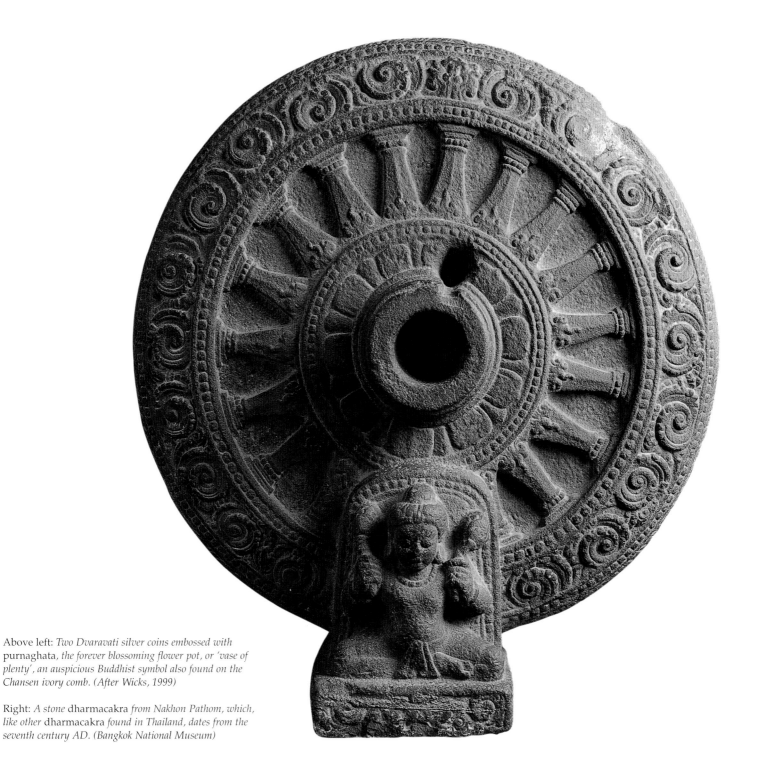

Above left: *Two Dvaravati silver coins embossed with* purnaghata, *the forever blossoming flower pot, or 'vase of plenty', an auspicious Buddhist symbol also found on the Chansen ivory comb. (After Wicks, 1999)*

Right: *A stone* dharmacakra *from Nakhon Pathom, which, like other* dharmacakra *found in Thailand, dates from the seventh century AD. (Bangkok National Museum)*

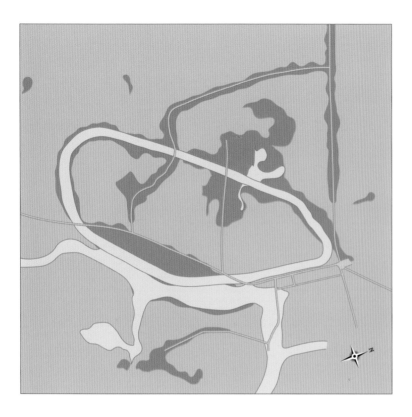

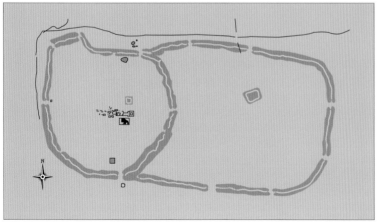

Maps of U Thong (above) and Si Thep (below). In contrast to the round moated settlements on the Khorat Plateau, Plains cities were typically elongated and were enlarged by the addition of adjacent areas rather than by concentric moats.

on rulers' personal ties with kin and friends in other areas. Dependent upon a chieftain's political skills and his ability to attract and sustain the allegiance of loyal supporters, such affiliations were fragile, and there was a constant shifting of allegiances (Higham, 1989: 239-40; Brown, 1996: 7-10). Political control waxed and waned and sometimes leapfrogged to noncontiguous geographical areas.

The Plains' chiefdom centers were now conspicuous not only because of their size but because of moats and earthen ramparts that surrounded them. Moated cities in the Plains differed from those that had been built on the Khorat Plateau in the previous millennium (Chapter 2). Moats on the Plateau were generally round and were situated on slightly elevated terrain within easy reach of streams that enabled agricultural development. In contrast, moated settlements on the Plains tended to be larger, were roughly oval or vaguely rectangular in shape, and when they needed to be enlarged, it was not by the addition of concentric moats, but by an extension located at one side of the original moated area. Moreover, their moats do not appear to have been constructed for irrigation (Moore, 1988: 275-63). Some say that they were perhaps built as protection from theft (Brown, personal communication, 2000).

While moated settlements on the Plateau were of various sizes and numbered in the thousands, those in the Plains were most noticable at major civic centers, many of which had been important towns on active trade routes in past centuries (Chapter 3). A moat surrounding U Thong, usually considered to have been the earliest of the chiefdom network centers, was constructed in the sixth century and measured 1690 by 840 meters. A moat at Nakhon Pathom was probably

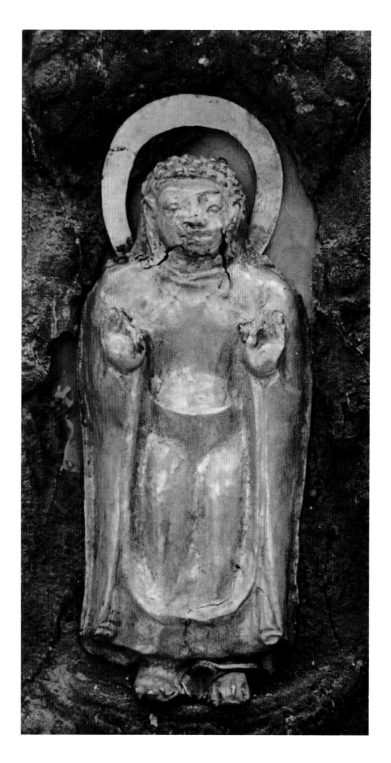

Two votive offerings found at Nakhon Pathom's Chedi Chula Pathon: left, a bronze chandelier, and right, a bronze plaque depicting the Buddha in double vitarka mudra. *(Bangkok National Museum)*

built in the seventh century, enclosing an inner city that now measured 3700 by 2000 meters. Chansen by the seventh century was also surrounded by a moat of somewhat smaller size (Wales, 1969: 20, 32; Higham 1989: 275; Bronson and Dales, 1970: 44).

While the city moats conspicuously identified the chiefdom centers as communities with sufficient resources to inspire subchieftain allegiance, Buddhism was also playing an important role in the establishment of political control. In pre-Buddhist times, a community's local identity and prestige had been engendered through elaborate mortuary practices that honored its most respected inhabitants. In contrast, Buddhism, with its universal beliefs, provided a cultural vocabulary that could be shared with nearby and not so neighboring communities. Cremation in the Buddhist manner replaced burial of the dead, and the interment of luxury goods with a deceased elite gave way to burial of luxury items that honored the Buddha (Bronson, 1979: 329).

Such was the case at Nakhon Pathom. Buried in a ceramic pot beneath what appears to have been a Buddhist assembly hall located near the center of the city were donations to the Buddha that included (instead of fine pottery and tools of the trade that one might expect in past centuries) a bronze three-branched chandelier, bronze bells, cymbals, and a small plaque depicting an image of the Buddha. Still, as in earlier times, the lay community appears to have gained prestige from the burial: two silver medals interred with the Nakhon Pathom donations noted in a script dated by epigraphists to the seventh century AD that the gifts were 'the meritorious work of the lord of Dvaravati' (Higham, 1996: 335-6; Wales, 1969: 37).

Seventh-century silver medals such as these inscribed in a south Indian Pallava script refer to Dvaravati and its rulers, although the rulers' names are not given.
(Bangkok National Museum)

Dvaravati was one of several chiefdom networks known to have existed in the Plains in the mid-first millennium AD, and several dozen inscriptions, some on silver medals, refer to Dvaravati, Lopburi, Tangur, Sambuka, and Anuradhapura. Dvaravati was without doubt the most important of these chiefdom networks. At least sixteen medals refer to Dvaravati, and these have been found in communities scattered throughout the Central Plains and its environs (Brown, 1996: xxiii, 64).

The most prominent of the Dvaravati sites were the old trading centers U Thong and Nakhon Pathom, which by the late seventh century were differentiated from less prosperous communities not only by their size and their moats, but by vast amounts of Buddhist architecture and sculpture. Now there were monastic buildings and stupas unlike anything seen before, images of the Buddha, and large sculptures representing *dharmacakra*, or the Wheel of the Law. We will return to Dvaravati's Buddha images and architecture in Chapter 5, below, but first it is worthwhile to consider the *dharmacakra* in some detail. Notable not only for their artistry, the *dharmacakra* shed crucial light on what appears to have been a sudden eruption of seventh-century artistic activity on the Plains as well its relations with India during a period when Dvaravati appears to have been irrevocably set on a cultural course determined internally.

The Dvaravati *dharmacakra*, which, according to Indian convention, symbolized the Buddha's First Sermon and the founding of a new religion at the Deer Park at Sarnath (Chapter 3), now provided monumental evidence of the establishment of Buddhism in the Central Plains. Beautifully executed in bluish limestone, laterite, or sandstone and measuring from one to two meters in diameter, most appear to have been supported on slender stone pillars, or *stambha*, some several

meters high. Some, at least, were accompanied by three-dimensional representations of crouching deer, reminders of Sarnath's Deer Park. And some of the wheels and pillars were inscribed with brief messages written in Pali that referred either specifically or indirectly to the Buddha's turning the Wheel of the Law, while a few others, rendered in the vernacular Mon or in Sanskrit, referred to secular matters (Brown, 1996: 115-120).

In the most important work to have been published on Dvaravati art in recent years, Robert L. Brown, basing his conclusions on stylistic evidence (below), has dated the earliest *dharmacakra* to the seventh century AD and their locations define the limits of Dvaravati political influence (1996: xxvi, xxxi, 136-7). Not surprisingly, most of the *dharmacakra* cluster along the river routes that had engendered the establishment of local and international trading centers centuries earlier. More than twenty *dharmacakra* have been found at Nakhon Pathom and four are from U Thong, while others clustered along the Pasak, Mun, and Bang Pakong rivers: two at Lopburi, near the confluence of the Chao Phraya and Pasak rivers; five from Si Thep, which controlled communications between the Central Plains and the Plateau via the Mun River; and another at Muang Sima, in the Upper Mun area of the Plateau. Farther south along the Pasak and Bang Pakong rivers there was one near U Taphao (Higham and Rachanie, 1998: 183). Several wheels were also set up in areas hitherto not encountered: the Peninsula and a more northerly area of the Chao Phraya River. On the Peninsula there was a *dharmacakra* near Phetburi, at the Peninsula's northern end, and at Chaiya and Nakhon Si Thammarat, near the Kra Isthmus. The southern limits of the *cakra* distribution appear to have Yala, in the far south of the Peninsula,

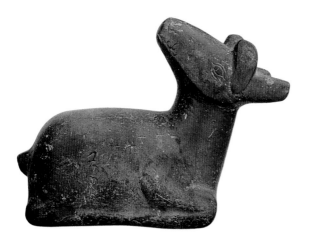

while the most northerly site was the Chao Phraya community of Muang Bon (sometimes referred to as Khok Mai Den), which, unlike other Dvaravati centers, appears to have been a newly emerging community without Neolithic or Bronze Period development.

Whatever the past histories of these communities, their *dharmacakra* now proclaimed their Dvaravati affiliation. Created under the patronage of a lay elite, the wheels atop their *stambha* would have attracted widespread attention, inspired a Buddhist following, and conspicuously announced to other communities the Buddhist-lay relationship on which Dvaravati political control must have depended.

If the locations and the function of the Plains *dharmacakrastambha* can be conjectured, however, the means by which their designs, and that of the Buddhist architecture and Buddha images that accompanied them, reached the area are not so apparent. In all the history of the Central Plains there had not been such a complete break with preexisting local artistic traditions and, although it is imperative to look for Indian sources, precise links are elusive. Trade between India and the Plains had faltered; there is no evidence of missionary work during this period; and the *dharmacakra* display little resemblance to the few Amaravati pieces that may have arrived several centuries earlier.

Stylistic connections with Indian art are few and difficult to interpret. When art historians look for possible links between works of art, they seek both chronological and geographic associations, along with any archaeological, historical, and textual data which might substantiate the significance of the stylistic and iconographic similarities. For the Indian and Dvaravati *dharmacakra* none of these links are detectable. Understandably, when the Dvaravati *dharmacakra* first came to the attention of twentieth-century art historians, they were

Above left: *A crouching deer that may have been placed at the base of a* dharmacakra *and recalls the Buddha's First Sermon at Sarnath's Deer Park.* (Bangkok National Museum)

Above: *Hypothetical drawing of a composite post and* cakra, *or* dharmacakrastambha.

A stambha, *or post, from U Thong that would have supported a* dharmacakra. (U Thong National Museum)

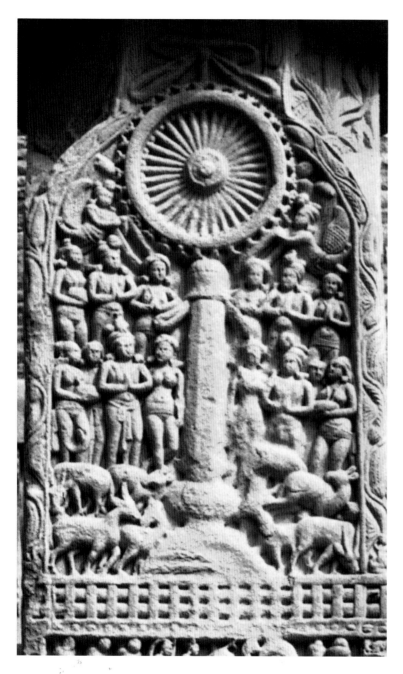

Relief depicting an Indian dharmacakrastambha, *Sanchi, India, first century AD.*
Dharmacakrastambha *were often carved in low relief in early India, suggesting that three-dimensional ones must have also been common, although none survive. Later Indian reliefs showed only the* cakra *without a supporting post. (Courtesy of Prapassorn Posrithong)*

dated to the latter centuries BC, when the Buddha was represented only in non-anthropomorphic form (Chapter 3; Damrong, 1926: 1; Charnvit, 1976: 17). But early *dharmacakrastambha* in India were often represented in carved reliefs, and by the third century AD, the *stambha*, even in relief, had been for the most part abandoned. Later, *dharmacakra* were confined more and more to reliefs on the bases of Buddha images (Brown, 1996: 78, 81, 167, 173-4).

As Brown has noted, there is 'almost no relationship between the Indian and Dvaravati *cakra*s in terms of patterns, design organization, and structure' (1996: 160). The very few, isolated decorative motifs that do seem to have derived from Indian prototypes are more perplexing than helpful in defining connections. For instance, a remarkably similar trompe l'oeil accordion-pleated design on the rim of a *dharmacakra* from Nakhon Pathom is so like a motif from the ceiling at the Buddhist site of Ajanta, in western India, that some sort of connection is undeniable (Brown 1996: 189-191). Yet, Ajanta had been abandoned in the late fifth century AD (Spink, n.d.: 40-1), two centuries before the Dvaravati wheels were constructed. A circle-and-volute pattern on a Nakhon Pathom *stambha* is surprisingly similar to one found on a contemporaneous Nepalese stupa, although direct relations between Nepal and Mon peoples from Dvaravati in the seventh century seem highly improbable (Brown, 1996: 150, 189). Moreover, the backward looking posture of the crouching deer that accompany the Dvaravati wheels is found elsewhere only in areas of unlikely Dvaravati contact: at Ajanta and neighboring west Indian sites, in Kashmir and Gandhara, far to the northwest, and in northern China. In India, unlike the three dimensional images that are the norm in the Central Plains, deer appear only in relief (Brown, 1996: 78, 81).

One of the most widely accepted theories devised to explain the chronological and stylistic differences between Indian and Dvaravati works of art is that over several centuries there were waves of settlers

from different areas of India who settled in the Central Plains and brought with them drawings or small objects which may have provided models for local reproduction. A wide variety of motifs and art styles that arrived over many years would have eventually been combined in a single object. The fact that there are no intermediary works in Southeast Asia to substantiate such a progression is explained by the loss of art objects that might have provided the missing evolutionary links (Coral-Rémusat, 1934; Coedès, 1963).

Aside from the fact that there is no evidence to support the multiple-waves-and-missing-objects theories, another compelling argument calls for their reappraisal. Brown in his detailed study of seven design motifs found on the *dharmacakra* was able to demonstrate that most of the design motifs were not derived from Indian prototypes. Rather, they were simplified or composite decorative interpretations of motifs that had been used in seventh-century AD Hindu temples that were being erected by Khmer-speakers in the Mekong region east of the Central Plains and the Plateau (Chapter 7). Moreover, the method by which the socles of the Dvaravati wheels were attached to the *stambha* was the same as that being used to attach lintels over the doorways in the Khmer temples (1996: 74-7, 148-58, 169-74).

Brown's critical evidence raises new questions, for in the seventh century AD there were fundamental differences between the Mon and the Khmer, political, religious, and artistic. In the distant prehistoric past the Mekong River and Plains peoples had shared the same language, and even in their Neolithic and Bronze Periods, after they had become linguistically distinct, they had developed along similar cultural lines (Chapter 2). By the sixth century AD, however, Khmer and Mon cultural traditions had begun to diverge dramatically. While the Plains peoples depended on a lay-Buddhist relationship for their political survival, the Khmer had chosen Hinduism as their official

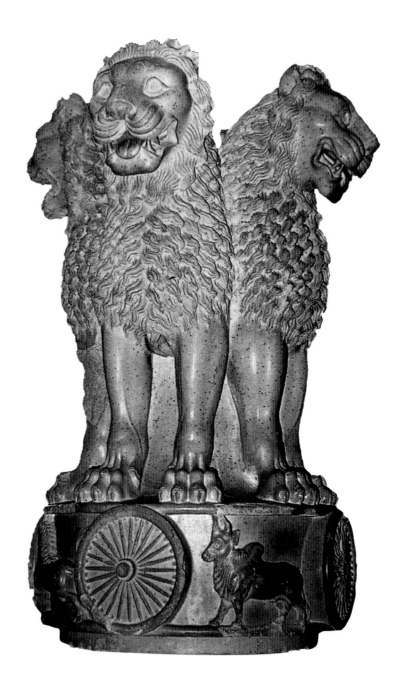

Capital of an Asokan pillar thought to have once supported a giant dharmacakra, *the pieces of which, like the pillar, are now in the Sarnath Museum. (Courtesy of Prapassorn Posrithong)*

religion (Chapter 7). *Dharmacakra* were not part of the Hindu iconography, and none are known to have existed in the Mekong area. Khmer designs in the Dvaravati context is puzzling.

To search for answers, we must return once again to India, where the concept of the *dharmacakra* had its origins. In the seventh century (when Dvaravati's *dharmacakra* appear to have been constructed), Buddhism in India (by this time, primarily Mahayana) was practiced most diligently in the Ganges region of the north. This was the area in which the Buddha had spent most of his adult life, and the places in which the significant events of his life had occurred had become important pilgrimage sites. There was Gaya (the scene of the Buddha's enlightenment) and Sarnath (the site of the First Sermon in the Deer Park). Not far distant was the university city of Nalanda, the most important center of Buddhist learning in the world. Ardent Buddhists traveled to the North Indian Buddhist sites from as far away as China and Island Southeast Asia.

Although there are no documented visits to the Ganges region by visitors from Mainland Southeast Asia in the seventh century, the Dvaravati people at that time were not stay-at-homes. Chinese sources attest to at least three Dvaravati tributary missions to China in the seventh century and the Chinese pilgrims I-ching and Hsuan-tsang (who did not visit Dvaravati), noted its location in their journals (Brown, 1996: xxii-xxv). It was during this period of international recognition that Dvaravati began to produce its own Buddhist architecture and sculpture, including the *dharmacakra*. And while Northern India was not known for Theravada missionaries, visits to the

Buddhist holy land by Dvaravati monks would not be surprising. The route that led from the Central Plains via the Three Pagodas Pass and Myanmar had been in place for centuries, and the flourishing Indian port city of Tamralipti (Tamluk), at the northern tip of the Bay of Bengal, was as accessible to the Plains peoples as it was to the Chinese (Basham, 1954: 223, 228).

Gaya, Nalanda, and Sarnath were providing foreign visitors with artistic as well as spiritual inspiration. Hsuan-tsang and I-ching applauded Nalanda for its international ambiance and its creative artistic exuberance, and, according to Hsuan-tsang's account and twentieth-century archaeological evidence, Sarnath was one of the most productive artistic sites in all of India. Under lavish lay patronage during the prosperous Gupta age (AD 320-c. 550), Sarnath had produced the finest sculpture that India had ever known, and the Gupta period style had persisted.

In spite of its readily identifiable style, however, the Gupta images of the Buddha were the culmination of lengthy artistic traditions and embodied stylistic elements that derived from the best that other areas in India, notably, Gandhara and the Ajanta region of western India, had to offer. Moreover, the Deer Park had been an important pilgrimage site as early as Asokan times, in the third century BC, and Sarnath was known for an abundance of Buddhist art from the ancient past (Paul, 1995: 1, xix, 42-44; 66, 107; Rowland, 1953: 140-4l).

At Sarnath, our hypothetical seventh-century Dvaravati pilgrims would have come into contact with a plethora of art styles that included the old and the new, the local and the foreign. From those many

examples, it would have been possible for them to choose what appeared most holy, beautiful, and relevant to their own religious needs. Returning, Dvaravati travelers, like their fellow pilgrims from China (who left written accounts of their journeys), would have arrived home with renewed inspiration and icons to bolster Buddhism in their own country. If lost objects are needed to explain stylistic differences between Dvaravati art and Indian prototypes, Sarnath and related sites in northern India (in contrast to unknown sites in Southeast Asia) provide more than enough examples to fill the stylistic gaps.

Judging from Hsuan-tsang's journals, one of the most notable monuments at Sarnath was a giant third-century BC Asokan pillar that marked Sarnath as the site of the Buddha's first preaching and his founding of a new religion. Hsuan-tsang described the pillar as 21 meters tall, and archaeological evidence suggests that it may have been at one time surmounted by the giant stone wheel now partially preserved in the Sarnath Museum (Rowland, 1953: 44; Brown, 1996: 161-2). This gigantic monument, certainly one of Sarnath's largest, would not have been easily forgotten by foreign visitors. And nothing would have been more appropriate to spotlight Dvaravati's establishment of Buddhism in the Central Plains. One can hypothesize that perhaps with the aid of small depictions on votive tablets, small clay icons stamped with Buddhist symbols and traditionally collected by pilgrims at India's Holy sites, Dvaravati Buddhists transported the concept of the *dharmacakra* along with artistic motifs derived from a variety of sources to the Central Plains, where their own local versions of the Indian objects were constructed. Soon there would be stupas and assembly halls and images of the Buddha, and *dharmacakra* would be erected at major chieftain centers. There, like Asoka's pillars (Chapter 3), the *dharmacakra* overtly proclaimed the establishment of the Buddhist religion and its symbiotic relation with the political realm. Although much smaller than the Indian pillar, Dvaravati's beautifully executed artistic masterpieces, unlike anything the Central Plains had seen before and conspicuously displayed at Dvaravati's chiefdom centers, must have inspired both political and religious awe.

There were a number of differences between the huge Sarnath example and those of Dvaravati. The Asokan wheel had been supported by four regal figures of lions, motifs that had apparently been imported from Iran in the third century BC, but which must have held little meaning for the Dvaravati pilgrims. Wheels and deer, on the other hand, would have been objects that were familiar to both sophisticated and initiated Dvaravati Buddhists, and unlike their Indian counterparts, the Dvaravati deer were rendered not in relief but three-dimensionally. Some Dvaravati *dharmacakra* bore an unmistakable resemblance to functional wheels. Unlike the Indian *dharmacakra*, some of the Dvaravati examples, perhaps for the edification of locals who had little familiarity with Indian iconography, were inscribed with short references to the Buddha's First Sermon. While Sanskrit had been formalized as the official language in the Ganges region, most Dvaravati religious inscriptions were written in Pali, which would have been introduced centuries earlier by the Amaravati missionaries.

Given this scenario, the inclusion of Khmer technologies and motifs in the *dharmacakra* is not so surprising. Unlike seventh-century

Central Plains peoples, those of the Mekong had been producing remarkable art for a couple of centuries (Chapter 7), and the Khmer could have provided technical and artistic expertise that Dvaravati lacked. Trade routes that had linked the Central Plains with the Mekong since Neolithic times were there to be used, and the Indic languages, Pali and Sanskrit, were providing a new means of communication among areas whose local languages differed. A Pallava script, a derivative of the old Indian Brahmi, had begun to be used for brief political and religious inscriptions in both areas (Basham, 1954: 398; Brown 1992: 50). And as we shall see (Chapter 5), there were short-lived Khmer political intrusions into the Plains as well. In the Bronze Period, Southeast Asians had begun to adopt new technologies to create artifacts that suited their own sensibilities, and the Iron Period had seen the adoption of a few foreign art motifs. Now, without question, foreign art motifs were essential to the design of the *dharmacakra*. While Dvaravati had had to travel to faraway India to acquire a symbol to express its politico-religious beliefs, technological and artistic assistance in the Mekong region would have been available much closer to home.

Although the Central Plains would never become entirely isolated either from the Mekong region or from India during the four centuries that make up the Dvaravati period, the old *sthaviravada* religious

traditions brought by Amaravati missionaries perhaps in the second or third century and the north Indian art styles adopted in the seventh century would continue to provide the basis of traditional Dvaravati art throughout its existence. While changes abounded in India and in most areas of Southeast Asia, Dvaravati would retain the original precepts on which its religion and art were based. The conservative nature of *sthaviravada* Buddhism, which must have played a major role: its adherence to the original teachings of the Buddha and to those of its elder monks allowed for little change. Apparently, the course that had been set was strong enough that there was no need to repeat the overseas quest for Indian Buddhist icons that had provided a basis for their art in the seventh century, and new styles did not emerge.

By the late seventh century, it seems, the stylistic, technological, and iconographical seeds of Dvaravati art had taken root and would continue to flourish without further foreign assistance. What would have once been valued as exotic was now part and parcel of the local socio-politico-religious structure. Provincial areas would look to the Plains chiefdom centers for artistic and religious inspiration rather than faraway India, and as in the past, growth would depend on local initiative rather than on any influence exerted from abroad.

Art of the Dvaravati Heartland

As early as the first centuries AD, when Buddhism is though to have been introduced into the Central Plains (Chapter 3), there must have been a need for buildings to be used for preaching and the performance of Buddhist rites. Although none of those early religious buildings survive, it can be surmised that they were simple structures similar to traditional indigenous-style houses constructed of clay, wood, and bamboo. In the seventh century, however, at about the same time that the *dharmacakra* were introduced in the Central Plains, there also appears to have been an outburst of building activity and a sudden emergence of complicated architectural designs that were entirely new to the area. Most notable, for both the architecture and the sculpture of this period is the evidence of a shift from the early south Indian, Amaravati relations noted above to unquestionable links with India's religious centers in the north.

Not surprisingly, two of the Dvaravati sites with the most notable Buddhist architecture were U Thong and Nakhon Pathom. As early trading centers, both cities had had the means to support viable Buddhist communities. Isolated Amaravati finds evidence the presence of Indian Buddhists in the early centuries AD, and the city moats and *dharmacakra* testify to their continuing political and religious prosperity in the seventh century. The U Thong buildings, located both within and outside the city moats, are now in extremely ruinous condition – only the bases survive – but they are numerous and provide some meager evidence of their original appearance. The scattered remains include the bases of what appear to have been rectangular assembly halls, squarish image houses, and stupas.

The bases of U Thong's stupas bases were round, square, octagonal, or hexagonal, and while the original appearance of the hollow buildings is undetectable, that of the stupas can be deduced from a few small votive stupas and depictions on contemporaneous votive tablets. The shapes of the stupas, like the *dharmacakra*, appear to have derived from northern India. Stupas at Amaravati and Nagarjunakonda as well as those in Sri Lanka included a hemispherical dome (shaped like the old earthen tumuli) that was surmounted by a spire, or *yasti*, which was composed of superimposed umbrellas, symbols of both royalty and Buddhism. A rectangular fence, or *harmika*, symbolically enclosed a sacred space around the *yasti*. In contrast, Dvaravati *stupas*, like those in northern India, were devoid of *harmika*, and their domes – ovoid, globular, sometimes in the shape of upturned tureens or *purnaghata* – lacked the perfectly hemispherical shape that typified south Indian and Sinhalese examples. Like stupas in most areas of India, north and south, however, the U Thong stupas were topped by a *yasti* of superimposed disks representing ceremonial parasols. As in India, the *yasti* were sometimes surmounted by a jewel-shaped pinnacle (Griswold, 1960: 40-1; Wales, 1969: 24, 45).

Dvaravati's most elaborate architecture was constructed not at U Thong but at Nakhon Pathom, which is thought to have succeeded U Thong as Dvaravati's most important chiefdom center sometime in the seventh century. No minor chieftain, Nakhon Pathom's ruler may have been endowed with some attributes usually associated with Indian monarchs. A terracotta 'toilet tray' used to hold cosmetics found at Nakhon Pathom was adorned with reliefs showing fly-whisks, parasols,

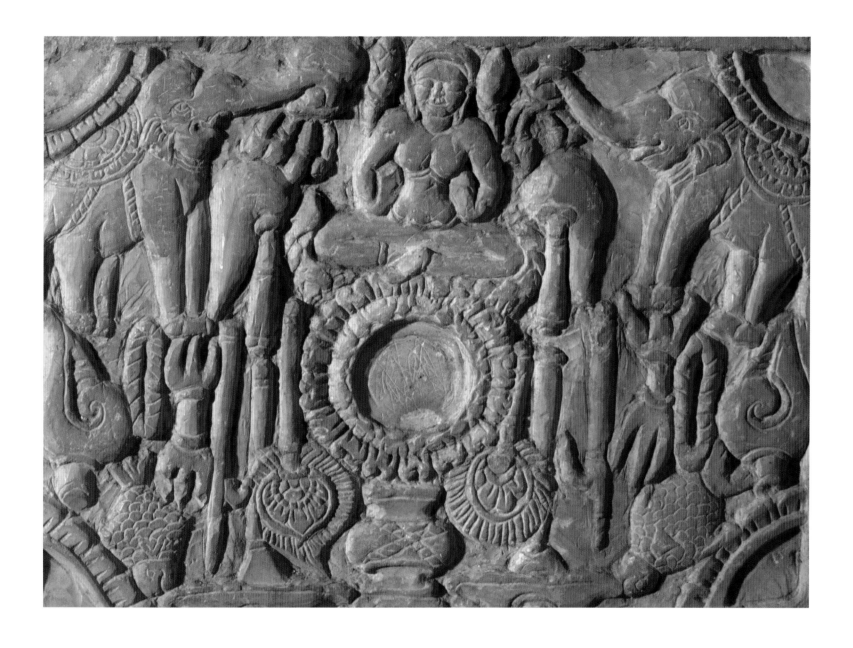

Opposite: *A fragment of a Dvaravati terracotta relief with a face-in-window motif. Such rounded windows with faces were common motifs in first-century BC Buddhist sites in India and in seventh-century Dvaravati art. (U Thong National Museum)*

A terracotta cosmetics tray from Nakhon Pathom. Decorated with both royal and Buddhist symbols, the tray is indicative of the cosmopolitan sophistication of Dvaravati culture. (Bangkok National Museum)

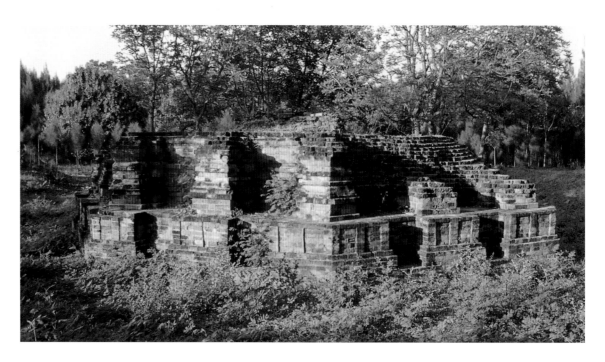

Terracotta finial of a Dvaravati stupa and schematic drawings of Dvaravati stupas conjectured from small votive stupas, pictures on votive plaques, and archaeological remains (after Griswold, 1960). These stupas have no harmika, and their domes are not as hemispherical as those in southern India. North Indian prototypes are suggested. (Nakhon Pathom National Museum)

Above right: The base of a brick stupa at U Thong. The octagonal base with niches appears to have been typical of the period.

conch shells, turtles, thunderbolts, and elephant goads – the regalia that had been adopted by Indian royalty (Wales, 1969: 49; Higham 1989: 275-6).

Like other events in the Dvaravati period, the shift in importance from U Thong to Nakhon Pathom is shrouded in mystery, for written records are few and brief. It is possible, however, that Khmer from the Mekong region (who had played a role in the design of the Dvaravati *dharmacakra*) were involved. Certainly, there were a number of Khmer in the area. Khmer sculpture and a few inscriptions written in the Khmer language have been found in Dvaravati's peripheral communities, where Khmer architectural and sculptural works were produced side by side with Dvaravati art. Those communities (about which more will be said in Chapter 6) included Si Thep, where the Central Plains met the Plateau, and Dong Si Mahaphot (sometimes referred to as Muang Phra Rot) on the Plains' southeastern edge. Even the old Dvaravati center, U Thong, was not immune to foreign intervention, for a copper plate inscription found there suggests that in the seventh century it was ruled for a time by a Khmer or Khmer-related chieftain (Brown, 1996: 49-52).

It was perhaps during this time of Khmer intrusion into what would become the center of Dvaravati's political and artistic heartland that major Buddhist activity shifted from U Thong to the already thriving city of Nakhon Pathom and prompted the building of its defensive moat. One

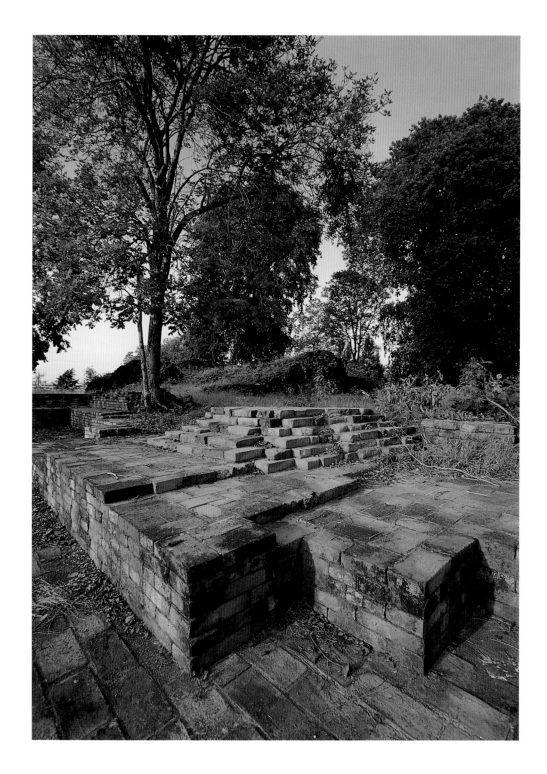

Above: *Ground plans of the Paharpur stupa, and the first and second states of Nakhon Pathom's Phra Men stupa. (Rowland, 1953; Dupont, 1959)*

Left: *The foundation of the Phra Men stupa (partially restored) suggests the Indian Paharpur stupa as a possible prototype.*

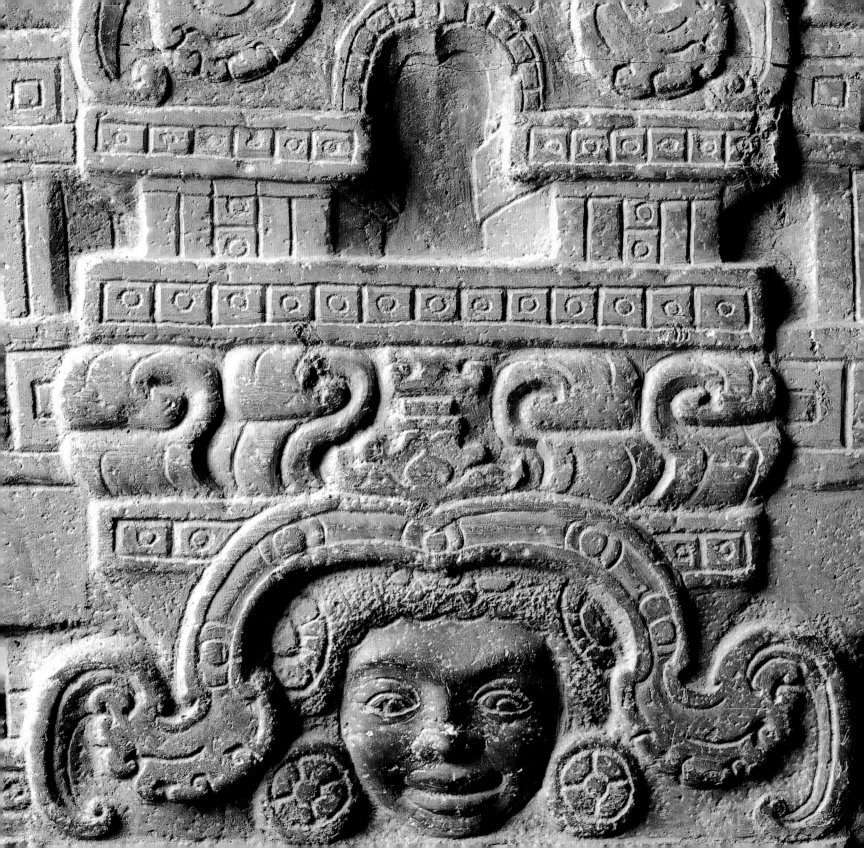

Elevation of Stupa 3, Nalanda, with rows of niches for Buddha images.
(Archaeological Survey of India Drawing)

First and second building stages of Chedi Chula Pathon, Nakhon Pathom. Seventh and eight centuries respectively. Chula Pathon's second state is discussed in Chapter 6.
(After Wales, 1969)

might speculate further that it was the Khmer threat that prompted the arduous journeys of Dvaravati pilgrims to the pilgrimage sites in northern India, where they could find the means to reinforce the Buddhist infrastructure on which Dvaravati's politico-religious chiefdom structure was based. Whatever the cause of Nakhon Pathom's rise to power, its efforts appear to have benefited the Dvaravati network as a whole. U Thong's period of Hindu domination must have been brief, for only a few examples of Khmer sculpture dating from the Dvaravati period have been found there, while its four *dharmacakra*, its wealth of Buddha images, and its architectural remains evidence the revitalized Dvaravati power that followed the seventh-century contacts with India.

It was Nakhon Pathom rather than U Thong, however, that produced the most elaborate art, both architectural and sculptural. Unfortunately, what is traditionally considered to have been Thailand's oldest stupa, the Phra Pathom Chedi, located west of Nakhon Pathom's old moated city, is now encased in a mammoth stupa built in the nineteenth century (Chapters 1, 10) and it is impossible to know the design of the original structure. A stupa known today as Phra Men, however, located not far south of Phra Pathom, is recognizable as a relative of the famed Indian temple at Paharpur, located not far from

Left: *A face-in-window motif on a stone architectural fragment from Nakhon Pathom.*
(Nakhon Pathom National Museum)

the mouth of the Ganges and, along with Nalanda, the site of one of India's most famous centers of Buddhist learning. The Paharpur stupa was distinctive, for its base was composed of three tiers of cruciform terraces with recessed projecting corners, a design unique among known India temples (Rowland, 1953: 153-5; Wales, 1969: 118).

Another Nakhon Pathom monument, Chedi Chula Pathon, located near the center of the moated city, perhaps in the vicinity of a royal palace, also evidences inspiration from the holy sites of the Ganges region. Although Chedi Chula Pathon is most often compared with a ruined structure known as the Puduveli Gopuram, at Negapatam, in southern India (Wales, 1969: 120-2; fig 11 A), there are even stronger stylistic connections with the Gaya's most renowned temple, the Mahabodhi, and with its close relative, the Sariputra Caitya (Stupa III) at Nalanda. Neither the Chula Pathon stupa nor the Mahabodhi temple retains its seventh century appearance, but archaeologists and art historians have conceptualized their earliest appearance from the archaeological remains. Originally, both bore a strong resemblance to the corner towers of Nalanda's Sariputra stupa, and both the Mahabodhi and the Sariputra stupa have been dated by art historians to the seventh century (Paul, 1995: 44; Rowland, 1953: 19, 152-3).

The Chula Pathon stupa, the Mahabodhi, and the Nalanda stupas belong to a class sometimes referred to as *caitya*, a form of stupa unrelated to the more common domed type that was the norm in both India and in the Central Plains. *Caitya* were composed of a solid

rectangular brick core indented on each side with horizontal rows of superimposed arched niches, each niche containing an image of the Buddha (Wales, 1969: 34-37). On the Nalanda building, there were also low stucco reliefs depicting rounded windows from which human faces gazed, a motif replicated in a stone relief found near Nakhon Pathom's Phra Pathom stupa and in a terracotta example from U Thong. The motif was an ancient one – examples can be found at the second-century BC north-central Indian site Bharhut, and it was replicated at Ajanta. Like the Ajanta-related three-dimensional accordion-pleated design on the Dvaravati *dharmacakra*, it may have spread from western India to Nalanda and then onward to the Central Plains. Chedi Chula Pathon in its first stage of construction is notable also for its variety of sculptural reliefs: elegant volute, lozenge, and lotus motifs, and in alternating panels, a marvelous array of mythological creatures. Pairs of lions flanked the axial stairs.

The designs of Nakhon Pathom's architecture were linked to a few other Dvaravati moated settlements located in what may be described as the Dvaravati heartland, an area that extended from the northern tip of the Peninsula to an area some distance north of Nakhon Pathom. This was the cultural core of the Central Plains, the area that would have been in closest touch with south India's Buddhist missionaries in the early centuries AD and in the seventh century became home to Dvaravati's largest concentration of *dharmacakra*. At the northernmost site, Muang Bon, at least sixteen stupa bases as well as a wealth of Nakhon Pathom style architectural reliefs provide evidence of the Nakhon Pathom tradition. And at the head of the Peninsula, Khu Bua, a small moated

community with a roughly rectangular shape not unlike Nakhon Pathom's had stupas and reliefs of both volutes and mythological animals that resembled the elearly reliefs at Chedi Chula Pathon. A seventh-century date for both sites is suggested.

Not surprisingly, it was the Dvaravati heartland that also produced Dvaravati's finest images of the Buddha, an eruption of which appears to have accompanied the introduction of *dharmacakra* and architecture. The images of the Buddha that were produced in the Dvaravati heartland in the late seventh and early eighth century are now considered 'classic Dvaravati'.

Both the number of these Central Plains images and the durable materials of which they were made suggest the important role they must have played as religious icons and as tangible evidence of the symbiotic relationship that existed between the Buddhist community and the lay persons who patronized its art. The stucco and terracotta reliefs that adorned the Buddhist temples portrayed various sorts of animals and mythical figures and tended to be small and whimsical, but Dvaravati's classic images, some two meters tall, were stately and imposing, radiating both power and spirituality. The larger images, like many of the *dharmacakra*, were most often constructed of a luminous bluish-white limestone, especially abundant in the Lopburi area. Bronze, which had been introduced to the Central Plains as early as the late first millennium BC (Chapter 2), was sometimes used for Dvaravati's smaller images.

Among all the major sculpture that would be created in Thailand throughout its history, it was the early Dvaravati images that were most distinctively related to their Indian prototypes, in this case, the best that

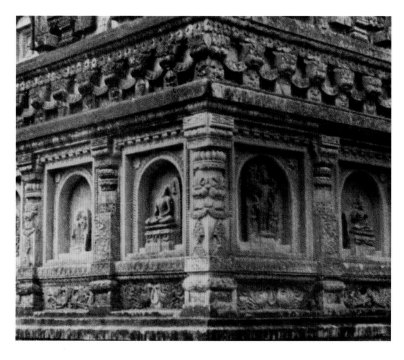

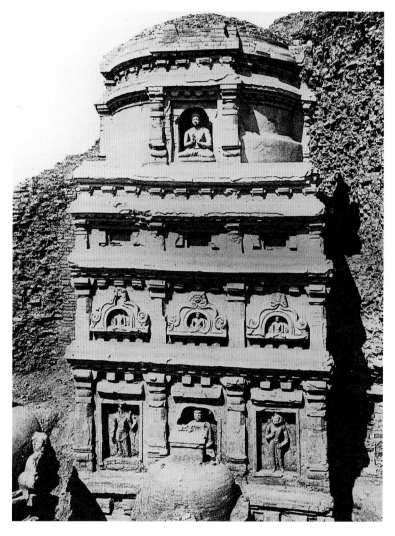

Above left: *Lower level of the Mahabodhi Temple, Gaya, India. The square base with niches for images resembles Stupa no. 3, Nalanda, India, which appears to have contributed to Dvaravati* caitya *designs.* (*Benjamin Rowland Photo*)

Above: *Facade of Stupa no. 3, Nalanda.* (*Benjamin Rowland Photo*)

Left: *Face-in-window motif from Stupa no. 3, Nalanda. This motif was popular at Dvaravati sites.* (*India Office Photo*)

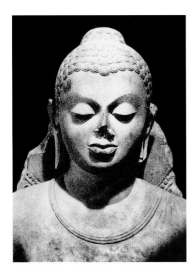 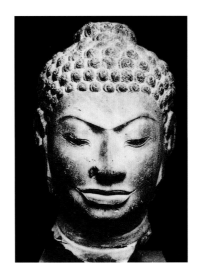 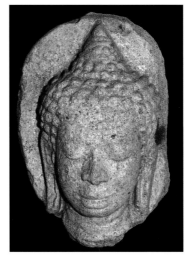 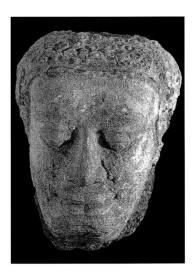

India had to offer – the fifth-century Gupta period images for which Sarnath was renowned. Gupta images differed dramatically from those that had been made several centuries earlier at Amaravati, for although images in both areas derived from the same Gandharan traditions that had emerged in northwest India around the turn of the millennium, the early style had over several centuries evolved into something very different. In contrast to the Amaravati figures, stockily engulfed in their heavy, voluminous robes (as depicted in the small relief that had been imported into the Central Plains), Gupta images were portrayed in clinging, diaphanous sheaths behind which the contours of the body were articulated. Over time the multiple folds that had typified the Gandharan robes had become more and more stylized, gradually diminishing into ropelike appendages, and in the Gupta period, the semblance of rippled folds disappeared altogether. The bodies discernible in the Gupta images were attenuated and graceful, and the human, fleshy attributes suggested by the earlier pieces were replaced with sleek, almost abstract renditions of the human form in which any hint of mortal imperfection had been erased. The faces were oval; the waist, narrow; the chest and shoulders, broad; and there was a harmony and balance among the parts that invoked an otherworldly spirituality.

Gupta images from the Ganges region also adhered to a stricter iconography than earlier ones. Snail-like curls, always curling to the right replaced Greco-Roman hairstyles and the Buddha's clothing began to replicate the details of a monk's robe more than a Roman toga. There was also a formal frontality which, in spite of a gentle sway to the body, was more iconic than naturalistic. The images appeared to be gently smiling, emitting an aura of inner serenity and compassion, the spiritual qualities for which the Buddha was esteemed.

Similarities between Sarnath's images and those produced in the Central Plains are striking and there is no doubt that Dvaravati adopted the former's most prominent stylistic and iconographic features. The *usnisa*, long earlobes, thick heavy curls, and rings that encircled the neck were retained and in some cases were enlarged out of proportion to other parts of the body in order to signify their iconographic significance. Like Sarnath images (but unlike Gandharan and Amaravati ones), the *urna* was often omitted.

In spite of the similarities between the Sarnath and Dvaravati images, however, there were also differences. The harmonious integration of parts that distinguished the Sarnath images were absent in most of the Dvaravati examples, and they lacked the gentle sway of the bodies that softened the formal frontality. But while the bodies may have been more rigid, the faces of Dvaravati's images were less stylized, gentler, and more approachable than the Gupta prototypes. Perhaps incorporating facial attributes that were considered most beautiful by the Mon, the faces were more human than the precisely rendered geometric shapes of the Indian examples. The cheeks were softened while cheekbones were firm. Eye were pensive and mouths were expressive, and steeply arched eyebrows met above a flattened nose. In the best Dvaravati pieces the inner, gently smiling spirituality for which

Left: *Heads of four Buddha images illustrating the gradual stylistic transition from an idealized form to increasingly naturalistic treatment. From left to right: a fifth-century image from Sarnath; a seventh-century classic Dvaravati head; a Dvaravati head perhaps dating to the eighth century, and a very late image made near the end of the Dvaravati period.*

Right: *Late fifth-century Sarnath image in the Bangkok National Museum.*

Far right: *A classic seventh-century Dvaravati image at Bangkok's Wat Benchamapophit. The cloth drapery on the Thai image was presented by devotees as a sign of respect. Both images are carved with clinging robes that reveal the contours of the body and contrast vividly with the heavily robed Amaravati-style images that had reached Southeast Asia in previous centuries. A slightly later thinly robed image is depicted on page 13.*

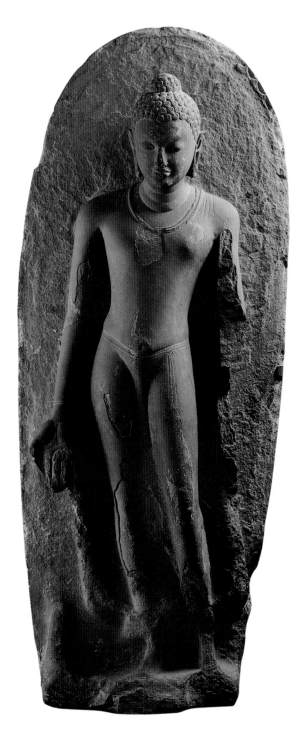

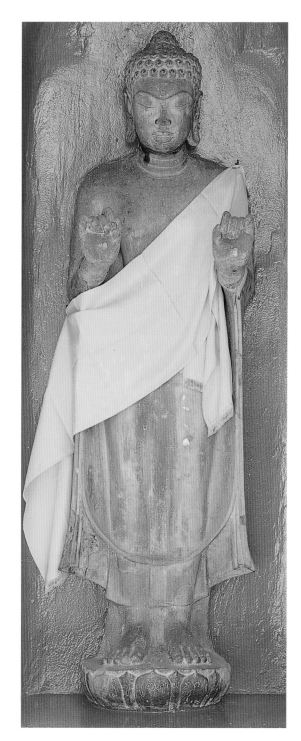

Pralambapadasana *image from Nalanda Stupa 3. (Archaeological Survey of India Photo)*

A pralambapadasana *image from Ajanta Cave 26.*

Terracotta votive tablet from Khu Bua, showing a pralambapadasana *image. Like other* pralambapadasana *images, this one probably represents the Buddha's First Sermon. (Bangkok National Museum)*

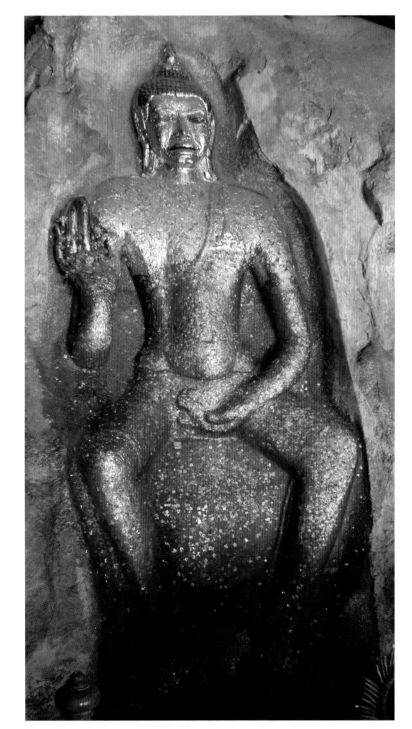

Pralambapadasana *image from Khao Ngu, Ratburi.*

the Gupta images are revered, was not only preserved but enhanced by its rendition in more lifelike ways.

Given the importance of the *dharmacakra* in Dvaravati art, one might expect that its Buddha images would represent the First Sermon as well, and Dvaravati's artisans adapted Indian iconography as the means to do so. In India, anthropomorphic representation of the First Sermon had been most often represented in images seated with legs tucked one beneath the other (Chapter 3). The hands were positioned in the traditional *dharmacakra mudra*, fingers curved as if turning the Wheel of the Law. Typically, however, classic Dvaravati images were standing with the hands separated and positioned at chest level in *vitarka mudra*, thumb and forefinger touching. The Gupta roots are evident, however, for the *dharmacakra* and *vitarka mudra* were closely related. Although in India the *vitarka mudra* was not used to indicate the First Sermon, it did express exposition, or teaching in a more general sense. In Thailand the two *mudra* were often interchangeable, and both the *vitarka* and the *dharmacakra mudra* are referred to as *pathom thetsana*, or the *mudra* of the First Sermon (Dhanit, 1967: 3).

The double *vitarka mudra* would become one of the foremost Dvaravati attributes to endure in later Thai art styles, and art historians have sought an outside source prior to its use in the Central Plains. There are still uncertainties, however, for the double *vitarka* is found neither in the Ganges region nor in other areas of India. Its use by Dvaravati artisans is sometimes attributed to a lost Amaravati tradition (Wales, 1969: 125), but a number of images in double *vitarka* have been found at the first millennium site of Sri Ksetra, in Myanmar, and

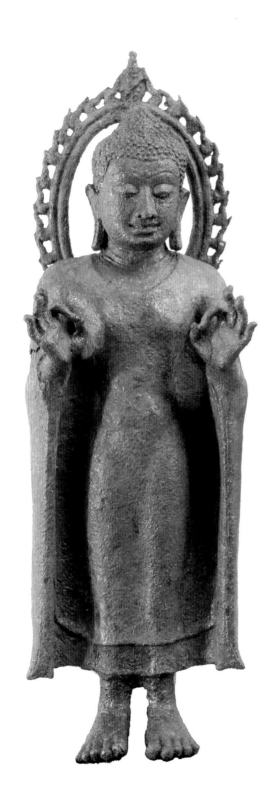

images in single *vitarka mudra* were not unknown at Mathura (Dupont, 1959: 181; Luce, Vol. 1, 1969: 144). Within the theoretical framework presented here, the missing links between the Indian and the Central Plains images should be sought, not in south Indian prototypes, but in some that may have been produced in the north.

Other Buddha images evidence Dvaravati's intimate connections with northern India. There were images in *varada mudra*, denoting charity, and some were seated in the yogic position. More often than not, however, images were seated in *pralambapadasana*, that is, in the so-called `European' manner with the legs dangling. In the late fifth century there had been a sudden eruption of *pralambapadasana* images at Ajanta and its neighboring site, Ellora (Spink, 1992: 10). From there the convention apparently spread quickly, for they began to have been produced almost simultaneously at Nalanda (Paul, 1995: 5-7;), whence the iconography could have spread to Thailand's Central Plains. Numerous votive tablets depict the Buddha in *pralambapadasana* pose (Coedès, 1926: 7-9). As with the standing images, Dvaravati artisans preferred the double *vitarka mudra* over the *dharmacakra mudra*, but the resemblance between the Dvaravati and the Indian prototypes is notable. Like Ajanta's and Nalanda's *pralambapadasana* images, most of Dvaravati's were monumental, designed to be prominently placed in architectural settings. It is not surprising that these monumental pieces were selected to represent the First Sermon, as Dvaravati's ubiquitous *dharmacakra* had done in the past. At least five such examples, about four meters tall, are known to have been made at Nakhon Pathom (where most of the *dharmacakra* had been installed). It is thought that four monumental *pralambapadasana* images faced the cardinal directions at Nakhon Pathom's Phra Men stupa. In one of its earlier states, *pralambapadasana* images in *vitarka mudra* were placed in the niches that

Stone carvings of the Buddha in pralambapadasana *and* vitarka mudra. *These carvings appear to have been used on the socle of a* dharmacakrastambha, *and like the* cakra, *represents the Buddha's First Sermon in the Deer Park. Here, converts flank the Buddha. (Nakhon Pathom National Museum).*

surrounded another of Nakhon Pathom's stupas, Chedi Chula Pathon (Dupont, 1959: 72, 75).

During the latter part of the first millennium AD, the Central Plains standing images, and to a lesser extent, the seated ones, were copied time and again in both the Dvaravati heartland and in areas peripheral to the Central Plains. As large numbers of such images continued to be produced throughout the period, they became less stylized, more naturalistic, and more ethnically Mon-like. There was also a decline in quality, never to recover after the first blossoming of Gupta-inspired art in the seventh century.

The continuity of Gupta-based Dvaravati art styles over such a long period of time is remarkable, especially in view of the dramatic changes that were taking place during the same period in India, in the Mekong region, and in Island Southeast Asia. Certainly, contacts with the outside world were not absent, for votive tablets apparently brought from the Ganges region evidence continuing contact with India (Coedès, 1926; Pattaratorn, 1999: 82-3)), and there were isolated examples of Sanskritic Buddhist art at Nakhon Pathom (Chapter 6). But the bits of nontraditional, intrusive art that appeared in the Dvaravati heartland, most notably in the late eighth century, were insignificant compared to the number of classic-derived images that were copied time and time again. As Woodward has noted 'It seems . . . that social conditions were not such that the newer influences could be used as creatively as had been possible in the past', and in the latter centuries of its existence Dvaravati entered a 'cultural shell' (Woodward, Vol. 1,

1975: 13). In spite of the wealth of artistic and religious traditions that Dvaravati appears to have turned to in order to formulate an ethos of its own, it appears that the conservative tenents of Theravada Buddhism and the time-honored teachings of the elder monks remained the central guiding force.

It was not until the tenth century, when the Khmer presence in the Plains became much stronger, that Dvaravati's classic images began to reflect enough foreign features to significantly alter their *sthaviravada* underpinnings and their Gupta-inspired artistic and iconographic attributes (Woodward, 1997: 52-53). But, as we shall see, the situation in Dvaravati's peripheral areas was decidedly different, and we shall turn to those areas next.

CHAPTER SIX

The Peninsula, the Pasak and Nontraditional Art in the Central Plains – Fifth to Ninth Century AD

Judging from the distribution of *dharmacakra*, the Dvaravati chiefdom network from time to time included a number of chiefdom and sub-chiefdom communities located beyond its heartland. Many of these neighboring communities were located along well-established trade routes that bypassed the chief Dvaravati centers, and given the fragile nature of chiefdom political control and the shifting of personal loyalties among chiefdom and subchiefdom leaders, allegiances between the political centers and their allies were probably weak. In spite of the political connections that their *dharmacakra* suggest, it seems probable that there were also alliances being established in a variety of directions, and Dvaravati's peripheral communities must have vacillated in their adoption of religious and artistic attitudes as well as their political ties.

Although some Buddha images in the peripheral areas followed the Gupta tradition that had been established in the Nakhon Pathom area, many sculptural and architectural works were startlingly different. While the Dvaravati heartland continued along its traditional path, its neighbors were bombarded by diverse multicultural influences that in some cases all but obliterated the Dvaravati presence. Possible cultural contacts with foreign areas were countless. The Pasak and Bang Pakong rivers still functioned as a passageway that connected the Gulf of Thailand, the Khorat Plateau, and China (Higham, 1989: 281), and as in past centuries, the Khmer were making repeated inroads into the Dvaravati cultural orbit. To the southwest, Sri Lanka, located near India's southeastern shores, joined India as a significant Southeast Asian contact. And the Gulf area was connected to India by way of the Kwae Noi River, the Three Pagodas Pass, and the Bay of Bengal. The Peninsula still functioned as a major crossroad between east and west. In contrast, the Chao Phraya River, at the center of the Dvaravati heartland, led only to remote Iron Period villages, which during the first millennium AD showed no signs of Dvaravati penetration (Brown, 1996: 62-4; Higham and Rachanie, 1998: 144-5). The Dvaravati heartland was certainly not isolated from the foreign contacts that were changing its neighbors, but for the most part it resisted the intensive and varied cultural intrusions that were persistently knocking at its city gates.

The most active site located between the Three Pagodas Pass and the Peninsula was a non-moated site, Phong Tuk, which during the latter part of the first millennium AD appears to have functioned not as a Dvaravati chiefdom or subchiefdom center, but as a halting place for travelers. A remarkable variety of foreign objects found their way to Phong Tuk, but in spite of the site's proximity to Nakhon Pathom and other Dvaravati centers, its acquisitions were not to change the course of the area's artistic traditions.

Like Dvaravati pilgrims before them, Phong Tuk's travelers must have visited India's major pilgrimage sites, for a small votive tablet, perhaps acquired as a souvenir from Gaya, evidences contacts with the holy sites of northern India (Coedès, 1926: 6; 1928 b: 202). And there were also objects imported from Sri Lanka. A large assembly hall, or *vihara*, in the Sinhalese style included a high oblong base with molded sides and stairways similar to ones built at Anuradhapura, the old Sinhalese capital (Coedès, 1928: 200-1).

Sri Lanka was probably also the source of a Phong Tuk image of the Buddha shown in a rippled, toga-like robe that was typical of

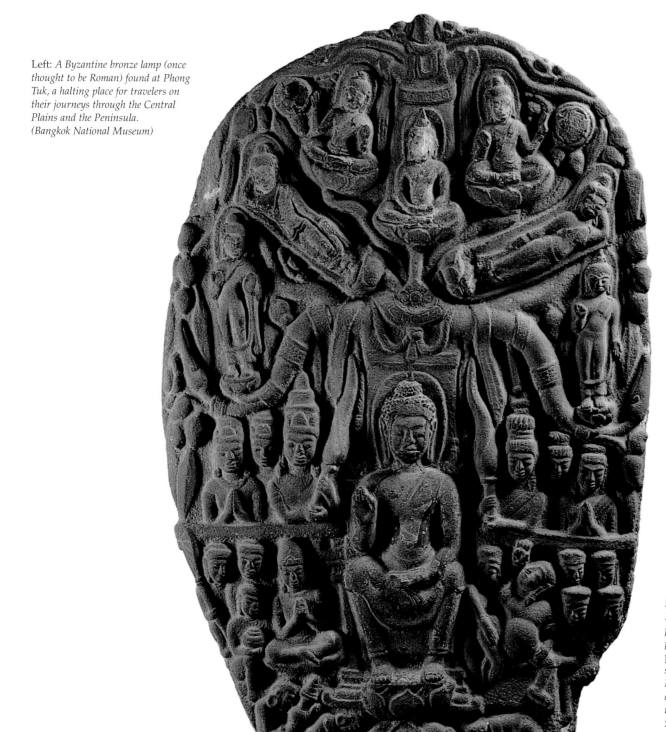

Stone carving depicting the Buddha in pralambapadasana *pose from the later Dvaravati period. While earlier* pralambapadasana *images symbolized the preaching of the First Sermon, by the eighth century this pose was used to illustrate the Great Miracle of Sravasti, by means of which the Buddha multiplied himself into many Buddhas. (Bangkok National Museum)*

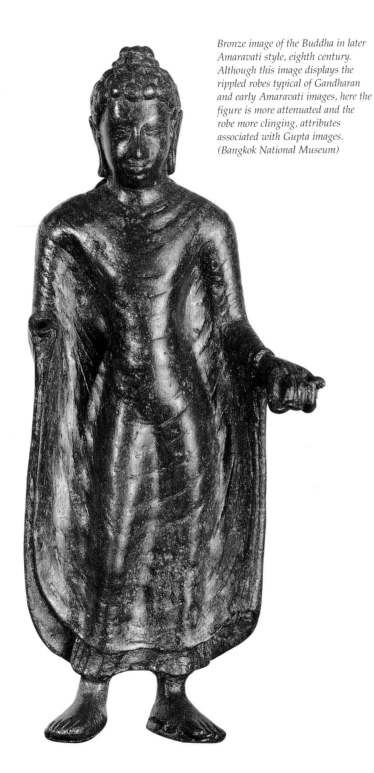

Base of a Sinhalese-style assembly hall at Phong Tuk.

Amaravati figures. The Phong Tuk image was more attenuated than those made during the Amaravati period, however, and has been dated to the eighth century AD. By that time the so-called 'later Amaravati' style was perpetuated primarily in Sri Lanka, where *sthaviravada* Buddhism, now known under the name Theravada, had become the state religion. The image, like similar ones deposited at various trading areas throughout Island and Mainland Southeast Asia is thought to have represented the Buddha Dipankara, 'Calmer of the Waters', patron saint of Sinhalese sailors (Fickle, 1989: 24-5; Hall, 1985, 37, 270 33n). Sometime during the latter half of the millennium, either by way of Sri Lanka or from the north, Phong Tuk received a large antique fifth- or sixth-century Byzantine lamp elaborately ornamented with a decorative palmette flanked by two dolphins (Brown, 1989: 10-17).

Another site, Khu Bua, located between Phong Tuk and the Peninsular, not surprisingly, was subject to a variety of foreign intrusions, and its art reflects many sources. Because of its Phra Pathon style stupa and the presence of a *dharmacakra* not far distant, Khu Bua was considered in Chapter 5, above, to have been the southernmost settlement in the Dvaravati heartland. But the site is notable especially for its nontraditional art, which would eventually provide a source of art styles in many parts of Thailand. More than one unorthodox Buddhist sect appears to have been active. There were perhaps *sarvastivada*, who shared many beliefs with the conservative *sthaviravada*, but who, nevertheless, used Sanskrit rather than Pali as their official language. Even less orthodox were Mahayana Buddhists, for whom there was no one single historical Buddha, but a myriad of future Buddhas, or *bodhisattva*, who postponed Buddhahood in order to

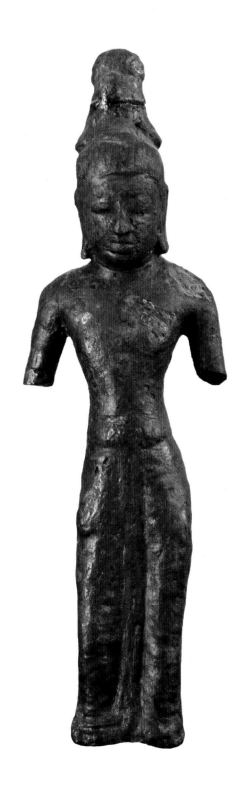

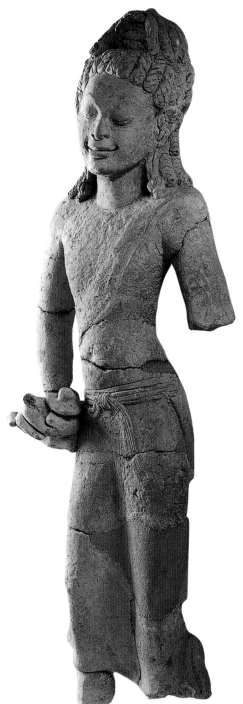

Far left: *Bronze image of a* bodhisattva, *Khu Bua, eighth century. This type of slender figure, with tall headdress like those ones shown in Sinhalese images would later, by way of Dong Si Mahaphot and Si Thep, inspire some of Thailand's best bronzes, near Prakhonchai, on the Khorat Plateau.* (Prachinburi National Museum)

Left: *Eighth-century Mahayana terracotta image from Khu Bua.* (Bangkok National Museum)

Left: *Stucco representations of* yaksa *from Khu Bua (far left) and Muang Bon (left).*

Right: *Terracotta relief of a* bodhisattva *with a fanciful headdress similar to ones worn by Mahayana figures at Ajanta. (Bangkok National Museum)*

Below right: *Stucco figure depicting prisoners and a guard from Khu Bua Stupa 10. The scene probably depicts a scene from a* sarvastivada *jataka. (Bangkok National Museum)*

help others on their way to enlightenment. Artistic endeavors were prodigious, and figures of *bodhisattva* would become a hallmark of Khu Bua art.

Khu Bua's Mahayana art is noted for its exceptional beauty and elegance. Constructed of terracotta rather than stucco, the Mahayana reliefs included an amazing array of *bodhisattva* figures that resembled elaborately attired and bejeweled figures in Ajanta's fifth-century murals. Unlike the Ajanta motifs that had reached the Dvaravati heartland by way of the Ganges region of northern India (Chapter 4), these Ajanta motifs appear to have arrived by way of Sri Lanka, where Ajanta's monks may have fled after its destruction (Spink, 1999: personal communication). The languid royal pose of the Sinhalese figures, their elongated languorous eyes, and their elaborate headdress provided clear evidence of the ever-increasing multicultural elements that were changing the face of Dvaravati's peripheral areas. Khu Bua's Mahayana reliefs are thought to have been made in the seventh or eighth century (Woodward, 1997: 48, 50).

Related to Khu Bua's Mahayana reliefs were seventh- and eighth-century standing bronze images of Avalokitesvara, the *bodhisattva* of compassion. Slim and long-skirted, the Khu Bua Avalokitesvara images, like earlier representations in India and Sri Lanka, are identifiable by depictions of the god Amitabha, the heavenly Buddha, in their tall, ornately arranged headdresses. Although there are differences in skirt style between the Khu Bua and Sinhalese examples, the Avalokitesvara images, like Khu Bua's stuccoes, appear to have derived from Sinhalese prototypes (Woodward, 1997: 48).

Perhaps of *sarvastivada* origin were eighth-century reliefs executed in stucco that surrounded one of the stupas located outside Khu Bua's city moats. In contrast to the ethereal Mahayana *bodhisattva*, these stucco figures depict inhabitants of the mundane world, charming, capricious, and human. Like the Mahayana terracottas, they are considered Khu Bua masterpieces. The figures included kings, queens, and royal attendants, accompanied by musicians holding stringed instruments. Among the non-royal figures was a zealous guard who was depicted kicking a reluctant prisoner. Although some of the figures were adorned with Dvaravati-style jewelry, some were in foreign dress – tall hats, tunics, and boots. The figures were probably representations of imaginary characters from Buddhist *jataka* stories, which reinterpreted pre-Buddhist Indian folk tales as moralistic Buddhist fables. But their dress was typical of clothing worn by Middle Eastern Semitic traders and reflect the variety of foreign elements that were sometimes being interjected into traditional artistic motifs (Lyons, 1965; Boisselier, 1975: 85-6; Wales, 1969, 60-2).

Given its close proximity to Phong Tuk and Khu Bua, it is not surprising that even Nakhon Pathom, the most important center of Dvaravati's conservative *sthaviravada* heartland, was not entirely immune to some exotic intrusion. The *pralambapadasana* pose, which had been an important iconic symbol of the First Sermon in earlier centuries, was now used in a different context. In India, *pralambapadasana* images could refer not only to the First Sermon but to miracles performed by the Buddha at the Indian town of Sravasti, and a Sanskritic source is suggested for a number of Dvaravati bronze reliefs

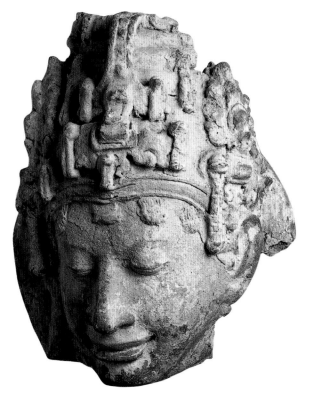

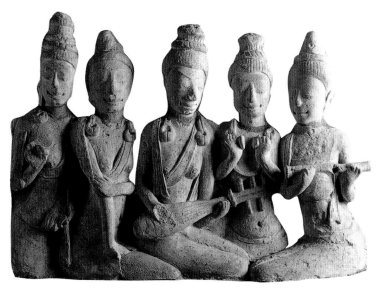

Stucco relief showing female musicians from Stupa 10, Khu Bua. (Bangkok National Museum)

Below: *Model of a Khu Bua stupa with niches indicative of a* caitya *design. (Ratburi National Museum)*

Overleaf: *Stucco panels depicting scenes from* sarvastivada jataka *tales that surrounded Chedi Chula Pathon in a second period of reconstruction.*

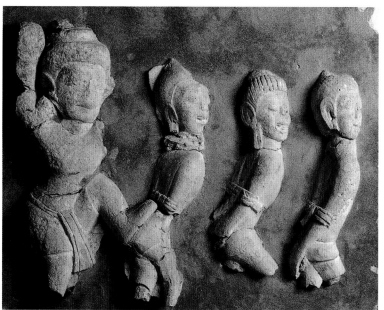

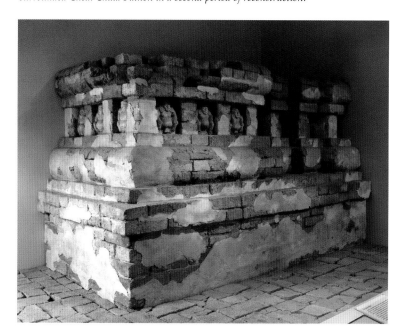

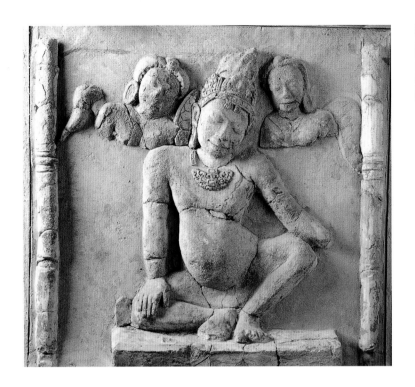

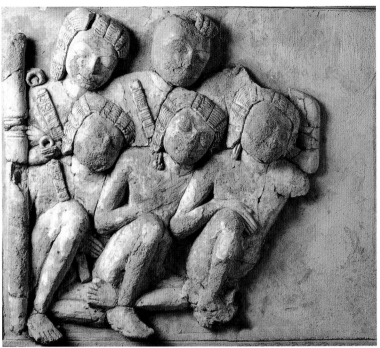

that depict these miracles (Brown, 1984). Moreover, in the eighth century, Nakhon Pathom refaced its central stupa, Chedi Chula Pathon, with *jataka* reliefs, and stucco was used side by side with the traditional terracotta (Piriya, 1974: 2), Like the Sravasti reliefs, the scenes appear to have been derived from Sanskritic sources (Nandana, 1978: Piriya, 1974). In a second reconstruction of the Chula Pathon stupa, in the late eighth or early ninth century, a Mahayana relief from northern India was buried beneath one of the building's four new corner towers (Woodward, 1997: 50).

In spite of the introduction of these Sanskritic elements, however, the impact of the foreign ideas on the Dvaravati heartland appears to have been minor. Like other introductions into the Central Plains which did not fit into the existing local framework, deviations from Dvaravati's established traditions failed to take hold. The Byzantine lamp from Phong Tuk may have inspired some plain, unornamented terracotta adaptations, but its elaborate dolphins and palmette were not copied (Brown, 1989: 15-17). As in past millennia, local interest was sparked by new technology rather than by exotic artistic motifs that bore no relevance to local cultural proclivities. The Sinhalese-style Dipankara image, which appears to have been brought by traders rather than missionaries, inspired only a few copies. And in spite of their artistic excellence, the Chula Pathon's *jataka* reliefs were covered over in the ninth-century construction, and its Mahayana reliefs remained hidden beneath the tower. The Sanskritic reliefs appear to have motivated reproduction only at Muang Bon, at the very northern extremity of the Dvaravati heartland (Piriya, 1974: 2). Unlike the peripheral areas, where foreign currents transformed the cultural picture dramatically, the *sthaviravada* Buddhism that had been introduced into the Central Plains in the early centuries AD retained its dominant position.

While the Central Plains remained enmeshed in its own traditions, the adjacent Peninsula was undergoing deep-seated changes. This area had originally been occupied by indigenous peoples unrelated to the Mon who had settled in the Plains, but by the first millennium AD the local population had intermixed with both Mon and Khmer (Piriya, 1980: 8). The histories of the two areas had not always been so different. At the beginning of the first millennium AD the Peninsula, like the Plains, had been home to a number of small autonomous chiefdoms, and those with centers that were located along the trade routes prospered (Hall, 1985: 65-7; Piriya, 1980: 10-11). Imports to the two regions at first were similar. Sometime in the latter centuries BC, two Dong Song kettle drums were deposited in the Kra area, the narrowest section of the Peninsula where contact between the Indian Ocean and the Gulf of Thailand was easy. And in the early centuries of the first millennium AD, there were inscribed stone seals as well as glass and carnelian beads like those traded between Oc Eo, Beikthano, and the Central Plains (Higham and Rachanie, 1998: 187).

As early as the third century, however, major differences between the Peninsula and the Central Plains began to emerge. Just when the Central Plains' trade with the outside world was diminishing, the Peninsula was evolving as a land of commerce and international trade, a crossroads for Indian, Chinese, Malay, Persian, and Arab traders (Piriya, 1980: 20). While Dvaravati was developing a homogeneous culture supported by a localized, conservative *sthaviravada* Buddhist structure that emanated from its own chiefdom centers, the Peninsula, with its multicultural connections, was thriving in its diversity.

During the first half of the first millennium AD there were contacts with both southern and northern India. The Peninsula produced some stocky images that reflected the Amaravati school of South India, and a local copy of a late fifth-century Sarnath image of the Buddha from Wiang Sa, in the Kra area, was remarkably similar to its Indian prototype. Like Sarnath prototypes, the Wiang Sa image was clothed in a plain transparent sheath, revealing the curves of the body, and there was a slight triple sway to the body, rendered in high relief against an arch-shaped backpiece (Piriya, 1980: 20; Fickle, 1989: 25-26). Mahayana Buddhism was represented by figures of *bodhisattva* similar to those at Khu Bua with tall elaborate headdresses. Most were representations of Avalokitesvara, but some portrayed Maitreya, the future Buddha (Piriya, 1980: 31-2, 136).

Even more prominent than the Mahayana images were Hindu ones. Hinduism, which by the third century AD was beginning to supplant Buddhism in most parts of India, was a complexly syncretic religion of many gods and complex rituals. Hindu kings, for whom religious and political matters were always entwined, employed brahmans, members of Hinduism's priestly class, to conduct elaborate and lavish court ceremonies that enhanced the rulers' prestige and helped establish their legitimacy. Peninsula chieftains appear to have done the same. According to contemporary Chinese accounts, as early as the third century Hindu merchant seamen who were arriving on these shores were accompanied by 'numerous brahmans [who] have come from India to seek wealth by serving the king' (Hall, 1985: 67). Hindu culture also spread among the commoners. Unlike the Buddhist monks in the Central Plains, the Hindu advocates were not committed to celibacy. Rather than forming a community separate from the royal realm as the *sthaviravada* Buddhists had on the Plains, high-caste Hindus married into local chiefdom families. Sanskrit became the

lingua franca of the Peninsula's elite, and devotion to Hindu gods became widespread (Piriya, 1980: 25-6).

By the fifth century, images of the Hindu gods Shiva and Vishnu had become common. Shiva was most often represented by linga, upright phallic stones that symbolized the god's strength and potency. But more numerous were anthropomorphic Vishnu images – large, imposing sandstone four-armed figures dressed in Indian *dhoti* held in place by a belt with a U-shaped sash, and a distinctively tall miter-like crown, or *kiritamukuta* embellished with vegetal designs. Such images had been made in northern India in the early centuries AD, but the earliest on the Peninsula, from Chaiya and probably the most ancient Hindu image discovered in Southeast Asia, has been dated to c. AD 400 (O'Connor, 1972: 39). The Chaiya image is thought to represent Vasudeva-Krishna, an ancestral Indian deity who would later become

Far left: *Vishnu image from Chaiya dated to c. 400 AD. This image is thought to have been the one image from which all subsequent Vishnu images in Southeast Asia derived. The tall miter-like hat would be preserved in later images, although the U-shaped sash would be altered. (Bangkok National Museum)*

Left: *An Amaravati-style image from the Peninsula. This is another indication of the multicultural contacts that the Peninsula had with other parts of Asia. (Bangkok National Museum)*

Shiva-linga. By the fifth century Vishnu images were numerous on the Peninsula, while Shiva was most often symbolized by linga. (Bangkok National Museum)

identified with Vishnu. Vasudeva-Krishna would have appealed to Peninsula peoples where ancestral traditions were important, and his image is thought to have provided 'the single extant seed' from which all other similar Southeast Asian Vishnus evolved (Brown, 2000). There would be a remarkable number of such images. According to Brown, while Southeast Asia's multitude of Vasudeva-Krishna-Vishnu images have often been credited to waves of Indian immigrants, in India the images evolved along lines different from that in Southeast Asia, and a case can be made that the two traditions were independent of each other. The Southeast Asian tradition reached the Khorat Plateau and would become especially notable in territories in the Lower Mekong region populated by the Khmer.

By the late sixth century a second, taller, more stately type of Vishnu sculpture based on the fourth-century prototype emerged. These magnificent images, some of which were two meters tall, display unusually high levels of technical skill and aesthetic sensitivity, and it is thought that they were made under court patronage (Boisselier, 1975: 97-8; Piriya, 1980: 27). The stance is imposing, shoulders are wide and rectangular, and the flat, rather lifeless expressions of earlier faces are replaced with a finely rendered intensity. The U-shaped sash is straightened, and the expertly rendered musculature of the chest and neck distinguishes them from both Indian sculpture and Peninsula prototypes. The new style appears to have resulted from an inflow of as yet undisclosed Indian attributes that altered what was a basically Peninsula art style (Dofflemyer, 1999: 40-1).

It was in the seventh and eighth centuries that Dvaravati made its presence felt in the Peninsula. This was the period in which several Dvaravati *dharmacakra* were placed in the region – in the extreme north, in the Kra area, and in the deep south (Chapter 4). There were also a few images of the Buddha whose style derived from Dvaravati prototypes. Although Buddhist sculpture in the Peninsula during this

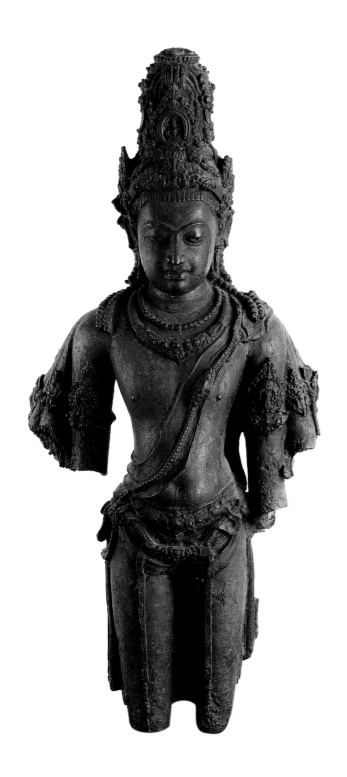

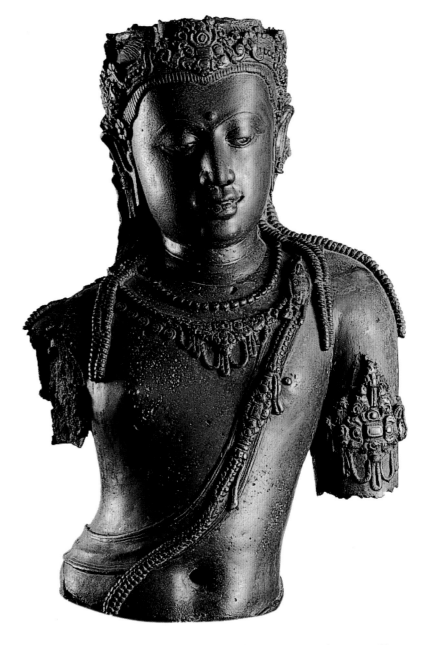

Two images of bodhisattva in the Indo-Javanese style introduced to the Peninsula by Srivijaya in the ninth century. (Bangkok National Museum)

Opposite: *Two tenth-century tablets depicting twelve-armed and four-armed Avalokitesvara, the bodhisattva of compassion.*
(Bangkok National Museum)

period shows some signs of Sinhalese influence, they are categorized at best as provincial Dvaravati, never rivaling in quality or quantity those produced in the Central Plains. Most Peninsula Dvaravati images were produced at Chaiya, and while several *dharmacakra* evidence Dvaravati culture in other areas, these pockets of penetration were small and isolated. In the northern part of the Peninsula, where one might expect the Dvaravati presence to be strongest, it is notable by its absence. Apparently, the Peninsula's Dvaravati areas were reached from the Plains by sea rather than overland (Brown, 1996: 42-3).

The Dvaravati presence here was short-lived. Although small votive tablets dating from the seventh and eighth centuries are remarkably similar to those produced in the Dvaravati heartland, their themes are primarily Mahayana, suggesting that Dvaravati's major cultural foundations had only weak effect on lands farther to the south (Pattaratorn, 2000). And soon after Dvaravati began to establish its footholds there, a new political force known as Srivijaya, a maritime kingdom with strongholds in Island Southeast Asia, began to make an even stronger impression. Srivijaya was not merely a network of loosely affiliated chiefdoms such as those on the Mainland, but rather a large kingdom with a royal capital located at Palembang, in southeastern Sumatra. Srivijaya's political power was based not only on the ability of local chieftains to establish personal ties with their neighbors, but on maritime links with Malay and Chinese merchants who were then the major transporters of foreign goods throughout the Southern seas. From the eighth to the eleventh centuries, Srivijaya was able to control maritime trade between China and the West, and its area of influence

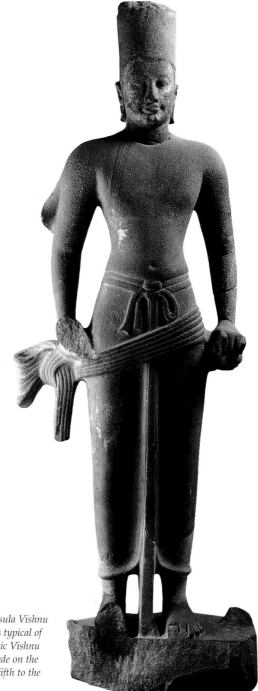

Fifth-century Peninsula Vishnu image. This image is typical of the many tall, hieratic Vishnu images that were made on the Peninsula from the fifth to the ninth century.
(Bangkok National Museum)

Model of a stupa-prasat, with twentieth-century embellishment. The original is now encased within a large Sinhalese-style stupa at Wat Mahathat, Nakhon Si Thammarat, in peninsular Thailand. (Chapter 10). (Betty Gosling Photo)

Left: A Stupa-prasat at Chiang Mai, northern Thailand. Although the stupa-prasat design derives from Srivijaya sources, it spread throughout much of Thailand. (Betty Gosling Photo)

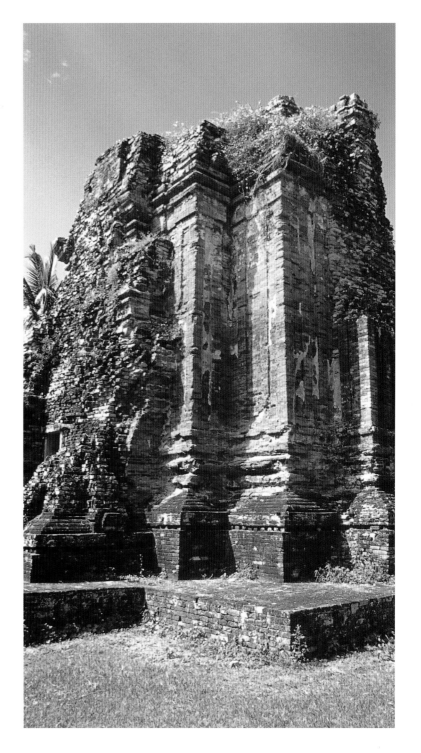

Cham-inspired tower at Wat Kaeo, Chaiya. Only the lower part survives, but the similarity with towers on the coastal areas of Vietnam illustrates the wide geographical range of Srivijaya's maritime empire.

included most of the old entrepôts that had been established along the existing trade routes – in southern China, in Champa (formerly, Sa Huynh, in Vietnam), at Nalanda (in northern India), in the Middle East, and in Java (in Island Southeast Asia). Not surprisingly the Thai Peninsula, located in the midst of the multicultural whirlwinds, also felt the impact.

Thanks to Srivijayan enterprise, the diversity of imports that arrived in the Peninsula was stupendous, not to be repeated again in Thailand for another millennium (at Ayutthaya in the fifteenth and sixteenth centuries). At some unknown time, two Chinese Sui Dynasty (AD 581-618) statuettes were deposited at Phetburi. (Boisselier, 1975: 68), while in the Kra area there was an extraordinary variety of Persian, Arab, and Chinese ceramics, and more T'ang Dynasty (AD 618-907) pieces than have been found anywhere else outside China (Higham and Rachanie, 1998: 187). Even more significant were new art traditions which were triggered by religious beliefs that altered the local infrastructure. Srivijaya had intimate contact with Nalanda, which was now devoted primarily to the practice and teaching of Sanskritic Hinayana and Mahayana Buddhism. As early as the seventh century, Chinese pilgrims en route to Nalanda had stopped at Palembang, and it too had become a major center of Mahayana Buddhist learning. From there, it was an easy step to the Peninsula.

The Peninsula's most outstanding art was produced in the ninth century and resulted from long-distance contacts with Nalanda by way of Java, which now had intimate dynastic ties with Palembang. Java's Nalanda-inspired Mahayana art was unrivaled elsewhere in Southeast Asia, and ninth-century Peninsula art reflected the Javanese expertise. The images portraying *bodhisattva* rather than the historical Buddha, were elaborately attired in heavy jewelry, ornate draperies, and headdresses whose extravagance surpassed that of the earlier *bodhisattva*. Sensual and human, they contrasted decisively with the

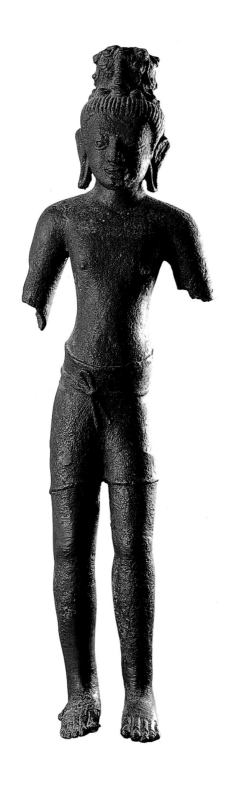

Ninth-century Mahayana image from the Prakhonchai area of the Khorat Plateau. Prakhonchai images are notable for their fine bronze casting, which had been practiced on the Plateau for many years. The style of this image derives from Peninsula prototypes that arrived by way of Si Thep, but also has Khmer attributes, most obviously, the short sampot, *which replaced the long skirt typical of Khu Bua images. (Bangkok National Museum)*

unadorned authoritative Vishnus. Executed in bronze and stone, in both quality and number they far surpassed the few provincial Dvaravati images that had been made in the Peninsula not long before (Boisselier, 1975: 94-6).

Srivijaya also inspired new architectural forms. In the eighth century, a Srivijayan monarch had dedicated a Buddhist temple at Nakhon Si Thammarat, near the old Dvaravati center in the Kra area (Hall, 1985: 81), and an important temple with strong Cham characteristics known as Wat Kaeo was built at Chaiya. Most prevalent were Javanese-style temples known as stupa-*prasat*, which were composed of a tall cubicle base (the *prasat*), surmounted by a hemispherical stupa. An eighth-century example survives at Chandi Sewu, in Central Java, and numbers of examples are found in the Peninsula and elsewhere in central in northern Thailand (Woodward, 1966: 38-9).

Neither the Peninsula's Hindu nor Mahayana Buddhist images inspired new traditions in the Dvaravati heartland. But while the Chao Phraya River had yet to be developed as a major thoroughfare linking north and south, the Pasak River, which paralleled it to the east and led to the Mun River, the Khorat Plateau, and the Mekong region, was as active as ever. Along its route art styles proliferated, and Khu Bua and Sinhalese art styles appeared side by side with Dvaravati's traditional art. In spite of its beauty and international flavor, however, Srivijayan art made little impact beyond the Peninsula, for there was less interest in lands that lay distant from the sea. On the other hand, pre-Srivijaya, Khu Bua-related Mahayana images as well as the Hindu Vishnus would engender two of the most widespread artistic traditions in all Southeast Asia.

An area around Dong Si Mahaphot and Muang Phra Rot, located in the Bang Pakong area just east of the Peninsula (not far from the old Neolithic site of Khok Phnom Di), appears to have been the major

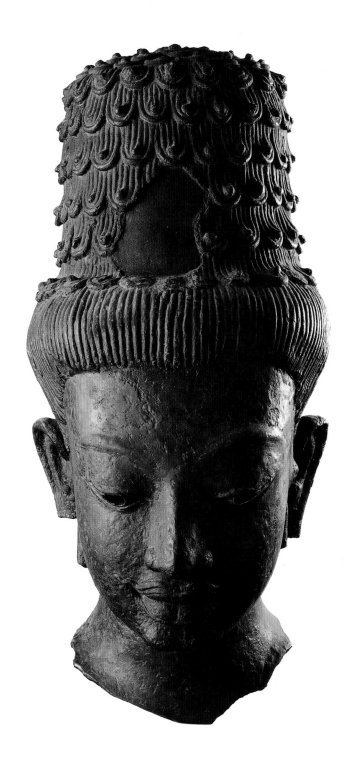

dispersal point for the Peninsula's multicultural art. Very similar to a Sinhalese piece is an impressive Dong Si Mahaphot image of the Buddha in *dhyana mudra*, seated beneath the head of the seven-headed *naga*, Mucalinda. *Naga*-protected images had been produced at Amaravati in the early centuries AD and were common in Sri Lanka. Votive tablets impressed with *naga*-protected Buddha images were common in the Peninsula in the seventh century (Pattaratorn, 2000: 176-7). While this iconographic type was never popular in Dvaravati art, it would in time inspire many objects in both the Mekong region and the Upper Mun area of the Khorat Plateau.

In the seventh and eighth century, the style of Khu Bua's Avalokitesvara bronze images spread from the Gulf area by way of the Pasak River northward to China and east via the Mun to the Mekong Region. A Khorat Plateau site, Prakhonchai, where a horde of related images was discovered, is especially notable. Like other Khu Bua-related images found throughout Southeast Asia, the Prakhonchai images portray the *bodhisattva* in elaborate, multitiered headdresses. But here the images were typically four-armed, mustached, and attired in a short Khmer-style *sampot*. As with other Mahayana items, however, they did not produce any lasting artistic or iconographic traditions. (Woodward, 1997; Guy, 1995: 48-59)

Seventh-century Vishnu images in the Peninsula style spread from Dong Si Mahaphot to Si Thep, where the Pasak River led to the Mun River, the Khorat Plateau, and the Mekong. At Si Thep, some Peninsula styles mixed with traditional Dvaravati sculpture, while its Vishnus were remarkably unique. These images are distinguished by a graceful triple flexing of the tall and slender body (*tribhanga*), and clothing consists of a scanty loin cloth, or *sampot* rather than the Indian *dhoti*. By now Si Thep had access to a plethora of artistic sources, ranging from the Mekong region to India. Each area may have played a role in the creation of the Si Thep style (Boisselier, 1975: 105; Woodward, 1983:

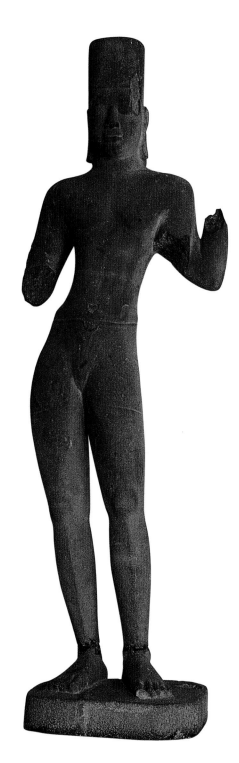

Seventh-eighth-century Vishnu image from Si Thep. While clearly resembling Peninsula Vishnu images, the Si Thep images are distinctive in the triple way of the body and Khmer-style sampot. *(Bangkok National Museum)*

379). Still, the images are so distinctly animated, moving so dramatically in space that traditional postures appear to have been abandoned (Dofflemyer, 1999: 43-46), and although Peninsula images provided obvious prototypes, as local sensibilities developed, there appears to have been less imperative to adhere to prescriptive canons.

Occasionally, Hindu and Buddhist iconographic types were mixed. Just south of Si Thep, at Phra Ngam Cave, a relief dating from sometime between the sixth and eighth centuries showed a *pralambapadasana* image in *vitarka mudra* accompanied by a four-armed Vishnu, the Hindu god Shiva, and a *rsi*, or brahman priest (Brown, 1996, 30-1; Woodward, 1975: 18-19).

While southern intrusions through the Dvaravati periphery and onto the Plateau distinguished the art of the outlying areas from that of the Dvaravati heartland, eventually differences between the center and the peripheral areas would be much less notable. In the tenth and eleventh centuries, Khmer intrusions, which had occurred sporadically since the seventh century, would eventually dramatically alter the art of the Plateau, the Dvaravati periphery, and the Dvaravati heartland itself. The Central Plains, which for half a millennium had remained self-contained and resistant to the multicultural forces that surrounded it, would no longer retain its long-established, ingrained traditions.

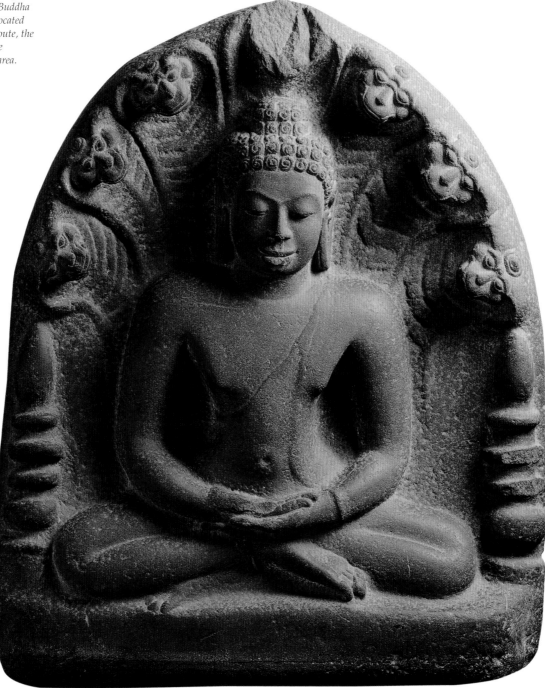

Left: *Low relief, Phra Ngam cave showing a Dvaravati-style* pralambapadasana *Buddha image flanked by Shiva and Vishnu. Located along the Dong Si Mahapot-Si Thep route, the Phra Ngam life-sized figures reflect the multicultural art typical of the Pasak area.*

Seventh-eighth-century stone relief showing the Buddha protected by a seven-headed naga. *Naga-protected images of the Buddha were but one of many iconographic types found in the Dong Si Mahapot area, but one that would become paramount in eleventh- and twelfth-century Plateau art. (Bangkok National Museum)*

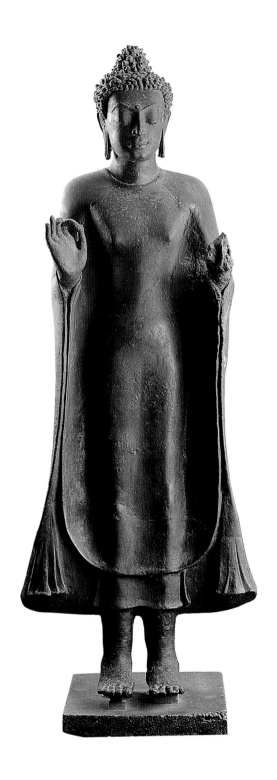

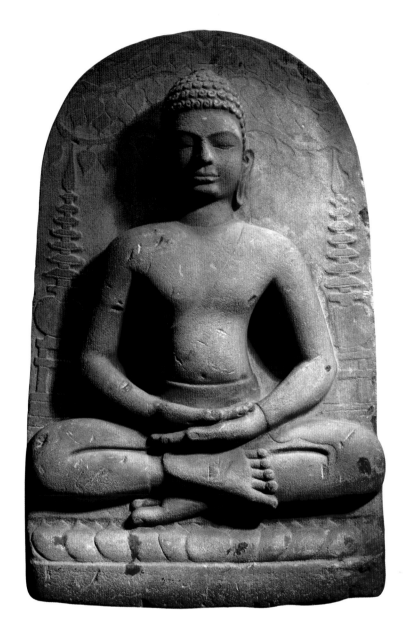

Seventh-century Buddhist art from the Dong Si Mahaphot area and western Plateau reflecting its wide array of multicultural connections. A dharmacakra *(above, right) (Prachinburi Museum) evidences a strong Dvaravati presence, and although sources for the relief of the seated image (above) (Prachinburi Museum) are obscure, the design of the stupas flanking the image suggests Dvaravati antecedents, as does the standing Buddha in double* vitarka mudra *(left) found on the southwestern Plateau. (Bangkok National Museum)*

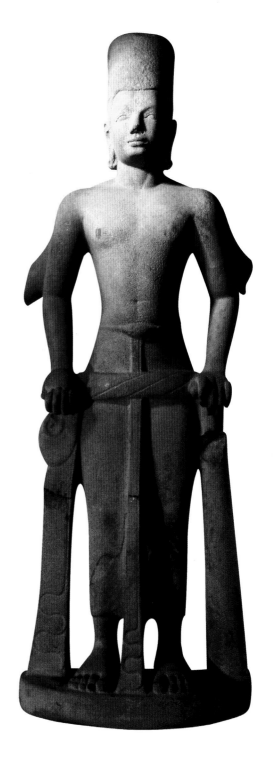

Right and above: *Hindu images from the Dong Si Mahaphot area reflecting Peninsula prototypes, a Shiva-linga and a Peninsula-style Vishnu image. (Both from the Prachinburi National Museum)*

CHAPTER SEVEN

Khmer and Dvaravati-related Art on the Khorat Plateau, Seventh to Ninth Century AD

By the late sixth century AD, Khmer-speaking chieftains from the Lower Mekong region of what is now Cambodia were beginning to establish a political presence on the southeastern part of the Khorat Plateau. This was a time when Mon chieftains were forming network alliances in the Central Plains, and a half century or so before Dvaravati's *dharmacakrastambha* would be installed to mark its major chiefdom centers. During the next six hundred years, the Khmer would make intermittent encroachments of varying degrees of intensity into the land that is now Thailand, and many Khmer would become permanent residents of both the Plateau and the Central Plains. At times the Khmer – both the foreigners with a home base in the Mekong region and those who had taken up residence in what had previously been primarily Mon territories – would dominate much of Mainland Southeast Asia. The Khmer – both foreign and local – would also make enormous contributions to Thailand's art and culture. In spite of their centuries of cross-cultural intermingling, Khmer and Mon cultural traditions would remain dramatically distinct, a reflection of fundamental idiosyncratic, unblendable poltico-religious ideologies. In order to understand the Khmer's role in formulating art styles in both Tai and pre-Tai Thailand, we must approach matters from both the Mon and the Khmer perspectives.

In the beginning, the Khmer and the Mon had not been so different from one another. Both had arrived in Southeast Asia in prehistoric times from southern China with a common language, and in the latter centuries BC, after they had become linguistically distinct, both Mon and Khmer communities began to cluster in small chiefdoms in western Mainland Southeast Asia that over time coalesced into

widespread networks like those in the Central Plains. Moreover, by the early centuries AD, U Thong (in the Central Plains) and Oc Eo (in the Mekong delta) were receiving a few similar overseas objects that inspired a scattering of local reproductions (Chapter 3). Based on this evidence, historians have sometimes, mistakenly, considered the Mekong region and the Central Plains to have been politically unified (Wales, 1969: 1-2).

In spite of some overseas contacts in common, however, major lines of communication connected the Mekong region and the Central Plains with foreign lands that were located in opposite directions. These disparate contacts steered the Mon and the Khmer along dramatically different paths, both culturally and artistically. While the Chao Phraya River, provided access only to undeveloped territories, the Mekong was a route to China, and judging from Bronze Period imports along the Mekong (Chapter 2), communication between the Upper and Lower Mekong regions over the centuries continued. From the early centuries AD, eastern Mainland Southeast Asia had numerous contacts with China via the South China Sea, and beginning in the third century AD there were intermittent Khmer diplomatic missions to the Chinese courts (Mabbett and Chandler, 1995: 74).

Above: *Fragment of a lintel in seventh-century Cambodian style. This piece is indicative of strong Khmer influence in Thailand's coastal area, most likely reached by sea. Lintels depicting facing* makara *spewing a variety of objects is an Indian motif that was adopted by the Khmer. (Bangkok National Museum)*

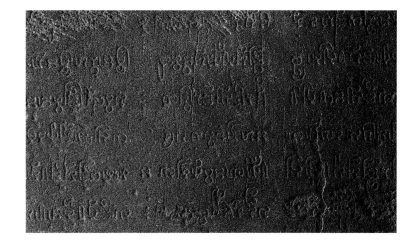

Fragment of an inscription from Prasat Khao Noi on the southern Khorat Plateau, dated to 637. Inscriptions such as this one, written in Khmer and Sanskrit in a south Indian Pallava script, were an important means by which Khmers in the seventh century established their territorial rights. (Bangkok National Museum)

Connections between the Khmer and their neighbors in China are not difficult to identify. Early on, both the Chinese and Khmer had established elitist status based upon genealogical lists that traced their rulers' links to ancient venerated ancestors, both real and mythological (Wechsler, 1985: 123-6; Vickery, 1998: 70). And both Chinese and Khmer deities included earth and territorial spirits, whom the ruling elite propitiated in order to secure the fecundity of the soil and the prosperity of their chiefdoms. For both the Chinese and the Khmer, mountains were thought to be the abode of the lands' most powerful spirits, offering political legitimation to the rulers who had claim to the surrounding territories (Hall, 1985: 138; Wechsler, 1985: 172-4, 190; Mabbett and Chandler, 1995: 109-10). Mountains were so important to the Khmer that it has been suggested that the name of one of their earliest chiefdom networks, Funan, may have been derived from *banam*, the Khmer word for mountain (Coedès, 1952: 3; Vickery, 1998: 36).

During the latter part of the first millennium AD, similarities between Chinese and Khmer traditions would persist. Unlike India, China had developed an architectural symbolism based on the rectangle rather than the circular shape that characterized early Indian stupas. A square mound symbolized the earth, rectangular altars marked the abodes of the gods, and the 'rigid, finite, and unnatural [rectangular] design' determined the layout of Chinese imperial cities (Wu, 1963: 11, 29-30). Thus, Chinese cities became artificially contrived geometric, man-centered and man-ordered earthly microcosms and as such, contrasted with the irregularly shaped circular or oval cities such as those found in India, the Central Plains, and the Khorat Plateau. As we shall see in the next chapter, the Khmer, like the Chinese, would build precisely measured rectangular cities centered on mammoth square pyramidal structures that linked the terrestrial world of man with that of the gods (Coedès, 1952: 17-21). By then, however, ancient traditions would be reinterpreted according to Indian concepts, and the pre-Indian world and its Chinese associations would one day be largely forgotten.

As in the Central Plains, Indian thought had begun to reach the Lower Mekong region in the early centuries AD, and in both instances, South India appears to have been the major point of dispersal. Different paths of access, however, led to very unlike results. While the Mon in the Central Plains early on had direct communication across the Bay of Bengal (or less directly via the Myanmar coast) with south India and *sthaviravada* Buddhism, Indic traditions, reached the Lower Mekong region primarily via the Hinduized Thai Peninsula (Hall, 1985: 67-8, 70). Although elements of Buddhist thought would persist in varying degrees throughout Khmer history, it was Hinduism that became fundamental to its belief system. Hindu beliefs blended with the old pre-Indian Khmer elements and resulted in an amalgamation of the traditional and the imported that the conservative Buddhist tenets of the Plains did not allow.

Over time the Indic traditions began to produce a veneer that largely obscured the indigenous layer of beliefs. A Pallava script derived from Indian sources enabled the old oral Khmer genealogies to be put into writing (Vickery, 1998: 55), and royal genealogies were revised to include an Indian ancestor: from prehistoric times, Khmer serpent deities had been propitiated to insure the land's prosperity, but now (according to first-century Chinese accounts), Khmer rulers traced

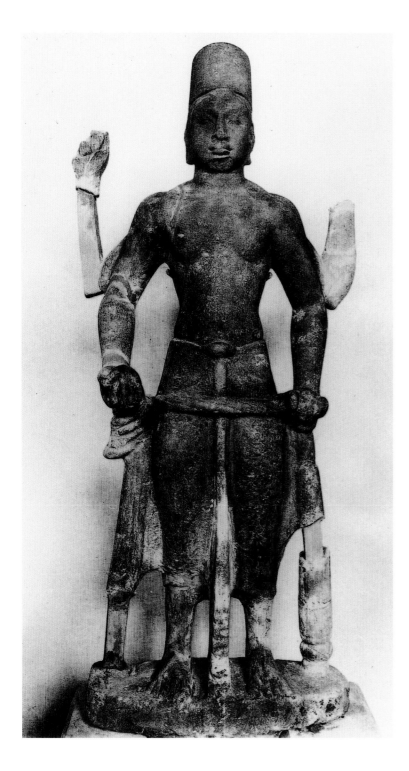

Late seventh-century Cambodian image of Vishnu in the Dong Si Mahaphot tradition. The exceptionally wide shoulders and the pronounced musculature of the torso result in an architectonic quality typical of Cambodia images. (Ars Asiatica, 1931)

their origins to the marriage of a *naga* princess and a visiting brahman priest (Coedès, 1952: 2-3; Hall, 1985: 49-50; Mabbett and Chandler, 1995: 70). Sanctioned by Brahmanical ritual, Khmer chieftains adopted the names of Indian gods that were linked to the suffix *-isvara*, a Khmer word meaning 'ruler' (Vickery, 1998: 140-9, 170).) In stark contrast to Dvaravati's brief royal inscriptions inscribed on medals that referred only to unnamed 'lord[s] of Dvaravati', Khmer inscriptions recorded not only the name of the ruler and his forbears, but linked him to the gods as well.

Khmer gods were soon provided new identities with Hindu names and characteristics. By the late sixth century the Khmer in the Lower Mekong region were producing fine Hindu images similar to those that were being made on the Peninsula. Images of Vishnu, like their Peninsula prototypes, were monumental, powerful, and hieratic and were adorned with the same tall mitered headdresses. Like local gods who had been amalgamated and transformed into Hindu deities, Vishnu was sometimes combined with Shiva to form composite images known as Harihara. And it was Shiva more than any of the other Indian gods who blended most intimately with the Khmer's ancient customs and beliefs. In India, Shiva was thought to have controlled the cosmological universe from his abode on the lofty mountain Kailasa, and mountains for the Khmers were already sacred. Now, a few local hills and mountains were equated with Shiva's Mount Kailasa, or alternately, with Mount Meru, in both Buddhist and Hindu thought the cosmological center of the universe.

The amalgamation of old with the new and the indigenous with the foreign provided Khmer chieftains who identified with the Indian gods enough political power to expand their territories in the

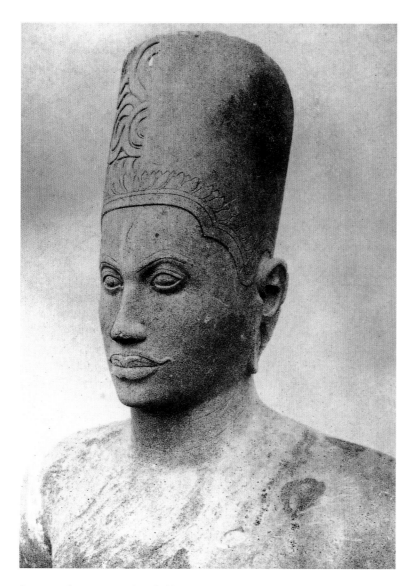

Late seventh-century Harihara (half Vishnu-half Shiva) from Prasat Andet, Cambodia. The dual identity of the image is indicated by the miter-like hat which shows Shiva's matted hair on the left side, but is plain on the right half. (Musée Albert Sarraut Photo)

Above right: Seventh-century head of Harihara found in Thailand near the Gulf of Thailand. In Thailand, although Shiva and Vishnu were sometimes venerated in the same temple, they were more commonly treated as two separate deities. (Prachinburi National Museum)

direction of the Central Plains. Sometime in the 590s perhaps, a Khmer chieftain named Bhavavarman, whose homeland was the Tonle Sap (Great Lake) area of the Lower Mekong region, erected a stone pillar on the northern rim of the Dangrek mountain range, which borders the southern edge of the Khorat Plateau, and in doing so announced himself ruler of the surrounding lands (Coedès, 1968: 68-9; Vickery, 1998: 21-22). The upright stone was not a rough-hewn menhir like the hundreds of megaliths that dotted the Plateau (Chapter 2), nor was it a *stambha* to support a *dharmacakra* like those that would be erected in Dvaravati territories in the next century (Chapter 4). Instead, the pillar was a linga, phallic symbol of Shiva, similar to those that had been produced on the Peninsula (Chapter 6). Linga, like other aspects of Hindu culture, blended with older beliefs. The Chinese had once planted trees representing important earth gods atop a square mounds to mark royal territorial rights (Coedès, 1952: 17-18), and now the Khmer installed linga on high places that were deemed sacred. However, these altars represented not a local tutelary deity but the center of the universe. Thus, the earthly and heavenly realms were identified; as Shiva ruled the cosmic world, so Khmer rulers ruled their earthly realms (Hall, 1985: 53, 276, n. 49).

By the seventh century the Khmer had begun to build temples to house their Shiva and Vishnu images, their linga, and their inscriptions. Even more than the movable objects, the temples played a central role in identifying major Khmer political settlements. The temples with their attendant brahmans and caretakers not only established economic centers that helped unify the surrounding areas but were highly visible monuments that marked the political centers symbolically (Hall, 1985: 136-7). Representing the sacred mountain of the gods, the Khmer

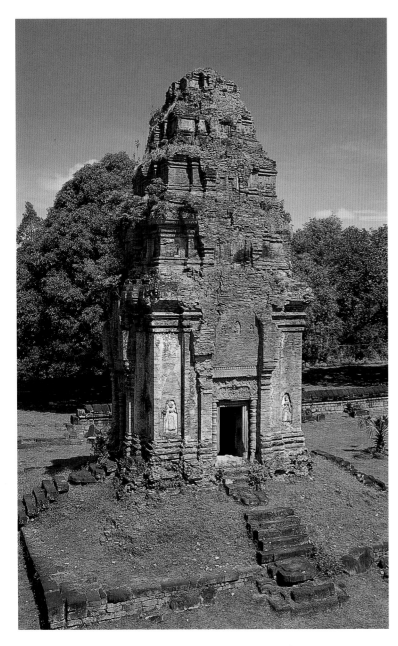

Bakong temple, Angkor, late ninth century. The Bakong is typical of early Khmer temples in which the doorway is situated at ground level rather than being elevated on a high sub-base. The cubicle shaped cella is surmounted by a tall mountain-like sikhara, *each conceived as an individual component. In later centuries these two elements would flow together in a more unified form.*

temples proclaimed the close connection between the natural universe, the supernatural world of the gods, and the earthly rulers who were intimately associated with their cosmic counterparts.

Unlike other aspects of Khmer culture, the temple design itself owed nothing to Chinese- or Peninsula-related concepts and only secondarily to local tradition. Instead, the earliest Khmer temples exhibited direct connection with India that bypassed the Peninsula and the Plains. Many theories have been proposed as to how Indian architectural designs were introduced to the Mekong region, and like theories that have been proposed for the introduction of Indian art into the Central Plains (Chapter 3), visiting brahmans or 'waves' of Indian settlers are often credited. Michael Vickery, however, has proposed that in the seventh century the Khmer were making journeys to India to study the ways of court officials, scribes, and architects and returned home with temple plans that inspired local builders (1998: 59). As suggested above (Chapter 4) it was during this same period that Dvaravati Buddhists, perhaps in response to Khmer intervention in the Central Plains, were traveling to India to reinforce their Buddhist traditions and apparently the Khmer were similarly motivated. As might be expected, however, the Mon and the Khmer returned home with very dissimilar Indian architectural concepts to meet their contrasting needs. While the Mon were building stupas and congregation halls, the Khmer concentrated on image houses. And while the Mon selected the *dharmacakra* to denote the symbiotic relationship between the lay and religious realms, the Khmer adopted a temple design that symbolized, not reciprocity, but politico-religious identification.

The most essential iconographic feature of the Indian temple was a tall conical roof, or *sikhara*, which according to Indian texts represented Mount Kailasa or Mount Meru. In India, the mountain-like

roof, which consisted of gradually decreasing tiers of layered stones, is thought to have derived from flat-roofed structures on top of which stone slabs of decreasing size were stacked to form a step pyramid (Kramrisch, 1946: 179-82, 189-93, 220-3). By the sixth century, however, pyramidal roofs were being constructed so that there was soaring interior space, and the Khmer adopted the same hollow design. Occasionally, the cella, the central chamber beneath the *sikhara*, was entered through a forechamber (*mandapa*) and a connecting porch (*antarala*), elements that were not considered essential parts of the temple proper in India (Kramrisch, 1946: 254) but which would eventually play significant roles in the development of architecture on the Khorat Plateau and the Central Plains.

There was one innovation in the Khmer temple design that particularly defined a local tradition. The earliest Indian temples, such as the cave temples at Ajanta, had been carved from solid rock, and the rock-cut motifs were later incorporated in the country's free-standing temples. The indigenous architecture of the Khmer, on the other hand, had consisted of simple rectangular huts constructed with upright posts and lateral beams that supported roofs of palm leaves or thatch, and the Indian-inspired temple designs retained some of the old post-and-lintel components. What had once been unobtrusive wooden supports over doorways and windows were transformed in the Indian-related buildings as conspicuous rectangular stone slabs that provided visual focal points above the major entryways of the cella. Not only functional, the lintels provided a fixed, demarcated space that could be filled with elaborate carvings of complexly arranged ornamental and iconographic reliefs. Although the designs in the lintels would vary over the centuries (and would become a major stylistic means by which art historians have been able to date the temples), the lintel itself would remain a constant hallmark of Khmer temple design.

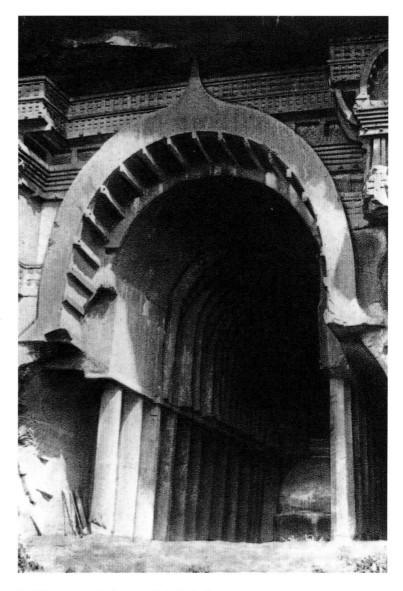

Buddhist cave-temple doorway, Bhaja, India, first century BC. Cut from the rock, early Indian temples were typified by a horseshoe shaped design that followed the curve of the excavation. In contrast, Khmer temples followed earlier wooden post-and-lintel construction in which lintels played an important role. Elaborately carved stone lintels remained a hallmark of Khmer temple design in both Cambodia and Thailand until the thirteenth century. (Benjamin Rowland photo)

Plan of Prasat Khao Noi.

False door on the rear of the temple.

While during the seventh century there may have been many Khmer temples built on the Plateau, all but a few have either been destroyed or rebuilt. Still, two small temples known today as Prasat Khao Noi and Prasat Phumphon, located on the northern slopes of the Dangrek range (west of Bhavavarman's *linga*), have enough surviving parts to give an idea of what others must have looked like. Like the Mekong region's earliest surviving temples, Sambor Prei Kuk and Prei Khmeng (which share seventh-century stylistic motifs with Dvaravati's *dharmacakra*), early Plateau temples were constructed of brick and consisted of three or four small structures, each embodying a cella and *sikhara* grouped casually on either separate or shared platforms. The buildings were entered from a single entrance on the eastern side, and at Prasat Khao Noi, the *mandapa*, which provided entry from the hillside passageway, was a conspicuous feature (Woodward, 1975: 24; Smitthi and Moore, 1992: 79-83). Hillside approaches and *mandapa* would become important features in later Khmer buildings that are attributable to a Plateau rather than a Mekong architectural tradition.

Lintels in these early temple areas, like those in the Mekong region, were elaborate and beautifully carved. A number of Hindu gods were represented: Shiva and Vishnu as well as numerous minor deities. Appealing to local Plateau sensitivities, which might not be well attuned to Hindu iconography, *makara*, crocodile-like creatures akin to

Opposite: One of three structures at Prasat Khao Noi that were built on a hill on the southern edge of the Khorat Plateau, seventh century. The temple's ground plan, construction of brick, false doorways, lintel designs, and hillside location are all typical of early Khmer-style architecture both in Cambodia and on the Khorat Plateau.

Prasat Khao Noi can be dated from its fine lintels, which mirror those used on the Sambor Prei Kuk and Prei Khmeng temples in the lower Mekong region of Cambodia (early and late seventh century, respectively). In these pieces the lintel is typified by a wide horizontal band punctuated by three or five medallions. The band may be flanked by facing makara, minor deities, or auspicious animals while multiple beaded garlands interspersed with ornate pendants fall below. (Prachinburi National Museum)

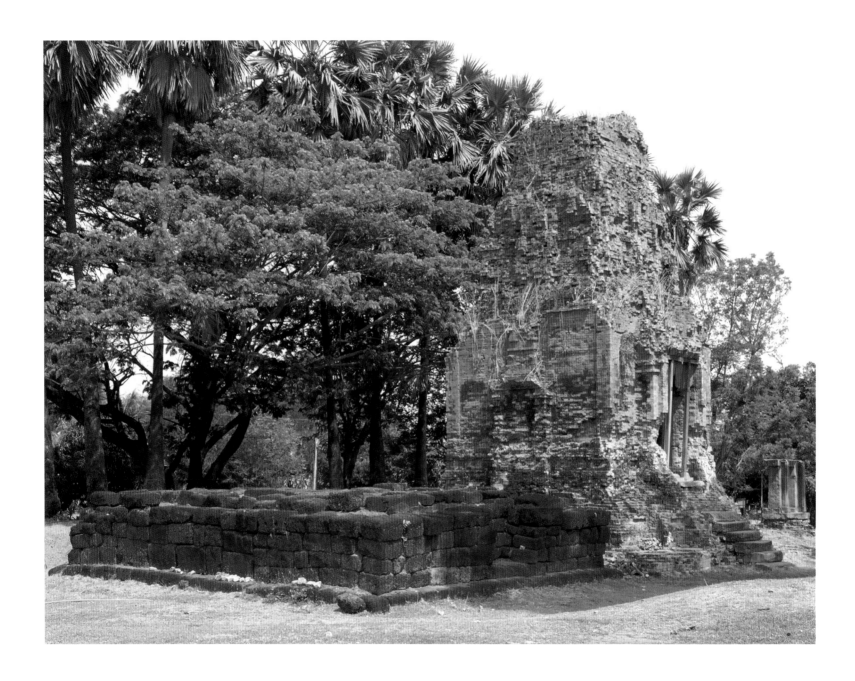

the *naga*, were important features, as were elephants and horses. In India (and later in Khmer art) animals such as these would serve as *vahana*, or vehicles of the gods, but here the animals were accorded an importance all their own (Higham and Rachanie, 1998: 192-3).

In the centuries following the introduction of Khmer architecture on the Plateau, Khmer expansion towards Western Southeast Asia continued. Between the seventh and ninth centuries, there was a concentration of Khmer inscriptions in the Upper Mun area, and eventually, there were many more inscriptions, written in either vernacular Khmer or in Sanskrit, scattered over the Plateau as well as a few in the Lower Central Plains (Higham and Rachanie, 1998: 194). At Si Thep, where five *dharmacakra* would later identify it as a Dvaravati constituent, Khmer inscriptions recorded the installation of Shiva-linga located in the east. As we have seen, for a brief time at least, there appears to have been Khmer rule at U Thong, in the Dvaravati heartland (Chapter 5).

The Khmer's westward expansion in the seventh century was sporadic and disconnected, however, and the Plateau was not totally theirs. In the eighth and ninth centuries, we find Dvaravati-related settlements in various areas. Some of the old round settlements such as Muang Sima (Chapter 2) were enlarged Dvaravati-style with the addition of peripheral moats rather than concentric rings that had been traditional. And although there were no *dharmacakrastambha* erected farther east than the Upper Mun area, several Mon inscriptions suggest

Above: *The design of a damaged Prasat Phumphon lintel with three medallions clearly evidences the temple's seventh-century date. (Surin National Museum)*

Middle: *Plan of Prasat Phumphon.*

Far left: *Prasat Phumphon, seventh century. Located on the southern Khorat Plateau. Prasat Phumphon shares attributes of early Khmer temple design with Prasat Khao Noi.*

that Dvaravati influence was considerable in the eastern Plateau, far into Khmer territories, where *dharmacakra* were sometimes carved in low relief on metal plaques, votive tablets, and ancient menhirs.

One important Dvaravati-related settlement was Muang Fa Daed, located on the Chi River. Muang Fa Daed originally had been an Iron Period site that was, over the centuries, enlarged by means of concentric moats. Sometime during the latter part of the first millennium AD, however, it became home to more than a dozen Dvaravati-style brick or laterite stupas and assembly halls. Roughly hewn menhirs were relocated and established as *sima* (boundary stones) to demarcate the environs of Buddhist temples, and others were re-carved with scenes from the *jataka*. At nearby Kantarawichai, sixty six silver plaques embossed with Dvaravati themes – images of the Buddha, *dharmacakra*, and stupas – were buried beneath a building sometimes identified as a Buddhist ordination hall (Piriya, 1974; No Na Paknam, 1981; Higham, 1989; Brown, 1996; Higham & Rachanie, 1998).

Illustrations of stupas embossed on silver plaques from Kantarawichai. Although these are highly fanciful renditions, they appear to have derived from stupas built in the Dvaravati heartland.

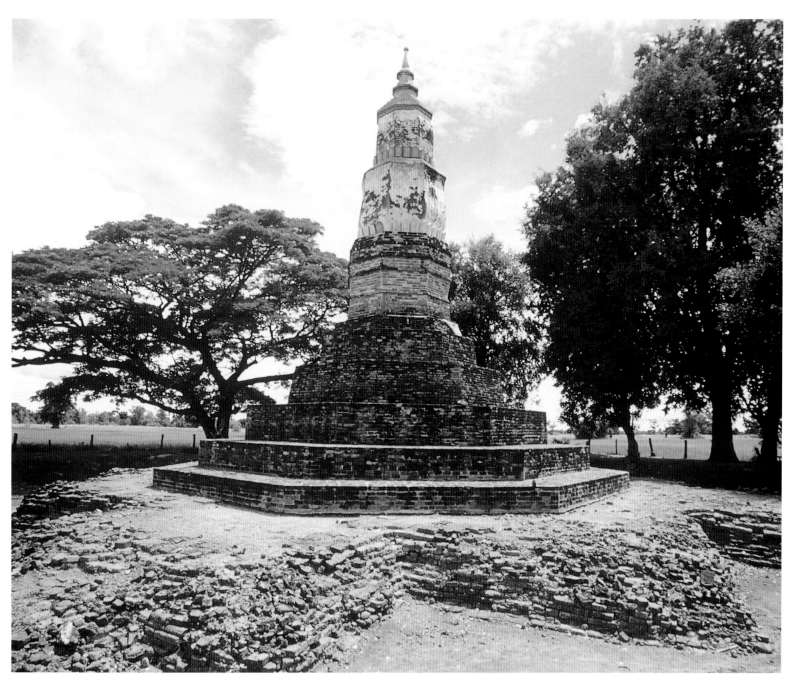

Phra That Ya Khu, a stupa at Muang Fa Daed. Before its
restoration, it had a redented base similar to ones at U Thong and
Nakhon Pathom.

Stucco reliefs that surround the Khao Khlang Nai stupa, Si Thep, seventh-eighth century. Although the stupa and its reliefs were overshadowed by monuments built during much later times, they retained a central position in the old section of the city.

In the long run, however, the Khmer presence on the Plateau would prove much more consequential than that of the Mon. Although Muang Fa Daed was apparently a settlement of some importance, its isolated location did not lend itself to further political expansion. The Khmers, on the other hand, would soon be moving strategically towards the Central Plains and the important centers in the Dvaravati chiefdom network. While the Dvaravati presence on the Plateau was short-lived and would one day be all but forgotten, the Khmer conquests on the western Plateau and in the Central Plains would make a lasting effect on Thai history, Thai culture, and Thai art.

That expansion was largely the result of new developments in the Tonle Sap area. Early in the ninth century, Khmer rulers were able to establish a strongly centralized rule in that area, and what had once been a conglomerate of chiefdoms and subchiefdoms became fused in what would become a powerful empire with its religious and political seat at Angkor, located at the northern tip of the Great Lake. More than ever before, Hindu temples played a major role in the establishment of centralized political control. By the tenth century it had become traditional for each of Angkor's kings to build a monumental temple at the center of his own royal city. In doing so, the king not only sealed his divine relationship with the central Hindu image to whom the temple was dedicated, but conspicuously identified the site of the temple as the politico-religious center of the Angkorean kingdom. While Dvaravati Buddhists, who venerated the historical Buddha as one to be emulated, not identified with, were building most of their temples outside the city moats (Woodward, 1975: 9), defining the center had become central to the Khmer's politico-religious ideology.

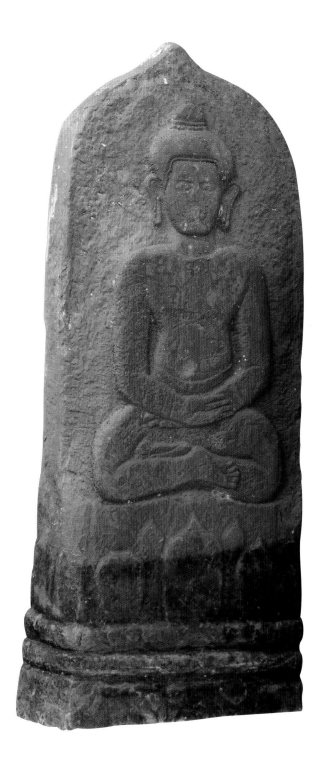

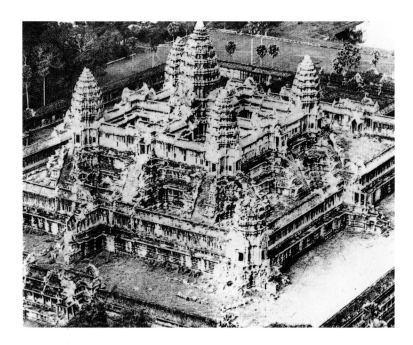

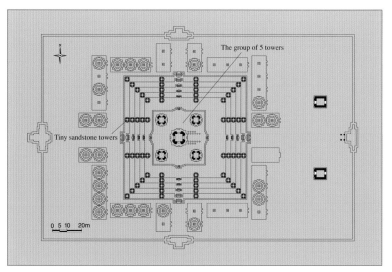

The mountain symbolism that had been expressed earlier in small, isolated structures built on the summits of natural hills was enhanced in magnificent edifices that were built on flat land and combined mountain and temple within one single enormous man-made monument. These 'temple-mountains' took the form of stepped pyramids, the summit of which was sometimes crowned, not by a single cella and *sikhara*, but a quincunx of towers that represented the five peaks of Mount Meru. Surrounding the temple-mountain were concentric walls, galleries, and moats that symbolized the ranges and oceans that were thought cosmically to encircle the sacred mountain.

Unlike the small pre-Angkorean temples that had been approached from one side of a natural hill, the centric arrangement of Angkor's temples was emphasized by four antechambers that surrounded the cella and *sikhara*, and large gates, one on each side of the walled enclosure, led to ceremonious stairways that converged at the summit. The temple-mountains, the royal cities in which they were located, and the Angkorean kingdom were royal microcosms of the mythological world from which gods ruled the universe (Heine-Geldern, 1956; Coedès, 1963: 39-46; Boisselier, 1966: 53-6, 62-5).

Angkor's temple-mountains surpassed in size and complexity anything that had been built previously in Mainland Southeast Asia, and during the last centuries of the first millennium when building was intensive, there was little Khmer construction on the Khorat Plateau. By the tenth century, however, when Angkor was powerful enough to extend its rule over most of the Plateau and establish a significant presence in the Lower Central Plains, building outside the Mekong region resumed. During the next few centuries well over three hundred Khmer-style temples would be built on the Plateau (Smitthi and Moore, 1992: 77). Many were small, not very different from those built in pre-Angkorean days, but a few of the larger and more important ones rivaled Angkor's in their grandeur and iconographic complexity. Those magnificent structures would embody significant architectural and iconographic elements that derived from local Plateau initiatives as well as Angkorean. While Mekong precedents are obvious in Plateau Khmer architecture, some significant local features would soon be incorporated in Angkorean buildings such as twelfth-century Angkor Wat. As we shall see, the Plateau-style architectural motifs and iconographies would play an even greater role in the establishment of architectural styles that persist in Thailand until the present day.

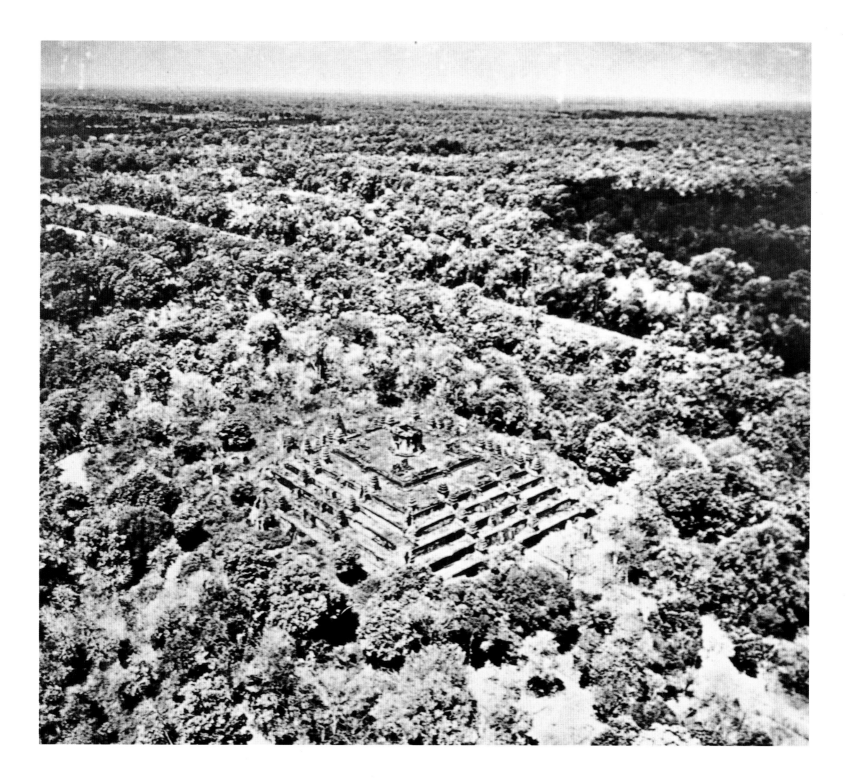

Khmer Art on the Khorat Plateau – Tenth to Twelfth Century AD

Sanskrit inscription from Prasat Bo E-ka, in the Upper Mun area of the Khorat Plateau, dated perhaps to 868. The inscription records the establishment of a linga, foretelling the establishment of important Khmer-style Hindu temples in the area. (Phimai National Museum)

When Angkor once again extended its political control westward, it established outposts in Plateau communities that had previously gained prominence because of their favorable situation along the trade routes connecting the Lower Mekong region and the Central Plains. Now, in the tenth century, these ancient communities acquired Khmer-style temples and along with them political and religious prestige unlike anything they had previously known. Plateau and Angkorean styles and iconographies intermingled, reflecting both local Khmer traditions and remarkable artistic and iconographic contributions from Angkor.

The Upper Mun area, which was pivotally located on Mainland Southeast Asia's east-west and north-south trade routes, was a likely target for Angkorean expansion. As we have seen (Chapters 2, 4, 6, 7), the Upper Mun had been settled during the early centuries of the first millennium BC and was the site of some of the area's largest and most elaborate Iron Period moated settlements. Its distinctively polished black pottery and profusion of elaborate bronze jewelry testified to its economic importance (Chapter 2). As evidenced by several bronze images of the Buddha, stone images of deer, and a *dharmacakra*, Muang Sima was at least for a while, in the seventh century, an important Dvaravati community. And at various times between the sixth and ninth centuries, inscriptions written in Khmer and Sanskrit announced sporadic, limited pre-Angkorean and Angkorean intrusions. It is only to be expected that over the centuries some Khmer had become local residents with allegiance to various chiefdoms located in the western Plateau rather than Angkor.

Thus, there were complex, multi-layered traditions – Plateau and Angkorean Khmer, Mon, Buddhist, and Hindu – on which the Upper Mun relied, and tenth-century Muang Sima's buildings reflected its multicultural roots. Unlike Angkor's temple-mountains, Prasat Bo E-ka, located at the center of Muang Sima, was Mahayana Buddhist (Higham and Rachanie, 1998: 195), while small temples such as Prasat Hin Muang Khaek and Prasat Non Ku, a few kilometers east of Muang Sima, were dedicated to Shiva or Vishnu (Manit, 1962: 14-17; Smitthi and Moore, 1992: 87-97, 329-30). Like both Dvaravati and early Mekong and Plateau Khmer temples, tenth-century temples were built of brick, and the temples proper consisted of a single cella and *sikhara* rather than a quincunx of towers, which was the norm for important temples at Angkor. Orientation was linear rather than concentric, but Angkorean attributes in the Upper Mun Hindu temples are also obvious. A surrounding moat could create the impression of a centric temple layout, and the temples were built on flat land rather than on hilltops.

Prasat Hin Muang Khaek's beautifully executed Saivite lintels reflected ninth- and tenth-century Angkorean prototypes while others resembled lintels at Koh Ker, a Mekong region site which in the tenth century had for a while replaced Angkor as the political and religious capital of the expanding Khmer empire. There appears to have been little, if any, three-dimensional Khmer sculpture produced on the Plateau during this period. But a few fine examples of stone Hindu images dating from various periods were acquired from the Mekong region and installed at various sites. There were a number of imported images at the Upper Mun site of Phnom Rung, which will be considered in more detail below.

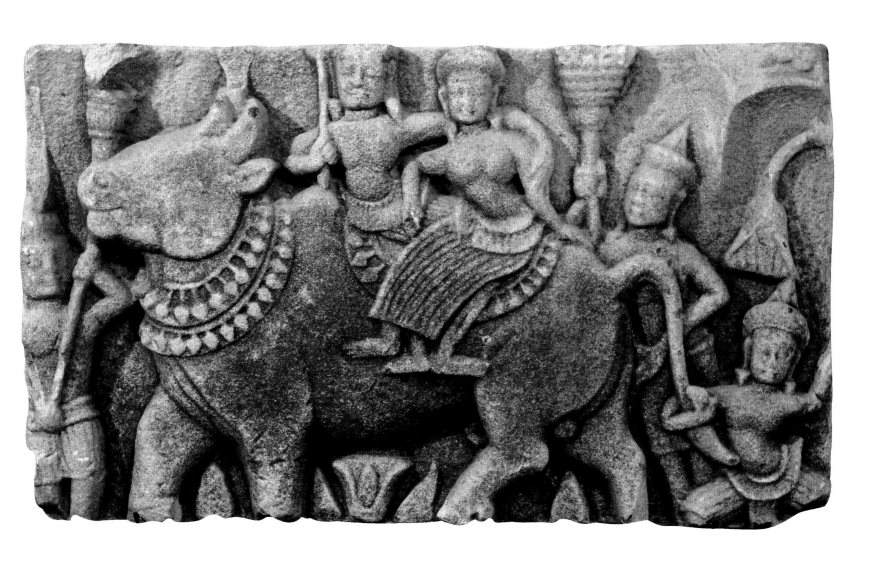

Fragment of a carving from Prasat Hin Muang Khaek, an important Hindu temple in the Upper Mun area, tenth century. The carving depicts Shiva and his consort, Uma, riding on a bull. (Phimai National Museum)

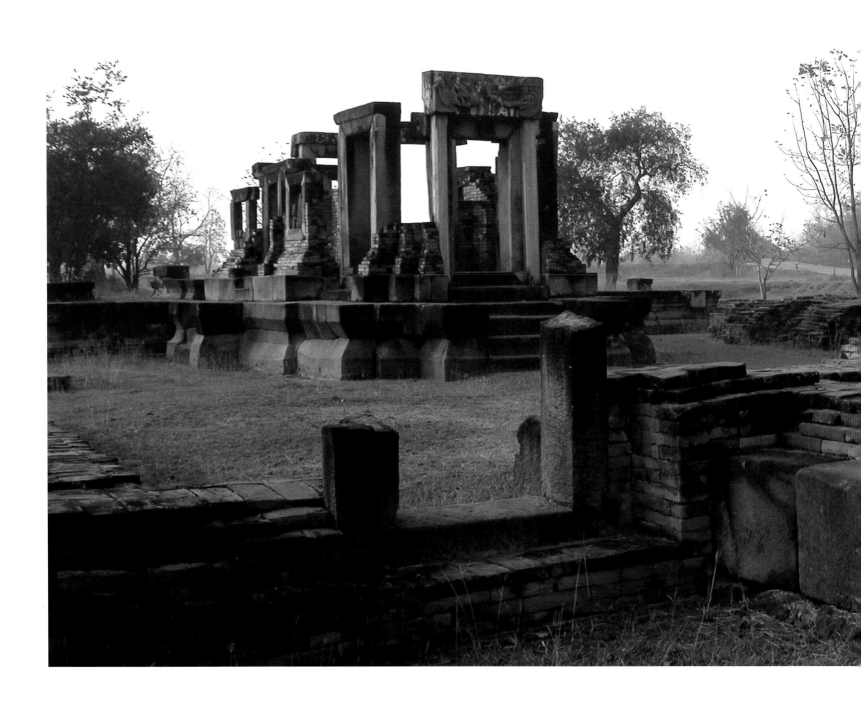

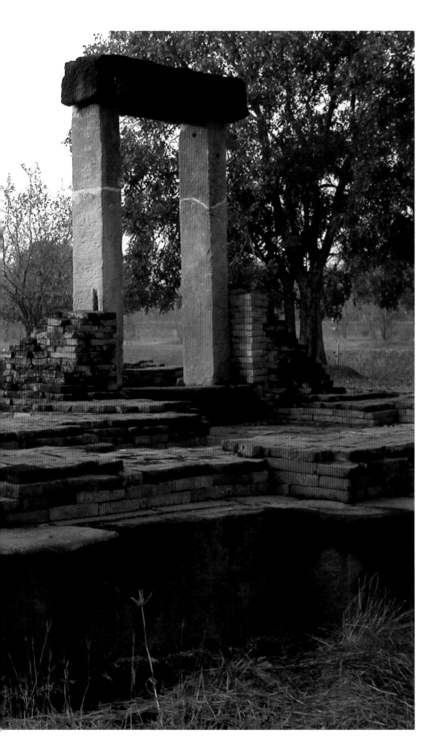

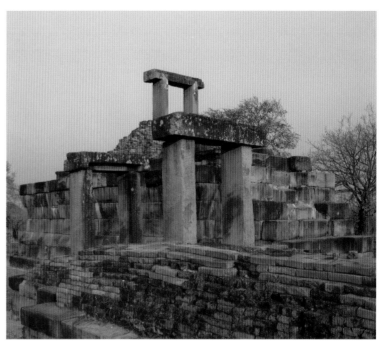

Left: *Prasat Hin Muang Khaek, Upper Mun area. Sandstone, which can be finely carved has now replaced the brick construction of earlier Khmer-style temples.*

Above: *Prasat Non Ku, Upper Mun area, tenth century. This brick and sandstone temple follows the earlier Plateau linear tradition of temple design and is situated on a hill, as shown in the ground plan below.*

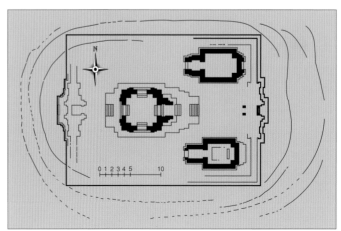

The Indian god Indra is mounted on his multi-headed elephant, Erawan, an icon which a millennium later, would become the official emblem of Thailand's present-day capital. The lintel below shows an unidentified deity and at right there is depiction of Vishnu and seated ascetics. (Phimai National Museum)

Opposite: The central portion of a lintel from Muang Khaek shows the three steps of Vishnu when he crossed the ocean represented by small fish. Along the top is a row of praying ascetics. (Phimai National Museum)

Lintels from Prasat Hin Muang Khaek reflecting the styles of mid-tenth-century temples at Koh Ker and Pre Rup, in Cambodia. Here the precisely spaced row of alternating garlands and pendants that typify seventh-century lintels is replaced with a mass of interconnecting vegetative motifs that all but obscures the structural nature of the lintel. Here, the broad band that emphasized the horizontality of the earlier lintels has become narrower and more ornamental and is sometimes inflected at the center. The row of replicated medallions typical of seventh-century lintels is replaced by one central ovum that may depict any one of a variety of Hindu deities. (Phimai National Museum)

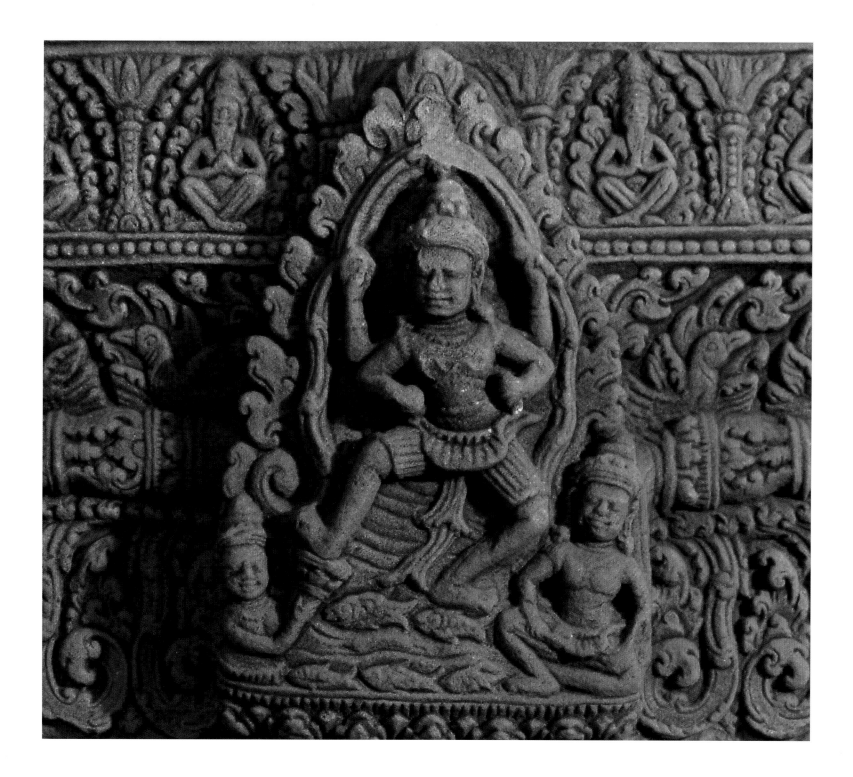

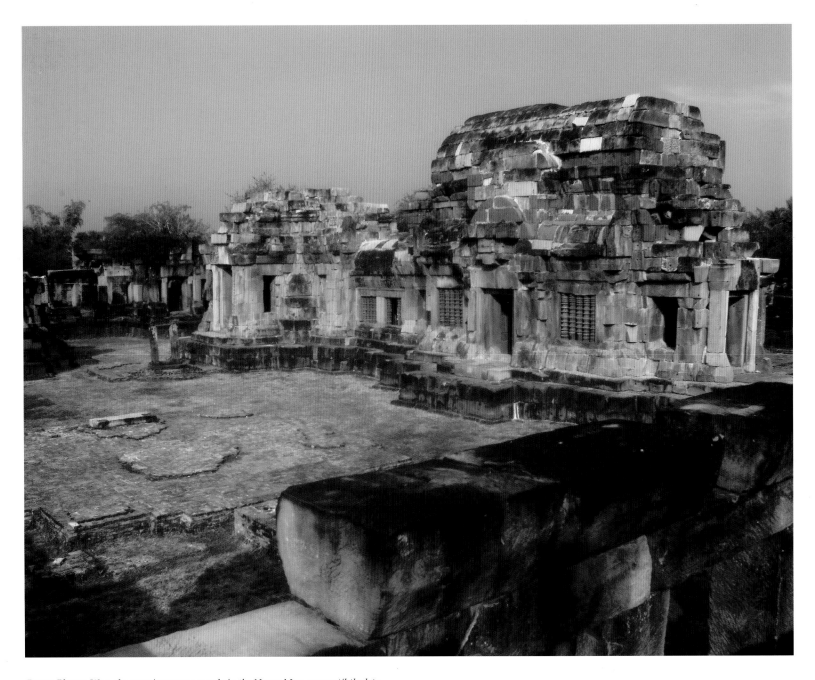

*Prasat Phnom Wan, the most important temple in the Upper Mun area until the late
eleventh century. What must have been a lofty* sikhara *would have once surmounted
the cella, far left. The large* mandapa *at right was connected to the cella by an* antarala,
which marked the center point of the temple complex.

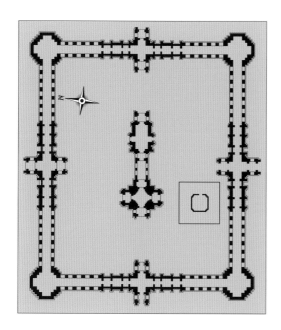

Northern doorway to Prasat Phnom Wan surmounted by an eleventh-century lintel. The angular downward inflection of the bar at the center of the lintel is typical of lintels at Angkor's eleventh-century Baphuon. (Betty Gosling Photo)

Eleventh-century Upper Mun temples are notable for their Angkorean attributes. Prasat Phnom Wan, an important eleventh-century flatland temple located fifty kilometers east of Muang Sima, was constructed entirely of sandstone rather than brick. Four elaborate gateways surmounted by large towers, or *gopura*, marked the cardinal points of a gallery that surrounded the temple courtyard, emphasizing the importance of the topographic and ritual center of the temple complex. Reflecting different stages of building, Prasat Phnom Wan's lintels incorporated Angkorean designs of the ninth, tenth, and eleventh centuries (Manit, 1962: 30-2; Smitthi and Moore, 1992: 103-15). Although Angkor's architectural and iconographic influence was significant, some attributes that derived from pre-Angkorean Plateau architecture survived, and the linear layout mixed with Angkor's concentric one. In spite of its four gateways, the eastern entrance to the Prasat Phnom Wan cella was through a *mandapa* and *antarala*, which vied with the cella and *sikhara* for visual importance. Endowed with elaborately carved balustered windows, the *mandapa* rather than the cella and *sikhara* occupied the center of the complex (Smitthi and Moore, 1992: 103).

Prasat Phnom Wan's linear-cum-centric ground plan would set the stage for future temple building in the region. Soon after its construction, however, significant departures from both the Angkorean

Balustered windows, Prasat Phnom Wan. The red sandstone of the balusters contrasts dramatically with the gray sandstone of the temple proper.

123

Lintel at Prasat Phimai, late eleventh century. The lintel depicts a standing Buddha with hands in double vitarka *(now destroyed). Like Dvaravati double-vitarka images, this one would have symbolized the Buddha preaching.*

and local traditions would have an even greater impact on Thailand's future temple designs. The late eleventh and early twelfth centuries were a time of political disruption at Angkor with several different rulers contending for power, and for a short period the Upper Mun area was ruled by local Khmer free of Angkorean domination. Upper Mun temples built during this period reflected the area's political independence.

In 1080 a local Khmer chieftain, Jayavarman VI, whose homeland was the western Plateau, seized the throne from the Angkorean kings and established what is known today as the Mahidharapura dynasty. Jayavarman VI was unrelated to any known Angkorean royalty, and there is no evidence that he ever resided at Angkor. During Jayavarman VI's reign (until c. 1107) there were no royal temples built at Angkor, while conversely, in the Upper Mun region building was spectacular (Briggs, 1951: 178-9; Coedès, 1968: 152-4; Woodward, 1975: Vol. 1: 61; Woodward, 1983: 48; Smitthi and Moore, 1992: 232; Jacques, 1997: 147-150).

There is no inscriptional evidence to provide details of the brief Mahidharapura period, but architectural remains suggest that Jayavarman VI could only have established his capital at Vimayapura, present-day Phimai, located amidst three branches of the Upper Mun River, thirty-four kilometers northeast of Prasat Phnom Wan. A magnificent temple, Prasat Phimai, was built near the center of the city and is the region's only possible contender for royal temple status. Not only does its design suggest the temple-mountain symbolism of Angkor's royal temples but the predominance of crowned images

depicting conquering and violence seem to reflect a transfer of power from Angkor to the Upper Mun area of the Plateau. If there is any doubt as to Prasat Phimai's architectural and iconographic influence on later royal buildings, one does not have to look far. Its innovative features would be incorporated at Angkor (in Angkor's masterpiece, Angkor Wat) when royal building resumed in the old capital after Mahidharapura's demise, and they would become major features of Thai royal temple design until modern times. Crowned double *vitarka mudra* images have become a hallmark of Thai sculpture.

The city of Phimai, like other sites in the Upper Mun area, had been occupied since the Plateau's Neolithic Period, and in the Bronze and Iron Periods was a major center of pottery production (Chapter 2). But Jayavarman VI's Phimai was nothing like the hundreds of old oval moated communities (such as Noen U-Loke and Muang Sima) that dotted the region. Instead it was a rectangular, walled city that resembled royal cities at Angkor. Prasat Phimai, which must have functioned as the king's royal temple, constructed of sandstone and situated at the center of the northern precinct of the royal city, was approached from a royal landing on the river by way of a ceremonial gateway and a long avenue that bisected the city's southern wall. An elaborate bridge bordered by banisters in the form of *naga* provided access to the temple (Higham and Rachanie, 1998: 198).

Prasat Phimai more than any of the Plateau's previous buildings resembled Angkor's royal temple-mountains. Like Angkor's mid-eleventh-century Baphuon, the temple was situated within both inner and outer courtyards, the outer one delineated by a wall, the inner one

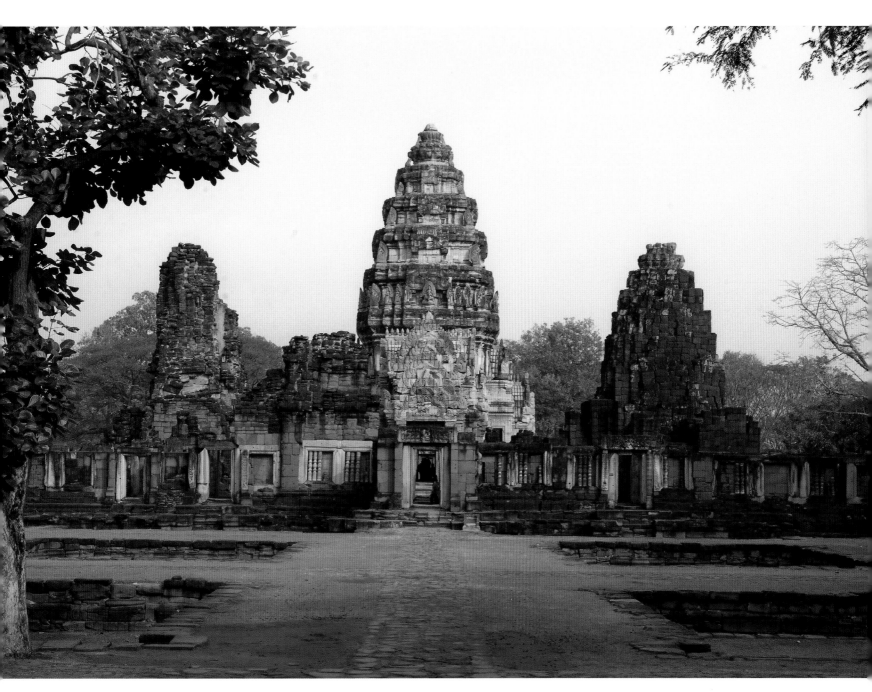

Prasat Phimai, built around 1100. Not only was Phimai the most important temple in the Upper Mun area but in all of Thailand. Many stylistic and iconographic features at Phimai were soon incorporated in many temples in both Thailand and Cambodia.

Section of the naga-*balustrade that led to the entrance of Prasat Phimai.*

Below: *Ground plan of Prasat Phimai, showing the concentric layout that had evolved from Phnom Wan and was the rule for royal temple-mountains at Angkor.*

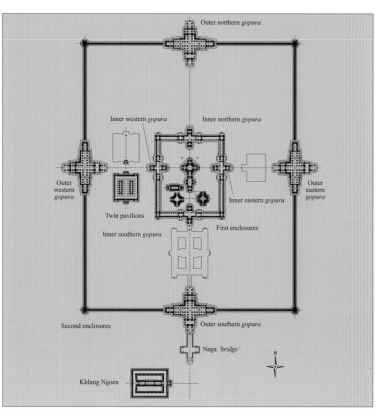

Outer northern *gopura*

Inner western *gopura*

Inner northern *gopura*

Outer western *gopura*

Outer eastern *gopura*

Inner eastern *gopura*

Twin pavilions

First enclosures

Inner southern *gopura*

Second enclosures

Outer southern *gopura*

Naga '*bridge*'

N

Khlang Ngoen

by a pillared gallery. And, although a linear approach to the temple was still acknowledged by means of a *mandapa* and *antarala* through which the cella was entered, they were not as large as Prasat Phnom Wan's.

Porches on four sides of the cella clearly marked it as the temple's ceremonial focal point, and its centricity was reinforced by intersecting avenues that led from four ornate gateways in the surrounding walls. The complex design of the outer gateways announced the importance of the center: surmounted by huge *gopura*, the gatehouses were flanked by elaborate lateral porches that resulted in a cruciform ground plan like that of some Angkorean subsidiary buildings. A grand array of pilasters and richly carved Angkorean style hexagonal pillars flanked the gateways' doors and lintels, and pediments framed with complex double moldings surmounted the lintels on both the gatehouses and the temple proper (Manit, 1962: 38-43; Smitthi and Moore, 1992: 229-66, 335).

Still, while Angkorean concepts were critically important to Prasat Phimai's architectural design, it was its local adaptations that made it especially notable. While Angkor had relied on a quincunx of towers atop a huge pyramidal structures to emphasize the mountain symbolism of its temples, Prasat Phimai's single tower was raised only slightly above the flat land on which it was built and its mountain symbolism was expressed not by a monumental base but by innovations in the cella and *sikhara* themselves. By means of antefixes, the traditionally angular sides of the *sikhara* became gently curved in a mountain-like profile while

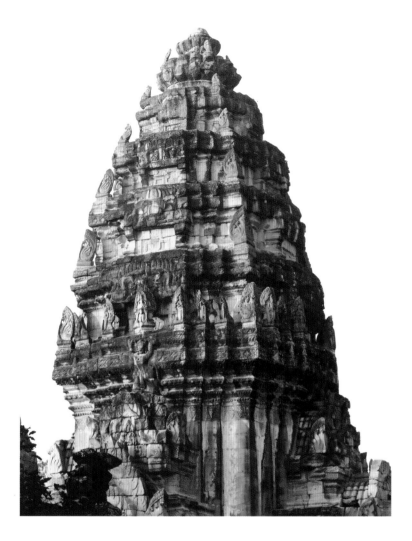

Left: *The* sikhara *portion of the Phimai* prang.

Above: *Antefixes at the corners of the* sikhara *provide a smooth contour that blends with the cella situated beneath it.*

Below: *Ornate base moldings that soar to the tops of the cella doorways support tall vertical redentions, thereby unifying the lower and upper parts of the monument* (overleaf).

at the same time, it gently merged with the square cella beneath it. Soaring vertical redentions ate away the corners of both cella and *sikhara*, emphasizing their verticality, and the elaborate ornamental moldings at the base of the cella were geared to the height of the *sikhara* rather than to the doors of the shrine (Woodward, 1975, Vol. 2: 3). No longer were cella and *sikhara* two juxtaposed entities, but a lofty composite 'cella-*sikhara*' embedded with mountain symbolism. The composite form would become an architectural prototype for future religious buildings, not only on the Plateau, but in the Central Plains and at Angkor. In Thailand the cella-*sikhara* would become even more unified, creating a sleek, bullet-shape known as a *prang*.

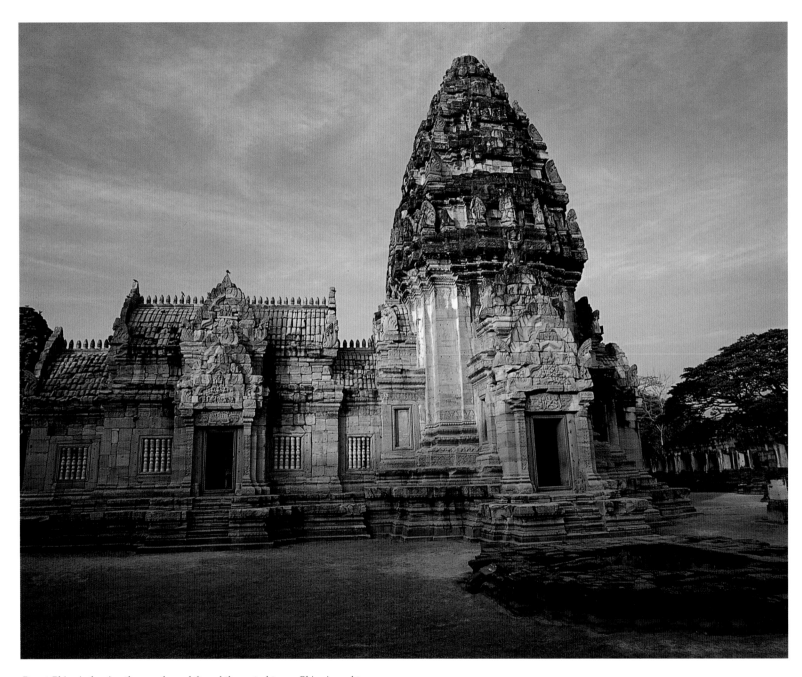

*Prasat Phimai, showing the mandapa, left, and the central tower. Phimai sought
temple-mountain statue not only by unifying the cella and sikhara portions of the
monument but by raising the cella on a high base. Temples embodying Phimai's
innovative features are known today as 'prang'.*

The interior of the Prasat Phimai eastern gopura, *illustrating the mammoth proportions of the sandstone pillars and the importance of internal space in the peripheral structures that led to the* prang.

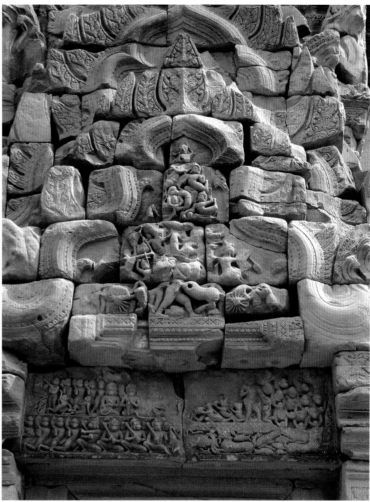

A pediment and lintel carved with scenes of Rama and his troops marching to battle.

The Prasat Phimai prang *rises majestically above its surrounding galleries. Clearly evident are the corner antefixes that provide the* prang *with a smoothly contoured profile. The eastern* gopura *can be seen at the right.*

Relief on a lintel depicting a naga-*protected Buddha. Located above the main entrance to Phimai's* prang, *the relief indicates that a free-standing* naga-*protected Buddha must have been the temple's major image.*

More dramatic than Phimai's architectural innovations were ideological and iconographic changes that marked it as a monument which, though clearly related to Angkor, was in some respects peripheral to the Angkorean mainstream. Although there is no reason to think that Jayavarman VI had abandoned Angkor's god-king tradition, he chose Buddhism rather than Hinduism to support his godlike persona. Buddhism was not entirely new to Angkor. There had been pockets of Sanskritic Buddhism in the Mekong area since pre-Angkorean times, and in the tenth century Buddhist practices of various sorts had been adopted by some of Angkor's high officials (Woodward, 1975, Vol. 1: 32, 43). Not until Jayavarman VI, however, did Buddhism function as the Khmer state religion. Perhaps the selection was due to the lengthy Buddhist tradition in the Upper Mun area, for some of the concepts expressed at Prasat Phimai are not identifiable among Angkor's religious traditions.

According to a Phimai inscription, Jayavarman VI's cosmic counterpart was the Lord Vimaya (from whom the name 'Phimai' derives). Vimaya's origins are not known, and Phimai's central image is no longer in situ. From a meticulous analysis of carvings on the temple's lintels, however, Hiram W. Woodward, Jr., concluded that its central image must have portrayed the Buddha seated beneath the hood of a seven-headed *naga* in a style that would be replicated many times in the late twelfth-century Central Plains (Woodward, 1979: fig. 8). The lintel over the main (southern) entrance to the Phimai cella depicts a *naga*-protected Buddha flanked by adorants, and in another lintel a person apparently of some importance prostrates himself before a *naga*-protected image. In yet another scene a *naga*-protected image is carried in procession. It seems likely, as Woodward has suggested, that the god Vimaya, to whom Phimai was dedicated, and with whom Jayavarman VI identified, was represented by a *naga*-protected image (1975, Vol 1: 56; 1979: 77; 1997: 77-8).

While the identification of a Khmer king with a *naga*-protected image was certainly a break with traditional Angkorean practice, its adoption was not revolutionary. As we have seen (Chapter 7), following a long history in other areas, the *naga* had had special significance in the Lower Mekong region. At Amaravati, Nagar-junakonda, and Sri Lanka, the *naga*-protected image had represented the Buddha sheltered by the *naga*-king Mucalinda as he sat meditating during a rainstorm; and in the eighth century, *naga* images had found their way to the Central Plains and then to the Mekong region (Snellgrove, 1978: 76-7, 82). But, while *naga*-protected images had never become popular in the Central Plains, serpents had been considered

Two lintels depicting multiple crowned Buddhas in double vitarka mudra. *The multiple images are indicative of Mahayana Buddhist beliefs, while the double* vitarka mudra *stems from a much earlier Dvaravati iconography. The dress reflects eleventh-century Angkorean clothing and the crowns provide the Buddha with regal presence not previously encountered. (Phimai National Museum)*

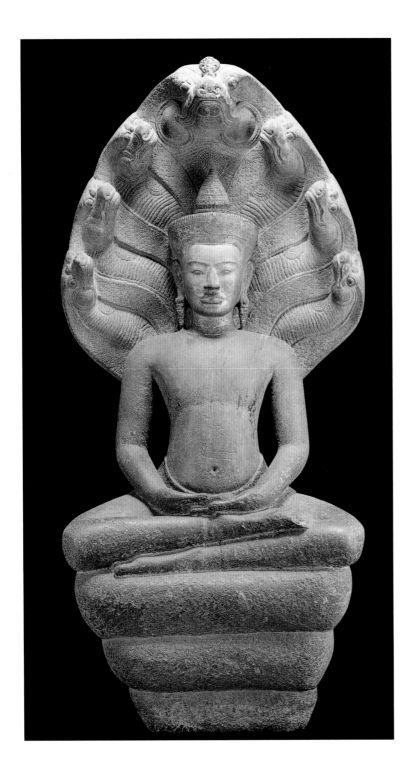

major deities in the Lower Mekong region since pre-Buddhist times. Claim of descent from a serpent had legitimized a king's rule before contacts with India, and by the tenth century, *naga*-protected images of the Buddha had become common. They had appeared many times within a Saivite context in eleventh-century Baphuon reliefs (Boisselier, 1966: 272; Woodward, 1975, Vol. 1: 36, 56; 1997: 71-2).

In spite of its weighty political overtones, however, the meditative, compassionate Buddha, unlike the Hindu gods he had replaced, was not altogether compatible with the powerful image the Khmer god-kings customarily projected. And Jayavarman VI's mission was to conquer his enemies and to unify and govern a fragmented Khmer kingdom. As Woodward has pointed out, 'the theme of conquering of enemies and impediments of all sorts . . . was absolutely central at Phimai' (1975, Vol. 1: 61).

Images of the Buddha at Angkor had already acquired some of the attributes associated with powerful Hindu deities: in the Baphuon reliefs, the Buddha had been depicted, not in monastic robes, but in traditional eleventh-century Angkorean dress, his torso adorned only with elaborate necklaces. Artists at Phimai went even further to transform the Buddha's monk-like persona and concealed the *usnisa* with a Khmer-style crown similar to those that had previously been depicted on Shiva and Vishnu images (Boisselier, 1966: 262). But although the crowned, *naga*-protected image with which Jayavarman VI identified must have been awesome, Phimai's builders did even more to enhance the monument's fundamental theme of conflict and conquest. A relief on one of the lintels depicts Krishna, an avatar of Vishnu, defeating a struggling monster, and four other lintels depict the mythological King Rama, also a Vishnu incarnation, fighting valiantly to rid the world of oppression.

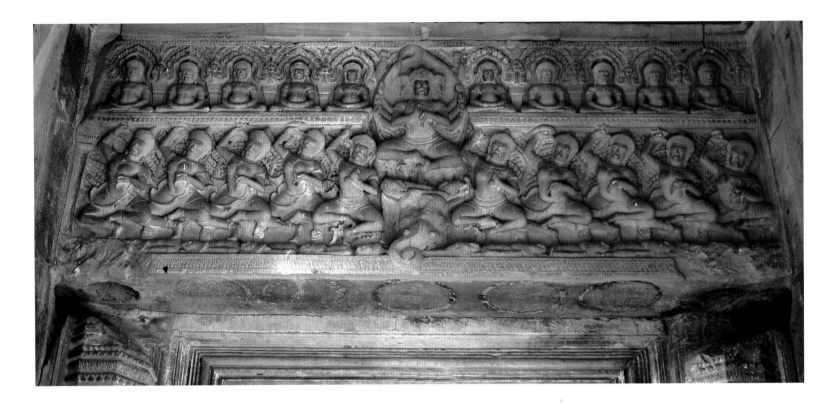

While Phimai's *naga*-protected Buddha images and Hindu scenes must have derived from Angkorean iconography, other elements suggest new connections from entirely different directions. Themes of power and conquering arrived from northeastern India, Myanmar, and the Central Plains. In one of the Phimai scenes the Buddha is depicted in *bhumisparsa mudra*, the earth-touching gesture that symbolized the Buddha's victory over worldly desires (Chapter 3). This was an iconographic type which, because of its reference to the Buddha's enlightenment at Gaya, was especially popular in the Ganges region. But it had not appeared before in Southeast Asia (Boisselier, 1966: 265). It has been suggested that still another scene depicts the Buddha converting the heretic king Jambupati to Buddhism, a story that would later become particularly popular in Myanmar. Burmese roots are suggested. In the Jambupati scene the Buddha is shown in Khmer-style crown, and although his hands are no longer extant, they were probably in double *vitarka mudra*, the gesture of exposition, with a monastic robe covering both shoulders, in the style of Dvaravati images (Woodward, 1975, Vol. 1: 67-9; 1983: 383; Fickle, 1989: 41).

Also indicative of contacts with the west were reliefs that depicted ferocious multi-headed, multi-armed deities found in Tantrism, an unorthodox branch of Buddhism that had developed in northeastern India in the eighth century. Tantrism proclaimed enlightenment, not by means of meditation or compassion, but by power and coercion. Although a small late tenth-century stupa at Thma Puok, at Angkor, had depicted a demonic Tantric deity with four arms and three heads, Tantrism had been largely ignored in Cambodia (Boisselier, 1966: 304). And although there is inscriptional evidence of Tantric practices on the Plateau in the eleventh century (Pattaratorn, 1990: 11-14), there is no indication that they were widespread. At Phimai, however, Tantric deities were depicted on the eastern and northern lintels above the antechamber doors that led to the cella and on the bases of pilasters and columns (Boisselier, 1996: 172-3; fig. 46a; 304).

But even at Phimai, Tantrism appears to have been of limited importance. The deities depicted in the reliefs lack the traditional characteristics that provide specific identification with Tantric gods, and there are no goddesses or references to the sexual practices that

were central to Tantric beliefs elsewhere in Asia. Moreover, there is no organizational pattern to the reliefs that can be equated with Indian Tantric doctrine, and just how the Tantric images related to the central *naga*-protected image is uncertain (Woodward, 1975; Vol. 1: 63-7; 1997: 77-78, 199). The positioning of ferocious deities at the bases of Phimai's pillars suggest that, whatever deeper esoteric significance they might have embodied, they functioned most ostensibly as guardian figures for the more traditional Mahayana god-king, *naga*-protected Buddha image installed at the center of the monument.

With political control established (at least for a while) at Phimai, the importation of sculpture in the round from Angkor ceased and local artisans began to produce numerous images of their own. Images that can be attributed to Phimai workshops (such as Phimai's central *naga*-protected image) are no longer in situ and some are widely scattered in museums and private collections. While only a few of these images can be traced with any certainly to the Upper Mun area, on iconographic and stylistic grounds, art historians have ascribed a number of them to Phimai workshops (Woodward, 1979).

Unlike Angkor, where large religious images had been executed in sandstone (Boisselier, 1966: 263, 325), the Plateau had had a long tradition of bronze casting, and its twelfth-century bronzes are among the best that Thailand has ever produced. Noen U-Loke had been noted for its ornate bronze jewelry during its Iron Period, and eighth-century Mahayana images were notable at Prakhonchai (Chapters 2 and 6). Although continuity between bronze production in the Plateau's various periods has not been established, technical analysis has shown that images attributed to late eleventh-century and early twelfth-century Phimai are similar in tin and lead content to the Prakhonchai images and very different from the minor bronze pieces produced at Angkor. High-tin bronzes had been widely distributed in the Central Plains and on the Plateau since the late first millennium BC, and some continuity with Phimai bronze casting can be suggested (Woodward, 1983: 383; 1997: 79; Bennett and Glover, 1992).

Judging from the scattered examples, the Plateau in the twelfth century produced a few multi-armed Tantric pieces, but much more common were crowned, bare chested *naga*-protected and standing images of the Buddha. Twelfth-century crowns were heavier and more complex than in the past, and some standing images were rendered Dvaravati style in double *vitarka mudra*. With increasing frequency, the *vitarka mudra* was replaced by the *abhaya mudra* (Boisselier, 1966: 274-5; Woodward, 1975, Vol. 1: 69-73; 1997: 86; figs. 70, 73, 294, 8n; Felten and Lerner, 1989: 224-7).

The Upper Mun sculptural tradition would persist for at least a century and spread into the Central Plains. Tantrism, on the other hand, with no local tradition on which to build, was short-lived and would have only minor effect on Thailand's later religious art. In 1107, a year after Jayavarman VI's death, a Phimai inscription of 1108 reported that the king's chief general donated an image to the temple that portrayed himself as the Tantric god Trailokyavijaya, the 'Conqueror of the Three Worlds', converter of Shiva to Buddhism, and the demolisher of anger and ignorance (Manit, 1962: 49-51; Woodward, 1975, Vol. 1: 63). By now, however, it appears that Phimai no longer functioned as a royal temple. In 1113, five years after the Tantric image was installed at Phimai, rule was restored at Angkor and architectural construction resumed. Angkor's new ruler, Suryavarman II, began construction of a temple-mountain, Angkor Wat, whose design would incorporate many of Prasat Phimai's architectural innovations. On the Plateau, the Mahidharapura center of power moved one hundred kilometers southeast to the ancient hilltop site of Phnom Rung, where Tantric elements were minimal.

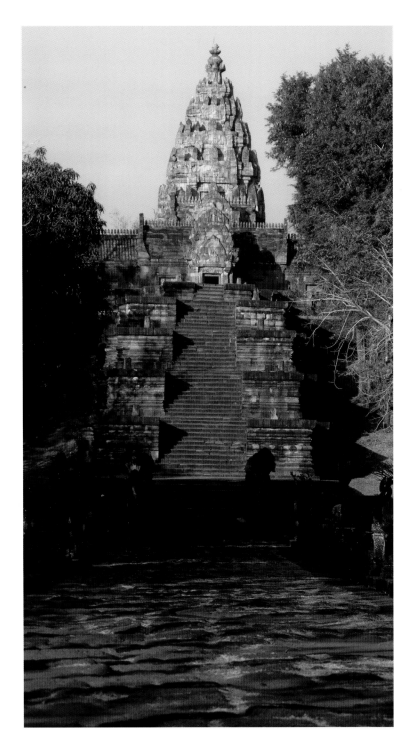

The grand stairway to Prasat Phnom Rung. The ground plan (opposite) shows the coordination of concentric and linear temple layouts. The lengthy entryway up the side of the hill follows the Plateau tradition, while a concentric ground plan at the summit reflects the Angkorean layout that had been established in the Upper Mun area at Prasat Phnom Wan and Phimai.

Phnom Rung had been an active Hindu site of long standing. In the tenth century, a few temples had been built over ruined eighth-century foundations, and eleventh-century style lintels similar to those at Angkor's Baphuon suggest continuing relations with Angkor (Smitthi and Moore, 1992: 269, 281, 287). Under Mahidharapura rule in the early twelfth century, Prasat Phnom Rung retained its Hindu heritage, but the royal concepts of conquering remained much the same as Phimai's. Rama is shown in a struggle with his enemies and there were also scenes of real-life conquests. A warrior, perhaps Narendraditya, who succeeded Jayavarman VI, was depicted standing on the head of an elephant with an enemy dangling from the elephant's trunk (Smitthi and Moore, 1992: 274).

The temple complex was enlarged beyond anything yet seen in the region, and Phnom Rung today still ranks among Thailand's grandest religious monuments. What must have at first been a narrow path that led almost a half kilometer to the summit of the hill was by the twelfth century a splendid processional way that included a paved avenue seven meters wide and 160 meters long that was flanked by 134 carved sandstone boundary markers. Along this awesome hillside approach to the temple proper there were also grandiose stairways, causeways, terraces, *naga*-balustraded bridges, four cruciform terraces, and chapels.

The summit of the hill, 350 meters above the surrounding plains and symbolically important in itself, was nonetheless surmounted by a huge temple that incorporated the centric orientation that emphasized the Meru cosmology. The temple proper was enclosed within a gallery

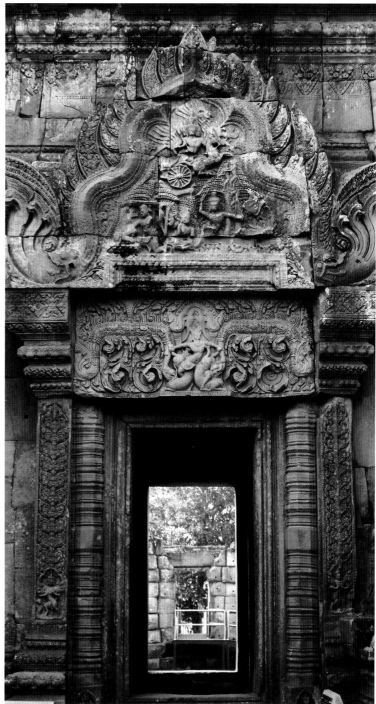

Right: *Phnom Rung doorway, pediment, and lintel, twelfth century. Although Tantric elements are less obvious here than they were at Phimai, themes of battle and conquest continue in the Phimai tradition. Here both Rama and Vishnu are seen in battle.*

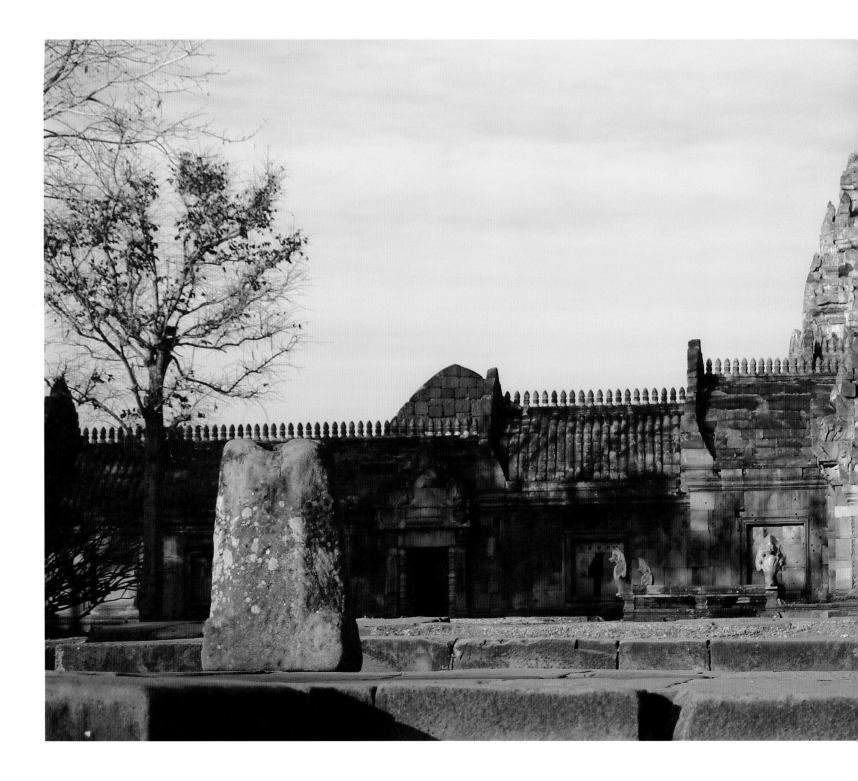

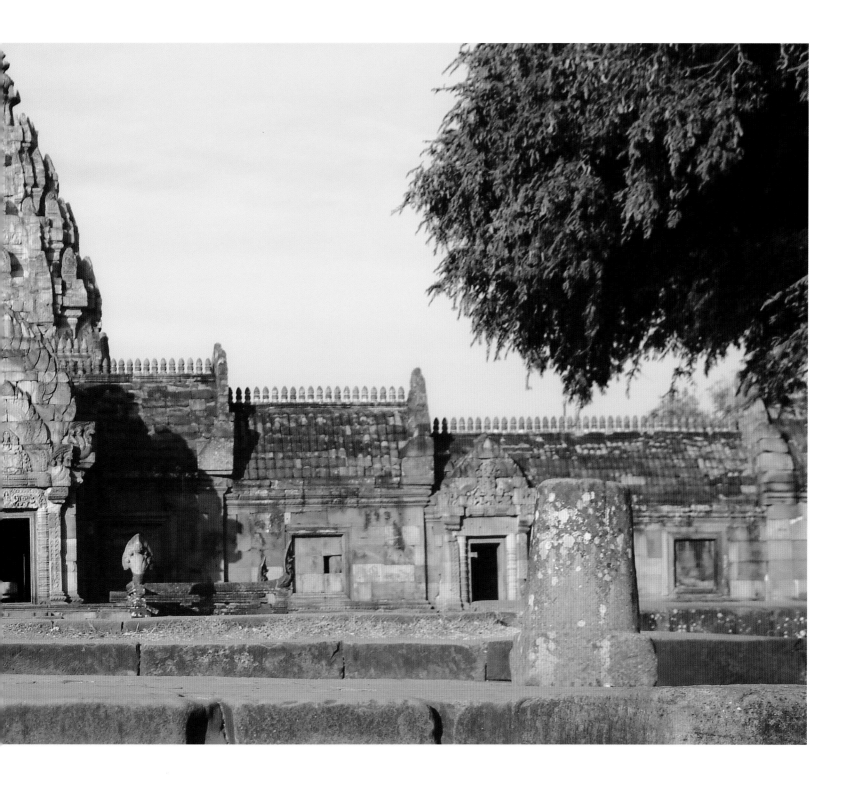

A Phnom Rung twelfth-century pediment with a relief showing a scene from the Ramayana.

Right: *This lintel from Phnom Rung is carved with an unusual represention of Vishnu Anantasayin in which the god lies upon a* naga *whose flattened body in turn lies upon a* makara.

Previous pages: *The Phnom Rung* prang *soars above its surrounding gallery.*

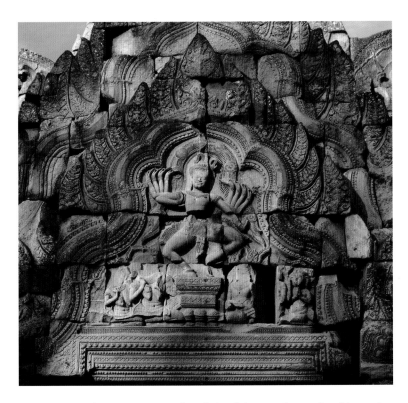

measuring 66 by 88 meters, and with its elaborate decorative friezes, its double pediments, lintels, and ornate pilasters, surpassed in grandeur even its prototypes Phimai. Following Phimai's innovations, Phnom Rung's cella and curved *sikhara* were now unified in *prang*-like fashion with redented corners and high-rise moldings. The *antarala* and *mandapa* no longer acted as entryways, but situated a meter lower than the *prang*, appeared as relics of the past and seemed to function more as buffers rather than entryways to the lofty structure nestled in their midst (Report, 1967: 47-9; Smitthi and Moore, 1992: 267-305).

Prasat Phnom Rung was the last great temple to be built on the Plateau, but there were less imposing versions of the Phimai style in the Central Plains. At Si Thep, two tall brick towers, dated to the eleventh or early twelfth century (Anuvit, 1979: 104), have the tall redented corners, high moldings, and double pediments that typify Phimai's innovative architectural design. A similar temple at Lopburi (later known by its Thai name, Wat Mahathat), whose construction began in the twelfth century (Woodward, 1995: 335-7), would eventually, in the thirteenth century, become the most important temple in the city, and later, in all the Central Plains (Chapter 9).

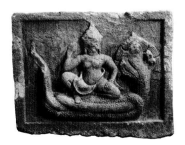

Above left: *The pediment above the* mandapa *doorway is carved with an image of an eight-armed dancing Shiva.*

Above: *Small sandstone plaques depicting tutelary deities responsible for protecting territories in all directions.* (Phimai National Museum)

143

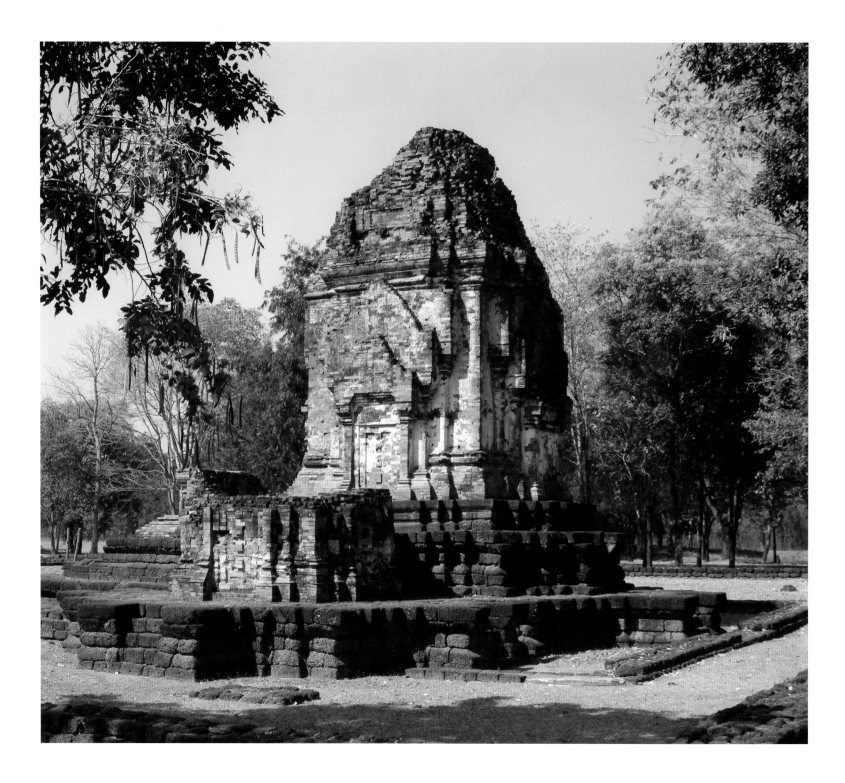

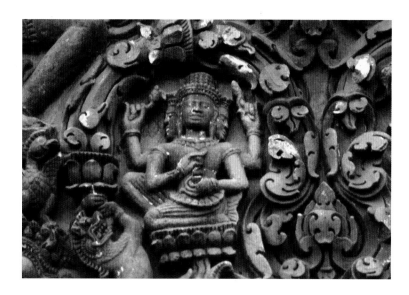

Many events would intervene between the Mahathat's two stages of building, however. In 1113, while construction at Phnom Rung was still underway, Angkor once again gained supremacy as the seat of the Khmer empire. A young kinsman of Jayavarman VI, Suryavarman II, was installed on Angkor's throne, and the construction of royal temple-mountains at Angkor resumed. Suryavarman II's masterpiece, Angkor Wat, incorporated many elements that had originated at Phimai: crowned Buddha images; Dvaravati-style symmetrical standing images; guardian reliefs at the bases of pilasters; curved, *prang*-like *sikhara*; and large bas reliefs depicting battle scenes (Boisselier, 1966: 172; 274-5; Woodward, 1975; Vol. 1: 84-5). The Angkorean quincunx of towers was approached by an impressively lengthy ceremonial causeway.

The flow of architectural concepts appears to have been one-sided, for Angkor Wat's contributions to the Plateau were limited. One exception was a small temple, Prasat Sikharaphum, which centered around a quincunx of brick towers, the hallmark of Angkorean temple-mountains. Sandstone door jambs and pillars were carved with guardians and *apsaras* in the Angkor Wat style (Report, 1967, 59-60; Smitthi and Moore, 1992: 219-25).

In spite of the reestablishment of Hinduism as a state religion at Angkor and at Prasat Phnom Rung, Phimai-style Buddha images continued to be made at Angkor, on the Plateau, and in Thailand's Central Plains into the late twelfth century. Stylistic and iconographic elements that had begun to arrive at Phimai from India and Myanmar continued to make their appearance. Some images appeared in *bhumisparsa mudra*, and in the late twelfth century there were elaborate altar pieces with images seated beneath a north-Indian style tabernacle (Woodward, 1997: 76, 79). One of Thailand's most important bronze masterpieces, a two-meter altar piece, most likely from the Upper Mun area and dated to the late twelfth century, was cast in thirteen segments and shows the Buddha with Khmer-style crown, in *bhumisparsa mudra* beneath an ornate tabernacle surmounted by a *bodhi* tree. Below, a depiction of Mara and his armies personifies the temptation and evil that the Buddha steadfastly resisted (Woodward, 1979: 73, 76-7).

Embedded in the Plateau's architectural and sculptural styles the melange of artistic and iconographic elements – Dvaravati, Phimai, and northwest Indian – would play a major role in the arts of the Central Plains in the thirteenth century. The progression was not a straight and narrow one, for there would be one more political intrusion from Angkor, this time of proportions that had not been encountered anytime in the past. In addition, significant intrusions of Mon peoples into the Central Plains from what is now Myanmar would leave a lasting legacy on the thirteenth century and later. As we shall see, however, although the local Phimai tradition with its multicultural roots would not survive, it would provide a critical link between Thailand's pre-Tai era and the present.

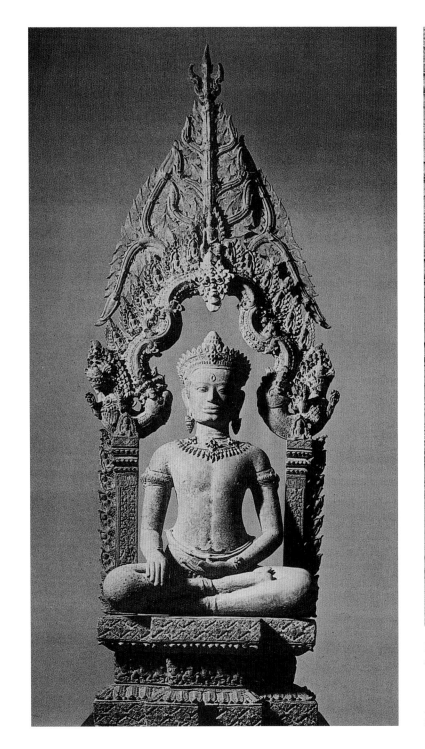

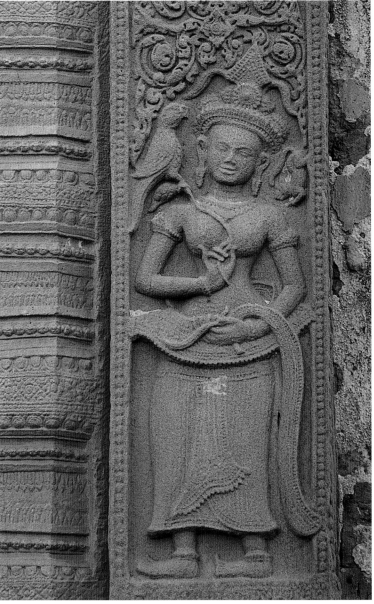

Left: *Large bronze altar piece, probably from the Upper Mun area, late twelfth century. (Kimbell Museum)*

Above: The apsara *or heavenly maiden from Sikharaphum is in the style of Angkor Wat.*

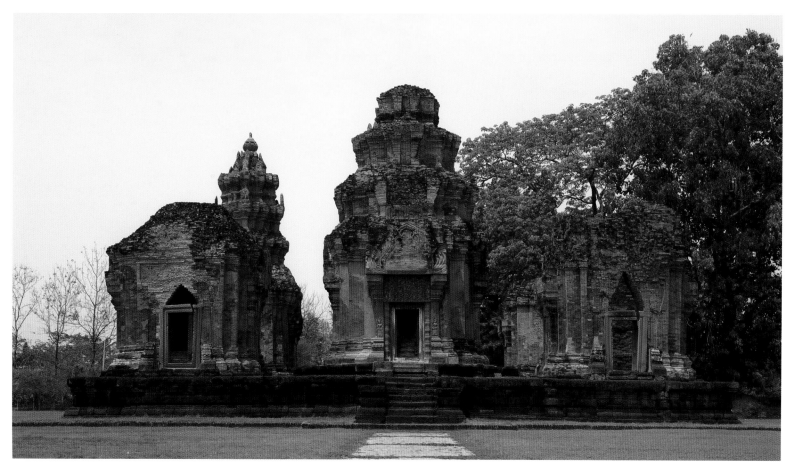

Above and far right: *The five towers at Prasat Sikharaphum arranged as a quincunx.*

Right: *Detail of a Sikharaphum lintel depicting a four-armed Vishnu.*

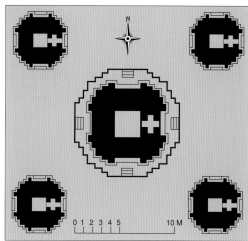

Art in the Central Plains and the Northern Highlands – Twelfth and Thirteenth Centuries AD

Although Phimai's early twelfth-century artistic traditions would survive in the designs of much later Thai art, during the latter part of the twelfth and the early thirteenth centuries the Central Plains produced many great works of art that were the products of renewed occupation by Angkorean Khmer. Angkorean-style work during that period was prodigious, unlike anything the area had seen before, and some of it is now included among Thailand's foremost historical monuments. While the influence of these Angkor-related pieces on later art styles in the Mekong region, the Khorat Plateau, and the Central Plains was minimal, they deserve attention not only for themselves but as evidence of what thirteenth-century inhabitants of Thailand chose to disregard in favor of other possibilities.

Not long after his accession in 1181, Angkor's last powerful king, Jayavarman VII, following centuries of sporadic Angkorean forays into the Plains, succeeded in occupying all the lands that had once been included in the Dvaravati chiefdom network as well as some lands farther to the north. At Angkor, Jayavarman VII had adopted the traditional god-king role in monumental style, erecting a huge temple-mountain, the Bayon, at the center of his own grandiose royal city, Angkor Thom. And like Phimai's Jayavarman VI (but unlike other Angkorean kings), Jayavarman VII adopted Buddhism as his state religion, and like his predecessor at Phimai, he installed a *naga*-protected Buddha in the royal temple as his sacred counterpart. Tantric elements became more important. While

Angkor Wat's royal image, like Phimai's, had been supported by numbers of unidentifiable ferocious deities, the Bayon *naga* image was accompanied by two gods of special significance: Avalokitesvara, the *bodhisattva* of compassion, and Prajnaparamita, the goddess of wisdom, the destroyer of ignorance and evil (Woodward, 1994-1995: 108; 1997: 81). Both Avalokitesvara and Prajnaparamita images would soon abound in the Central Plains.

Jayavarman VII left his mark as he expanded his territories westwards. Roads were built, and 121 *dharmasala*, variously defined as rest houses or as Buddhist shrines, were accompanied by 102 hospitals established for the use of travelers (Coedès, 1968: 176; Mabbett and Chandler, 1995: 205-6). Sometime during his reign, the king installed a large stone seated image in one of two image houses that were built to the east and west of Phimai's central *prang*-like tower (Smitthi and Moore, 1992: 233; Higham and Rachanie, 1998: 198). The statue is usually identified as an idealized portrait image of the king. Like other sculpture typical of the Jayavarman VII period, the image was both massive and human, powerful and gentle, remarkably reflecting the Angkorean king's mundane power as well as his Buddhist piety.

Although the old Mahidharapura sites on the Plateau were of interest to Jayavarman VII, it was the Central Plains that was his major objective. An inscription dated to 1191 installed at Preah Khan, a temple at Angkor that he had dedicated to his father, reported the installation of twenty-three images known as

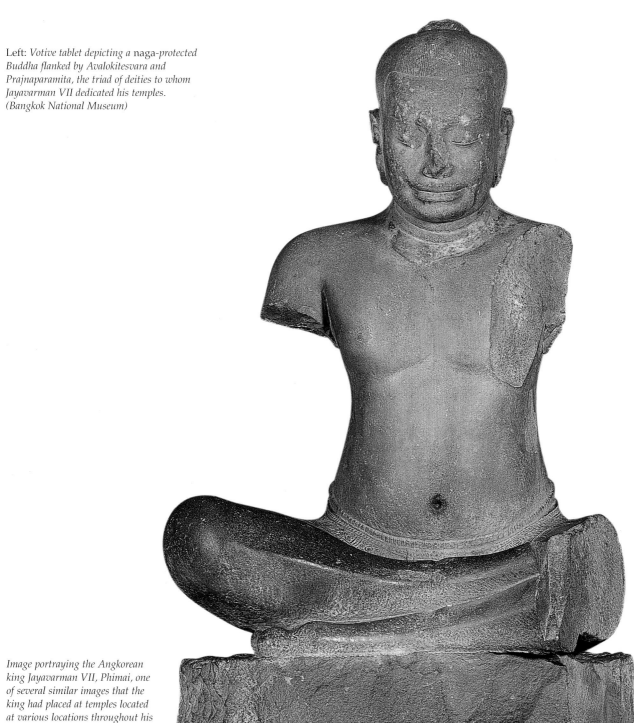

Left: *Votive tablet depicting a* naga-*protected Buddha flanked by Avalokitesvara and Prajnaparamita, the triad of deities to whom Jayavarman VII dedicated his temples.* (*Bangkok National Museum*)

Image portraying the Angkorean king Jayavarman VII, Phimai, one of several similar images that the king had placed at temples located at various locations throughout his expanding kingdom. (*Phimai National Museum*)

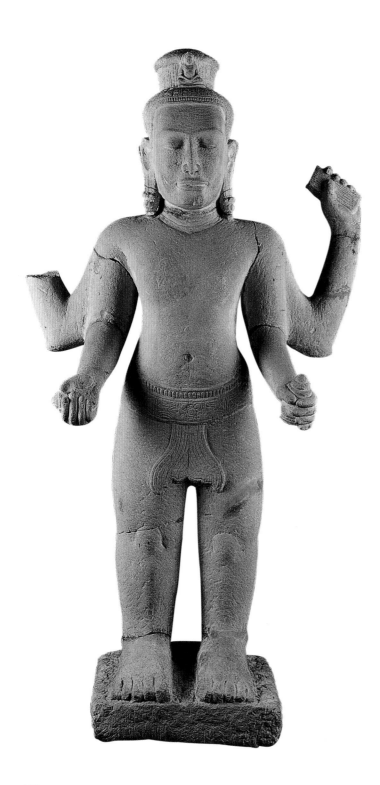

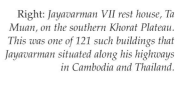

Right: *Jayavarman VII rest house, Ta Muan, on the southern Khorat Plateau. This was one of 121 such buildings that Jayavarman situated along his highways in Cambodia and Thailand.*

Far left and left: *Images of Avalokitesvara and Prajnaparamita found at Muang Singh, Jayavarman's westernmost settlement. (Bangkok National Museum)*

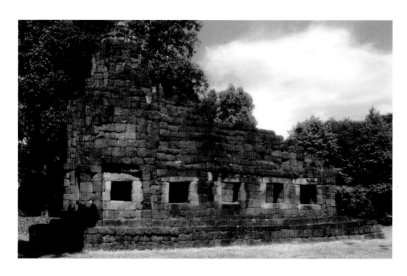

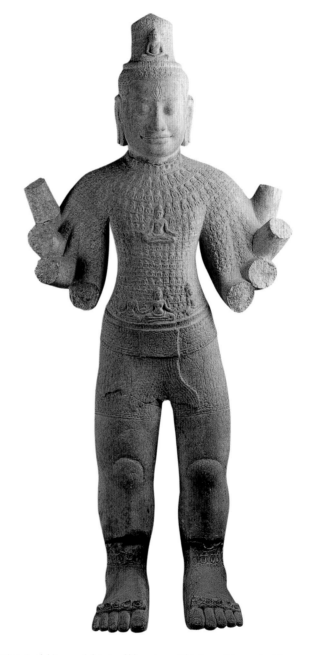

Jayabuddhamahanatha (Buddha, the Great Lord of Victory) at sites located throughout his farflung kingdom. Woodward has identified the Jayabuddhamahanatha images as 'radiating *bodhisattva*', eight-armed images with small figures of the Buddha covering (or radiating from) the chest (Woodward, 1994-1995: 105-9; 1997: 85, 103-4). Six of the sites listed in the Preah Khan inscription have been identified as sites in the Lower Central Plains, and both Jayabuddhamahanatha and Prajnaparamita images executed in the Jayavarman VII style have also been found at a number of Plains sites.

Like Angkorean-style images on the Plateau, some of these appear to have been imported from Angkor; some may have been made locally by newly arrived Angkorean sculptors; still others were crudely executed copies that must have been produced by local craftsmen. No matter what the source, the style of the Jayavarman VII stocky images contrasted sharply with the sleek, slender images that were the hallmark of Phimai's bronze sculptural tradition. There were a number of differences: like his portrait statue at Phimai, Jayavarman VII's images were massive, the component parts larger and fewer. At the same time, the faces, with lowered eyelids and expressive smiles, were softer and more human than their more stylized Phimai faces (Woodward, 1997: 84-6, 123). Crowned images were less common, and there were indications of a monastic robe on what had previously been unclothed chests (Woodward, 1975, Vol. 1: 105-6). A short or mid-length *sampot* replaced the Baphuon-type robe typical of the Phimai images.

A 'Radiating Avalokitesvara', late twelfth century. This type of image depicts a multitude of small Buddhas emanating from the chest. This is thought to be one of the twenty-three 'Jayabuddhamahanatha', or Great Lord of Victory, that an Angkorean inscription of 1191 states Jayavarman VII had placed at temples at Angkor and throughout his kingdom. (Bangkok National Museum)

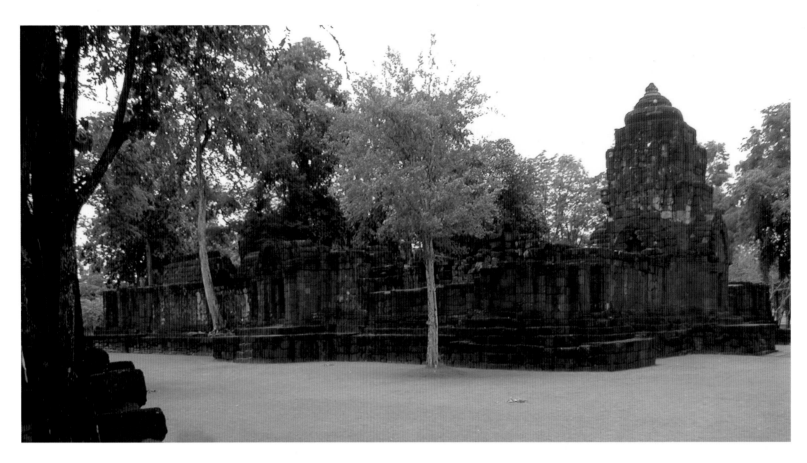

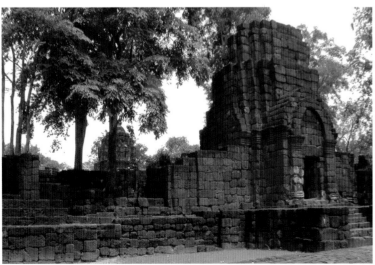

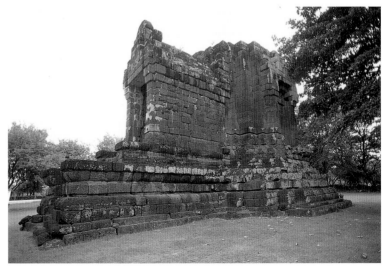

Top left: *Prasat Muang Singh, located at one of Jayavarman VII's large settlements in Thailand. Temples such as this appear to have been hastily built. Laterite rather than sandstone was used as a building material, and since laterite cannot be finely carved, decorative motifs were applied in stucco.*

Below: Gopura *that provided access to Prasat Muang Singh.*

Below Left: *The Ta Pha Daeng shrine, twelfth century, located in the Yom River area of the north Central Plains (later, Sukhothai). The image house would once have been surmounted by a lofty* sikhara *while the prominent* mandapa *suggests Plateau connections.*

Right: *Wat Chao Chan, Si Satchanalai. Located forty kilometers north of Sukhothai, Chao Chan is thought to have once functioned as Jayavarman VII's northernmost rest house. It was probably converted into a Buddhist temple in the fourteenth century.*

By far the most important site in the southern peripheries of the Central Plains was Muang Singh, located near the confluence of the Kwae Noi and Maeklong Rivers, not far from the old Neolithic site of Ban Kao. Muang Singh was a large city built in Angkorean style: a large square area with several temple complexes enclosed within concentric moats and walls. Because of the ruined condition of the buildings, it is difficult to reconstruct their appearance, but the city is noted for its abundance of Jayavarman VII style sculpture that included both locally made and imported images of Avalokitesvara and Prajnaparamita (Subhadradis, 1978: 109-11; 1981: 164-8; Fine Arts Department, 1987; Smitthi and Moore, 1992: 317-19.)

There were also Angkorean outposts in the Yom River area of the Upper Central Plains, an area which later, under Tai control, would become renowned under the name Sukhothai-Satchanalai (Chapter 10). There is no evidence of either prehistoric or Dvaravati habitation of the Yom area, the Dvaravati presence having ended farther to the south, but there had apparently been an earlier Khmer presence. A large image house known today by its Thai name, San Phra Sua Muang or Ta Pha Daeng Shrine, has been dated to the early twelfth century, and its large *mandapa* suggests considerable Plateau influences. Some distance north of the image house, Jayavarman VII built a city whose plan focused on a monumental triad of towers known later by its Thai name, Wat Phra Phai Luang. Angkorean governorship during the latter part of this period is attested by a portrait statue of Jayavarman VII almost identical to the one that had been installed at Phimai. What is

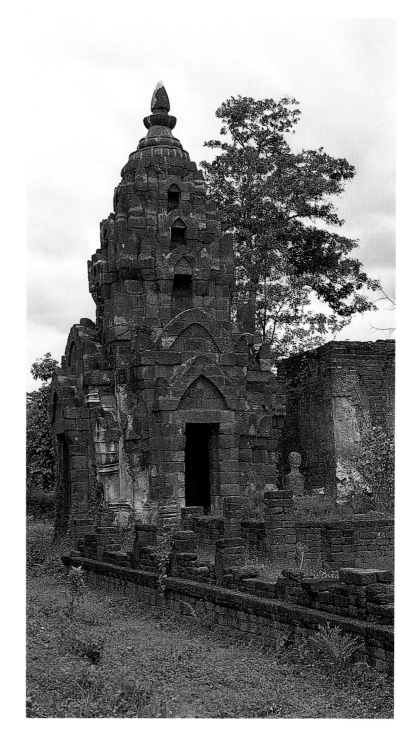

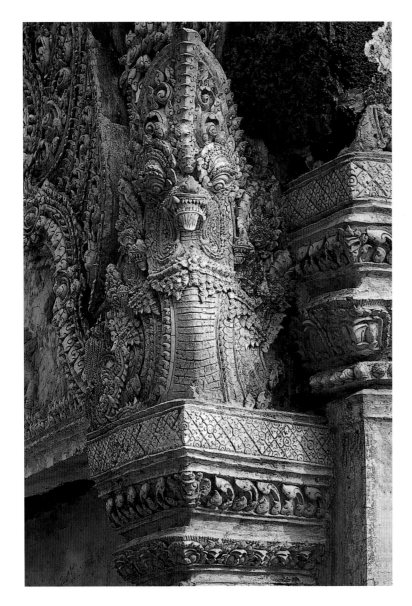

Above and above right: *Phra Phai Luang, stucco applied over laterite. The elaborately complex designs of the decor and the expertise with which it is applied contrasts with much of Jayavarman's hastily applied stucco work elsewhere in Thailand.*

Far right: *One of three towers at Wat Phra Phai Luang, north of Sukhothai's city walls, twelfth-thirteenth century. The three towers are typical of Jayavarman VII's temple plans and lack the high moldings and integrated cella-sikhara that would distinguish them as 'prang'.*

thought to have been Jayavarman VII's northernmost *dharmasala* known today as Wat Chao Chan was located fifty kilometers north of Wat Phra Phai Luang in what is now called Chaliang or Si Satchanalai (Griswold, 1967: 2-3: Gosling, 1991: 8-12).

While areas along the perimeters of the Central Plains appear to have been crucially important to Jayavarman VII's occupation, the king chose Lopburi, located in what was once the core of the Dvaravati heartland, as his provincial capital. Lopburi's previous history was a lengthy one and linked the new Khmer presence with the region's ancient past. This had been an important pottery and rice-growing area in Neolithic times (Chapter 2), and inscriptional evidence suggests that it had been an independent chiefdom before it was incorporated as an important center within the Dvaravati network (Chapter 4). Tha Kae, only a few kilometers from Lopburi, appears to have been inhabited continually from Neolithic times until the end of the Dvaravati period (Rispoli, 1992: 141). Both archaeological remains and inscriptional evidence attest to a Khmer presence at Lopburi in the tenth and eleventh centuries (Woodward, 1975, Vol 1: 51-53).

Sometime after 1181, Jayavarman VII installed one of his sons as governor at Lopburi (Woodward, 1997: 113), and the Angkorean presence became overwhelming, all but obscuring the city's earlier periods of habitation. Jayavarman VII's buildings at Lopburi contrasted decisively with those that he had built in his provincial areas. Many of his temples on the fringes of the Plains appear to

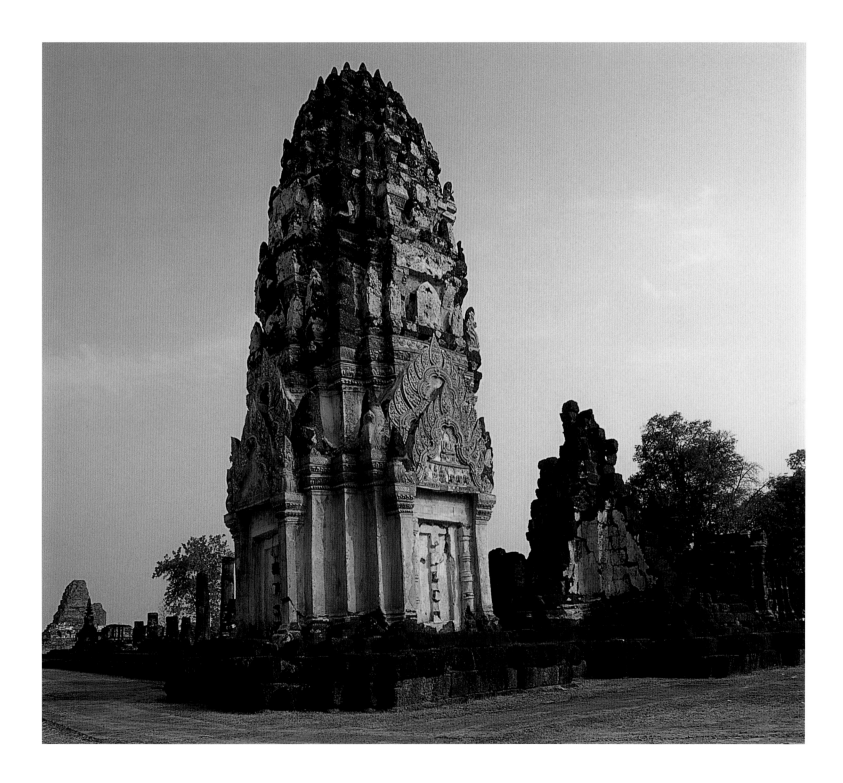

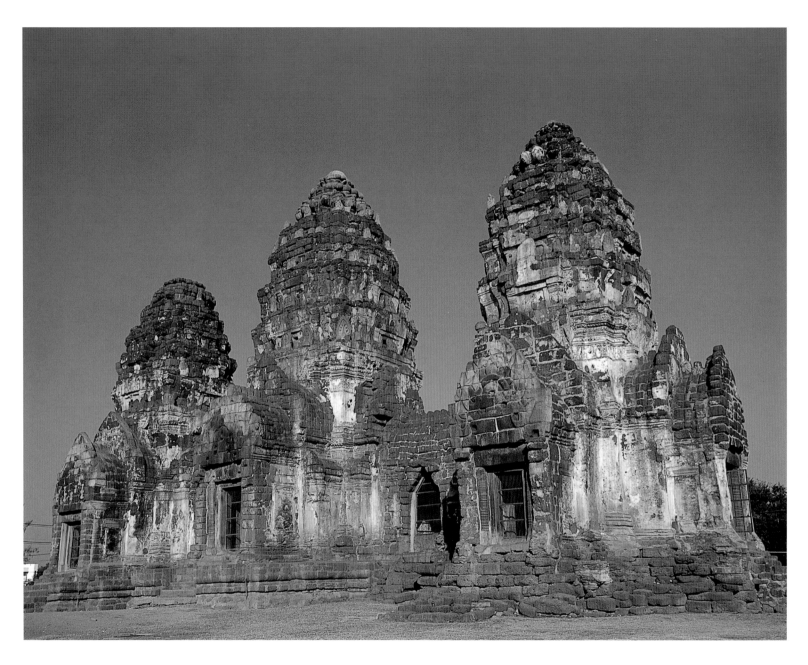

*Phra Prang Sam Yot, Lopburi, twelfth century. Lopburi, was Jayavarman VII's
provincial capital during his domination of the Central Plains, and this temple was
constructed of sandstone and brick rather than the laterite that was usual for temples in
Thailand. Its present-day name, which translates as `Three Prang', does not reflect the
design of the monument, which follows Angkorean styles rather than that of a* prang.

Gopura *at Angkor's Preah Khan temple, twelfth century,*
which was the prototype for Phra Prang Sam Yot.

Phra Prang Sam Yot stucco, added sometime after
completion of the building. (Betty Gosling Photo)

have been hastily built by local craftsmen, and constructed of large, roughly hewn, locally mined laterite blocks that were unsuited to carving, their exteriors were embellished with stucco rather than stone reliefs. In contrast, Jayavarman VII's major Lopburi temple, known today by its Thai name, Phra Prang Sam Yot, was constructed of sandstone and brick rather than laterite, and expert Angkorean workmanship is evident.

The overall design also derived from Jayavarman VII's Angkor and contrasted with both the Plains peripheral temples and with Prasat Phimai. The smoothly contoured, *prang*-like cella-*sikhara* design that was a Phimai and Angkor Wat hallmark is absent, and as Woodward has pointed out, Phra Prang Sam Yot's ground plan is almost identical to that of the principal gateway at Angkor's Preah Khan, where Jayavarman VII's 1191 Jayabuddhamahanatha inscription was installed (Woodward, 1975, Vol. 1: 108-10). Both the Preah Khan and Phra Prang Sam Yot monuments were composed of three cella and *sikhara* connected by buttresses.

The images that were once enshrined in the Phra Prang Sam Yot towers are no longer there, but their identification is supported not only by Angkorean ideology but also by extant Lopburi images and votive tablets, both of which portray the *naga*-protected Buddha-Avalokitesvara-Prajnaparamita triad. The Lopburi

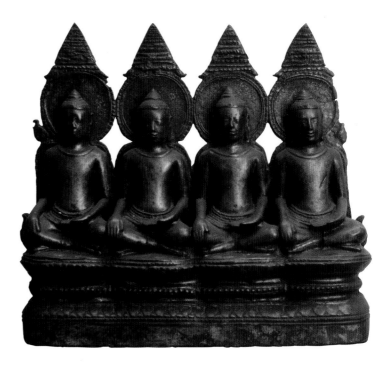

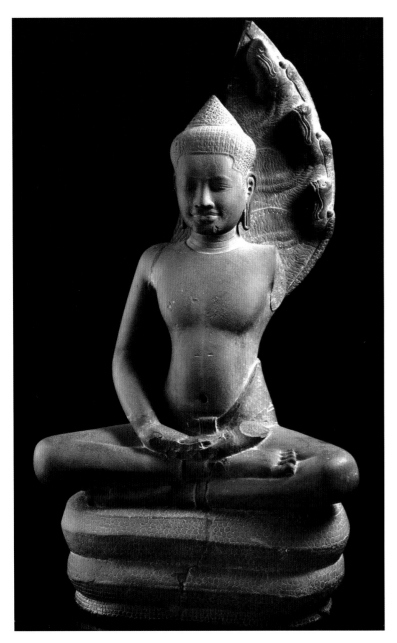

Far left and far right: *Two* naga-*protected Buddha images from the Jayavarman VII period. These images lack the crisp, idealized appearance of earlier images made on the Khorat Plateau. Their softer, more human faces are typical of images of the late twelfth or thirteenth century, and such images were most often made of stone, in the Angkorean tradition, rather than bronze, which was a Plateau hallmark.*
(Bangkok National Museum and Phimai National Museum)

sculpture included both imported and locally made images of Avalokitesvara and Prajnaparamita executed in the Angkorean style and, more commonly, *naga*-protected and crowned, double *mudra* standing images rendered in Phimai fashion (Woodward, 1980: 156-8; 1997: 76-9, 85-6). Crowned and *naga*-protected Buddha images were now symbolic of both Jayavarman VI's and Jayavarman VII's rule, and although the inclusion of the Phimai-style images among the all-invasive Angkorean artistic and cultural milieu might seem surprising, there appears to have been a conscious effort on Jayavarman VII's part to link Phimai as well as Angkor to his new Central Plains capital.

Lopburi's Phimai-related sculpture is easily identifiable. Some pieces were executed in stone, apparently the result of Angkorean practices, but others were made of high-tin-content bronze that suggests the work of Plateau bronze workers. In either stone or bronze, the stylized Phimai-style images contrasted significantly not only with Jayavarman VII's heavy, stocky pieces but were closer in style to those at Phimai than to similar, chronologically intervening, sculpture at Angkor Wat. Crowns were heavier, more like hats than the wide bands that had encircled Angkor's images,

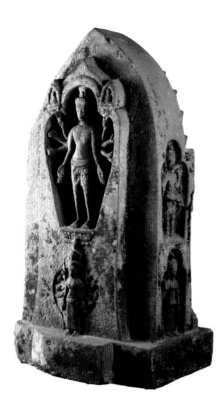

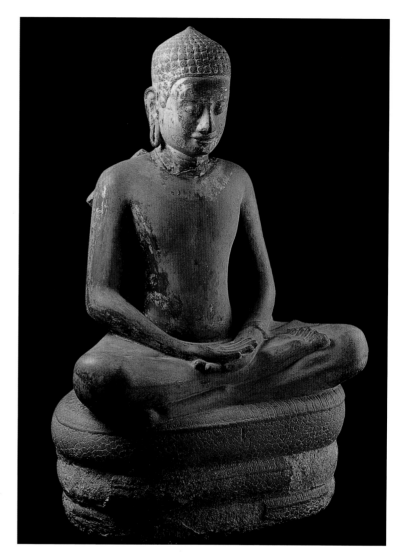

and inflections over the temples often covered the hairline. Although art historians classify these images as 'Angkor Wat' style, Woodward has suggested that they constitute a separate tradition that had been established at Phimai before Angkor Wat was built (1980: 156-7; 1997: 76-9, 85-6). Thus, in spite of the Jayavarman VII intrusion, the Phimai tradition was sustained, or perhaps, more accurately, revived. Unlike Angkor, Phimai had local significance, and it was the Phimai-style images, rather than Jayavarman VII's that would provide prototypes for future sculptural pieces in the Plains long after the Angkoreans had been driven away.

Not long after Jayavarman VII's death, around 1220, the powerful Angkorean empire once again began to disintegrate, slowly, but this time, irrevocably. Over-extended and over-built, Angkor no longer had the resources to control its farflung territories. In spite of the vast amount of Angkorean building on the Plains during the Jayavarman VII period, architecture in that style did not continue. A conscious rejection of Angkorean ideals, at least in the Yom area of the Upper Central Plains has been suggested (Coedès, 1962: 222). The Angkorean Phra Prang Som Yot-Bayon architectural style also faded into oblivion. Vestiges of

Above opposite: *Row of four bronze seated Buddha images, thirteenth century. The quartet contrasts with the triads of images that were commonly produced at this time. The figures are also notable for the* bhumisparsa mudra, *which appears to have been introduced to Thailand at Phimai, but Burmese sources are also a possibility. (Bangkok National Museum)*

Above left: *Stone stele, thirteenth century. Here traditional Buddhist iconography is found alongside Tantric elements, illustrating the multiple religious and ethnic sources that typify Thailand's thirteenth-century art. One side (depicted here) shows an eight-armed Avalokitesvara while the reverse side has a* naga-*protected Buddha image. The narrow sides show a four-armed Avalokitesvara and the Tantric deity Vajrapani. (Bangkok National Museum)*

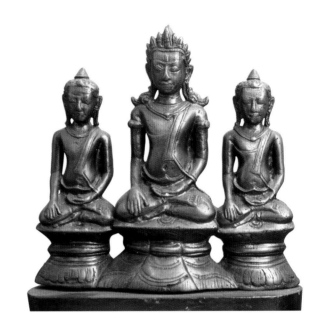

Right and opposite: *Two bronze triads, Lopburi style, thirteenth century. These images illustrate the iconography of Ariya Buddhism, practiced in Myanmar and Haripunchai, in Thailand's Northern Highlands. The crowns, made up of tall pointed leaf-like components contrast with the crowns on Khmer-style images. The* bhumisparsa mudra *reflects Indian and Burmese sources rather than Phimai's.* (Bangkok National Museum)

Angkorean sculpture would survive only in the warmer, more expressive faces of some Phimai-related images and in miscellaneous sculpture that defies classification (Woodward, 1997: 86, 114-15, 123).

Angkor's withdrawal from the Plains left the area politically and culturally undefined. Lopburi, as well as Suphanburi, which had superseded U Thong as a major city in the southern Plains, had sometimes functioned as a political center of a few small subsidiary communities. Now, however, free of both strong Angkorean leadership and widespread chiefdom alliances, most communities were acting independently, apparently without unifying leadership, political ideology, or religious doctrines (Wyatt, 1982: 64-5).

There was little left of Dvaravati, either artistically or ideologically, on which to build. Many sites including U Thong and Khu Bua had been abandoned; Nakhon Pathom, though still inhabited, was no longer a flourishing religious or political center; and Lopburi was now essentially Khmer. There is no evidence that any of the old *sthaviravada* Buddhist network had survived. Although an eleventh-century Khmer inscription noted that along with brahman priests, both Mahayana and *sthaviravada* monks were respected in the Central Plains (Coedès, 1968: 137), no Dvaravati temple architecture from the later Dvaravati period is identifiable. The quality of Dvaravati's sculpture in the round had begun to

decline several centuries earlier, and judging from the crude local copies of Angkorean sculpture that were produced in the late twelfth and early thirteenth centuries, Dvaravati's sculptural expertise had not been revived. The Plains had never had a bronze tradition that equaled that of the Plateau, and stonework appears to have reemerged only with the arrival of Angkorean artisans (Woodward, 1980: 157). Remnants of the Dvaravati presence can be found only in miscellaneous stucco details scattered among predominantly Angkorean motifs at a few of Jayavarman VII's sites such as Muang Singh. Stucco was a medium foreign to Angkor but necessary to embellish the provincial rough-hewn laterite temples, and apparently, Dvaravati expertise was sometimes called into play (Woodward, 1975; Vol. 1: 123).

It was not Dvaravati Mon but Mon from the north who would make their presence felt in the aftermath of the Angkorean intrusion. As early as the tenth century, Mon peoples who were culturally unrelated to Dvaravati had begun migrating from Myanmar to settle in Thailand's Northern Highlands (Woodward, 1997: 116), and by the thirteenth century these northern Mon had established themselves in a small chiefdom at Haripunchai, located near the present-day Thai city of Chiang Mai. The northern Mon practiced a distinctive and now poorly-understood *sarvastivada* religion sometimes referred to as Ariya Buddhism, which had roots

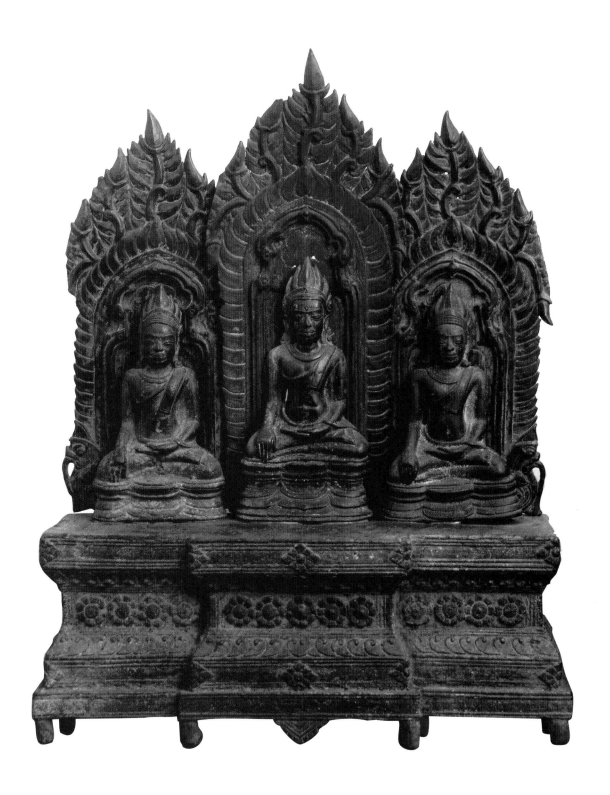

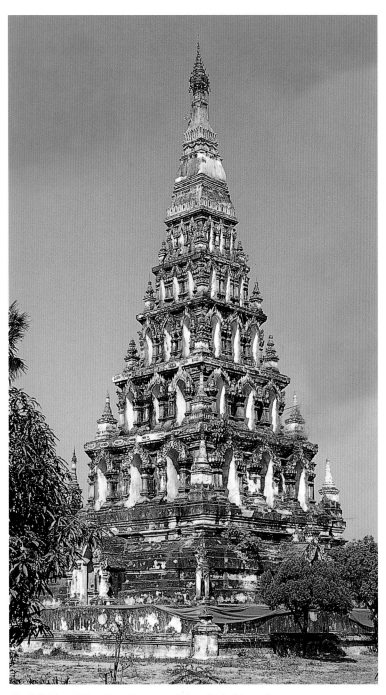

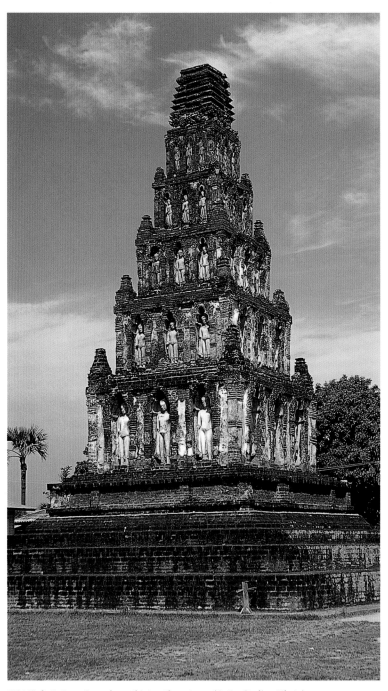

Chedi Si Liam, Wiang Kum Kam, near Chiang Mai, thirteenth century.
(Betty Gosling Photo)

Wat Kukut stupa, Lamphun, thirteenth century. (Betty Gosling Photo)

Right: *Head of a terracotta, Haripunchai image, twelfth-thirteenth century. (Haripunchai National Museum)*

Far right: *One of the sixty stucco images on the Kukut stupa. These images have been restored many times over the centuries, but perhaps give some idea of the originals. Triads such as these were typical of the period, and the hand held to the chest appears to have been a common feature.*

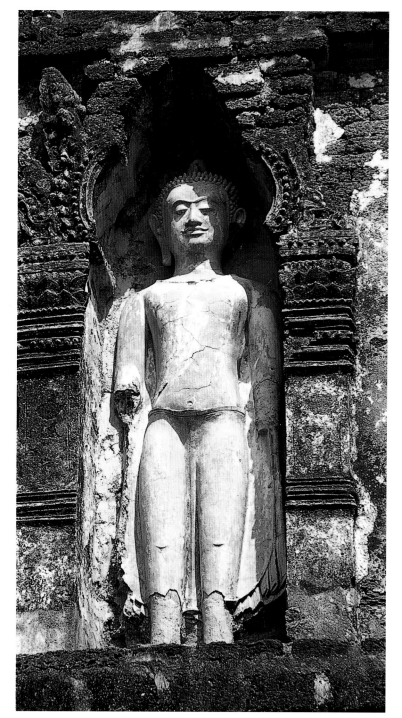

in Myanmar. And there were ideological connections with Gaya, which over the millennia had continued to flourish as India's most important Buddhist pilgrimage site. Haripunchai is known especially for its tall pyramidal towers, such as those at Wat Kukut and at Chedi Si Liam, whose style reflected that of Gaya's Mahabodhi temple. Sometimes said to have derived from Dvaravati's seventh-century *caitya* (which, as we have seen in Chapter 5 were also based on Mahabodhi designs), the Mon towers appear to have been cousins rather than descendants of the Dvaravati monuments. The iconography of the Haripunchai towers was neither Indian nor Dvaravati. Each of the towers' five stages was punctuated with niches for three identical standing images with right hands held palm outward against the chest, apparently a variation of the traditional *abhaya mudra* (Woodward, 1975, Vol. 1: 129-42; 1997: 115, 119, 130).

The triadic arrangement (unrelated to that of Jayavarman VII's triads) appears to have been iconographically significant, for Haripunchai also produced sculptural triads of seated images in *bhumisparsa mudra*. While the earth-touching gesture most certainly referred to the Buddha's enlightenment at Gaya, the significance of the triads is uncertain. The royal nature of the images is apparent, however. Images were frequently crowned. Some perhaps referred simply to the Buddha's royal nature, while others, like some Phimai reliefs, appear to relate to the Jambupati story. The crowns were very different from Phimai's, however, and consisted of upright leaf-like elements, reflecting north Indian prototypes. Facial details typified by wide, flattened foreheads, broad noses, and incised eyes,

Wat Mahathat, Lopburi, Thailand's most important temple complex in the late thirteenth century. Its stucco decor reflects the wide variety of ethnic and religious contacts that were typical of the thirteenth century. This monastery complex remained active for many centuries and its subsidiary buildings reflect the art and architecture of many periods. The prang, *far right, follows the Phimai tradition.*

eyebrows, and mustaches were distinctively Haripunchai, and the figures tended to be boxy and stiff. Executed in terracotta, artistic output was prolific, and multiple copies were often produced in molds (Woodward, 1997: 117,128-31).

While the northern Mon brought unity and a distinctive culture to a significant area of Thailand's Northern Highlands, their presence only added to the cultural confusion that already permeated the Central Plains. Not surprisingly, many Haripunchai images arrived in the south, where they collided with the bronze and stone *naga*-protected and crowned double *mudra* images that had been produced in the Phimai style. Thus, thirteenth-century Central Plains sculpture displays little correlation between ethnicity, style, medium, religious doctrine, or political ideology. Apparently, both the Haripunchai and Phimai traditions were respected, and especially in the Lopburi area, hand-on-chest and Haripunchai-style crowned images were commonly copied by artisans trained in both the Angkorean and Phimai traditions. The double *abhaya mudra*, which perhaps in the latter half of the twelfth century had begun to supplant the older *vitarka mudra*, was common, and images in *bhumisparsa mudra* sometimes appeared in place of the *dhyana mudra*. (Fickle, 1989: 69-70; Woodward, 1997: 13-4, 114, 119-23).

In architecture as well there was a confrontation and mixing of traditions that were most clearly exemplified at Lopburi's Wat Mahathat. As we have seen (Chapter 8; Woodward, 1995: 337), construction of Wat Mahathat is thought to have begun prior to the Jayavarman VII disruption when Phimai was still a political and

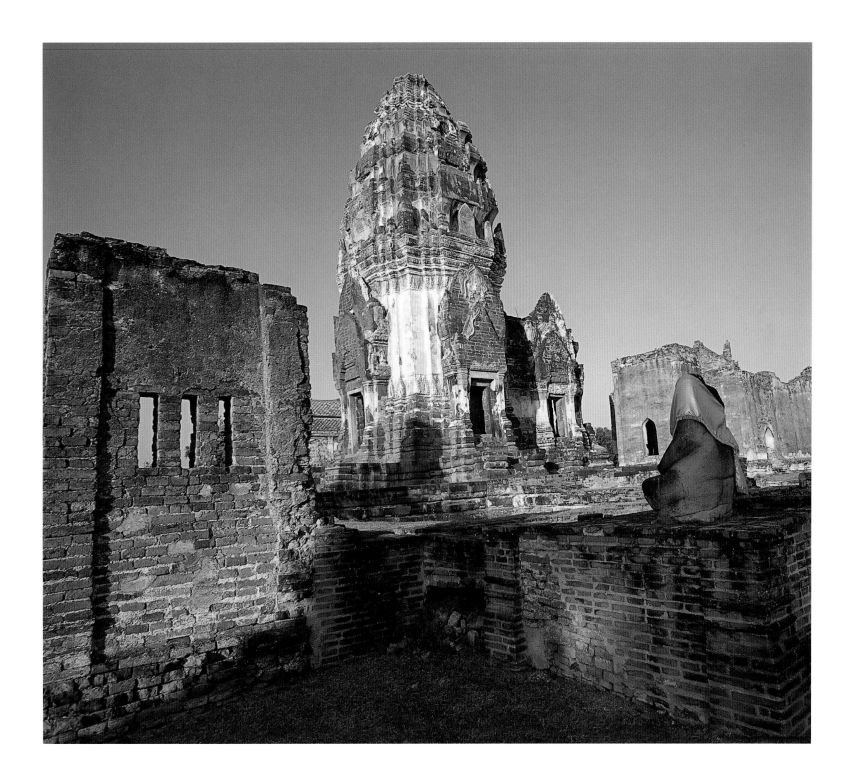

Wat Mahathat redented stupa of the Ayutthaya period 1350-1767. The dome is sometimes said to resemble the ribbed fruit of the cucumber tree.

religious center. When building resumed in the thirteenth century, new construction at Wat Mahathat included Mon features that had been recently introduced from the north. Ariya Buddhism was adopted and two peripheral towers were built to provide the triadic arrangement that Mon iconography required. As Woodward has demonstrated in a detailed study of the Mahathat's stucco, the decor included numerous northern Mon as well as Burmese details (Woodward, 1975, Vol. 2: 1-6, 10).

In spite of these intrusions from the north, however, the older, Phimai tradition prevailed. Tall, unobstructed corner redentions melded the cella and *sikhara* into a conceptually unified structure more than ever before. In contrast to Phra Prang Sam Yot's Angkorean-inspired moldings, the Mahathat moldings, like Phimai's, were proportioned to the height of the building rather than the doorway, and instead of Phra Prang Sam Yot's 'compact richness', 'leisurely plain courses' like those at Phimai were prominent. Unlike Phra Prang Sam Yot's multiple entrances which invited entry, the single door at the Mahathat was situated high above ground level, and a *mandapa* and side porches seemed to obstruct entry rather than welcome access (Woodward, 1975, Vol. 2: 1-6, 10). Such details preserved the Phimai architectural tradition in the Central Plains. The incipient *prang*-like features that distinguished Phimai's central tower now came to fruition, and some art historians consider the Lopburi Mahathat to be the first true *prang* (Boisselier, 1965: 39, 41).

Although Phimai had not functioned as the royal seat of Khmer power for almost two centuries, it undoubtedly retained

An Ayutthaya period, Sinhalese-inspired, bell-shape stupa at Wat Mahathat contrasts vividly with the Ayutthaya period prang *beside it. Both monuments, however, have the attenuated profiles typical of later Thai art.*

symbolic importance. During the Jayavarman VII interruption, a road had been built to connect Phimai with Lopburi (Wyatt, 1982: 27), shortening the travel time that the old Mun-Pasak river route necessitated. And by now it seems only likely that there were more non-Angkorean Khmer residing in Lopburi than there were immigrants from the Mekong region. Particularly in the wake of Jayavarman's VII's uninvited Angkorean presence, the independent Phimai Khmer tradition must have been treasured, and Phimai-style architecture and sculpture provided links with a past free of Angkorean domination. While the Ariya Buddhism of the northern Mon made some significant inroads into the Central Plains, it was the god-king concept – central to both Phimai and Angkorean poltico-religious ideology – that provided Lopburi and the Plains with renewed cultural focus.

Amidst the cultural crisscrossings that typified the Central Plains in the late thirteenth century, however, there were two new phenomena that would soon play an even larger and longer lasting role than Phimai in bringing about cultural unity to the Central Plains. Although their presence was not to bring about immediate cultural change, it is thought that during the eleventh and twelfth centuries much of what is now Thailand had become inhabited by Tai speakers and that by the thirteenth century there was a large Khmerized Tai population at Lopburi (Wyatt, 1982: 27, 50-1). A more immediate and well documented catalyst in thirteenth-century Lopburi was Theravada Buddhism, the written form of the old *sthaviravada* Buddhism that centuries earlier had played a major role in the formation and perpetuation of the Dvaravati chiefdom

Stupa at Wat Som, Ayutthaya, fourteenth century, when there was renewed contact with Cambodia. Wat Som reflects Angkorean styles as well as those of Thailand's prang.

network (Chapter 4). While this ultraorthodox branch of Buddhism had largely died out in most of Asia, it had survived in Sri Lanka, where the *sthaviravada* tradition had been committed to writing. In the late twelfth century, Sri Lanka was considered to be the fountainhead of Theravada Buddhism, and both Burmese and Khmer monks traveled there to be reordained by qualified senior monks and to acquire authentic Buddhist relics and texts that would legitimize Theravada practice in their own countries (Coedès, 1968: 178; Aung-Thwin, 1985: 139, 145). At some unknown date, Lopburi acquired a great relic, or *mahathat*, thereby providing its main, Phimai-styled temple with its present-day name. Now its central *prang*, already heavily endowed with Mon doctrinal belief and Khmer god-king symbolism, also became a major Theravada monument.

By the early fourteenth century, monumental *prang* were beginning to dominate important politico-religious centers throughout the Central Plains. At Ayutthaya, which succeeded Lopburi as the Plains' political and religious center in 1350, *prang* were numerous and the most significant features of their predecessors were pronounced and even exaggerated. At Wat Phutthaisawan, built in 1353 (restored in 1898) and at Wat Ratchaburana, built in 1424, *mandapa* were of major importance. And at Ratburi, a city not far from the ancient site of Khu Bua with a history that included both Dvaravati and Angkorean political domination, the city's fourteenth-century Mahathat included both *prang* and *mandapa* that were situated on three superimposed molded bases. Although clearly modeled on Lopburi's Mahathat, the *prang*'s corner redentions were more numerous, eating away more and more of the corners, to produce an even smoother, more

bullet-like profile than in the past. Not only did the old distinction between *sikhara* and cella seem to have been entirely forgotten, but an extremely high base was also integrated within an overall cohesive design that had once consisted of separate, dissimilar, elements (Woodward, 1971: 61-2; 1975, Vol. 1: 125, 176; Vol. 2: 14, 16, 21-3, 26-7, 29, 167-8).

A least one more Angkorean-inspired building was built in Ayutthaya in the fourteenth century. By now, the city had become powerful enough to invade Angkor, and Ayutthayans returned home from the Mekong area with reinforcement for their god-king concepts. Brahmanical rites became an important adjunct to kingship, and a temple known today as Wat Som reflected Angkorean as well as Phimai design. In contrast to the numerous *prang* that were erupting throughout the Plains, Wat Som could be entered near ground level, and a disparity between the cella and *sikhara* is evident. By now, however, some of the traditional Angkorean features had atrophied: lintels were small and nonfunctional, and decorative elements, though reflecting prototypes at Preah Khan, were executed in stucco instead of stone (Woodward, 1975; Vol. 2: 27-8).

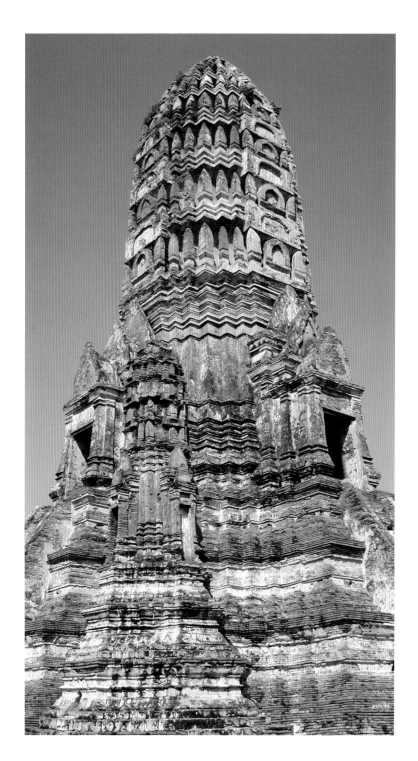

Prang *at Wat Chai Watthanaram, Ayutthaya, seventeenth century. During the Ayutthaya period, the* prang *design predominated, but became smoother and more bullet-like. Bases were taller, more ornate, decorative, and visually important.*

The Pre-Tai Legacy

Stone inscription ('The Ram Khamhaeng Inscription'), 1292. This Sukhothai inscription was one of the first to use a Tai script and language. (Bangkok National Museum)

Thailand's Theravada Buddhism and god-king ideologies, now symbolized jointly by Central Plains *prang*, undoubtedly played a crucial role in restoring cultural unity to the region in the thirteenth and fourteenth centuries. No less important, however, were numerous Tai-speaking peoples who now inhabited the areas once dominated by the Mon and Khmer. It was the Tai who were ultimately responsible for implementing and disseminating practices that would bring cultural cohesion to the lands that would one day become Thailand.

The Tai had begun to arrive in the Plateau, the Central Plains, and the Northern Highlands sometime in the latter part of the first millennium AD, and by the eleventh century, it is thought, many communities were 'substantially' Tai (Wyatt, 1982: 27-8). The Tai were an agricultural people who had migrated from southeastern China, where, like the Chinese and early Khmer, they had revered ancestral gods and mountain-dwelling deities (Chapter 7; Griswold and Prasert, 1969: 68-89). But soon their lives would change in a variety of ways. The Tai who settled in highly Khmerized centers like Lopburi and Ayutthaya mixed with the local Khmer population and adopted Khmer habits, but farther to the north in the vicinity of Phra Phai Luang, where the Khmer population may have been predominantly Angkorean rather than local, the Tai rebelled against their overlords and established a large farflung chiefdom network called Sukhothai-Satchanalai (Coedès, 1968: 194-6; Griswold, 1967: 6-7). There, a Tai territorial deity was given ultimate responsibility for the preservation of the Sukhothai-Satchanalai chiefdom and was royally honored at a

high altar (Phra Kaphung) located south of Sukhothai's city walls (Griswold and Prasert, 1971: 214). In what appears to have been a determined effort on the part of one early king, Ram Khamhaeng, to forge a Tai identity, a Tai language and script were used to record Sukhothai's significant political and religious events (Chamberlain, 1991). By the end of the Sukhothai period, well over half of its several dozen stone inscriptions were rendered in Tai, displacing the traditional Khmer, Sanskrit, and Pali that had been the norm in Southeast Asia for most of the past millennium.

Like Dvaravati rulers many centuries earlier, Sukhothai chieftains formed political alliances based on personal ties among friends and relatives in sometimes noncontiguous areas. And like Dvaravati, Sukhothai established a reciprocal relation with the Buddhist monastic organization, which for a while at least provided stability at home and a cultural link with other areas. Soon there would be journeys to Sri Lanka, where the old conservative *sthaviravada* traditions had been preserved in written form (Chapter 3, 9), while contacts with Myanmar and the Northern Highlands provided fuel for the newly acquired religious practices. Sinhalese-style, bell-shape stupas and Indian-inspired Buddha images, transmitted through Myanmar and Chiang Mai, proliferated along with Sukhothai's flourishing Theravada monastic order.

Although Sukhothai's religious organization was impressive, it lacked the strong, centric political concepts that the Phimai god-king concept supported. Old territorial gods such as those revered at

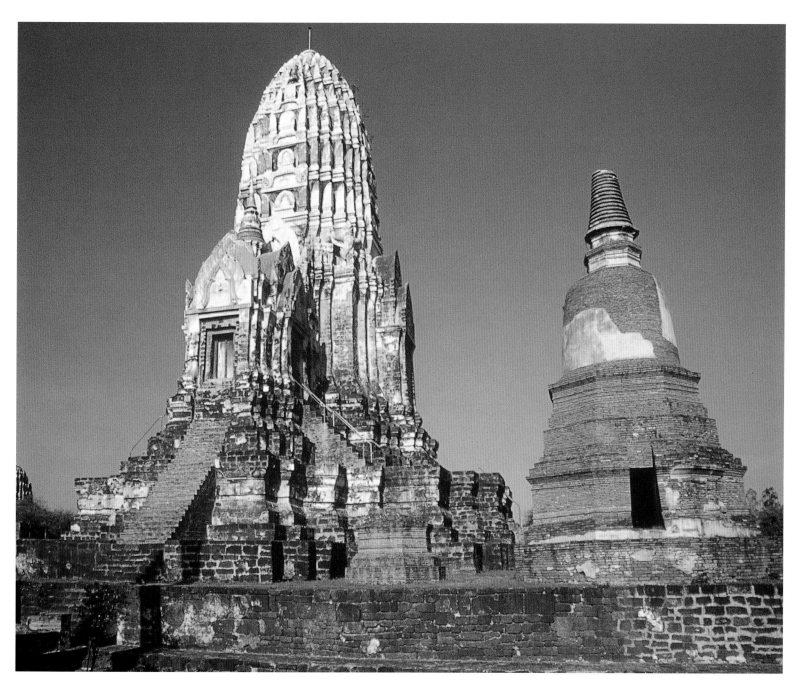

Bell-shape stupa and prang *at Wat Ratchaburana, Ayutthaya, fifteenth century. Khmer-related* prang *and round stupas, introduced from Sri Lanka, appeared side by side in Ayutthaya-period monasteries. Unlike many art styles that intermixed and blended over the centuries, the* prang *and bell-shape stupa have remained distinct architectural types until the present day.*

Wat Kon Laeng pyramid, Sukhothai, thirteenth century. After the establishment of Tai communities, mountain-like structures were used to mark places of special importance outside the city walls rather than at the center as had been practiced by the Khmer. The Wat Kon Laeng pyramid is identified as 'Phra Kaphung', cited in the Ram Khamhaeng inscription as the abode of Sukhothai's tutelary deity. (Betty Gosling Photo)

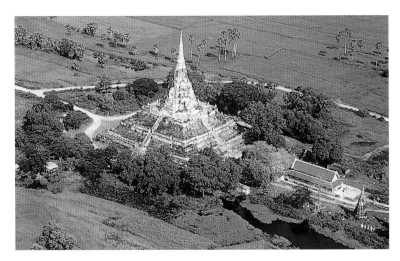

Phu Khao Thong (Golden Mount), near Ayutthaya. Like Phra Kaphung, Phu Khao Thong, is located outside the city, and is said to have been the abode of a guardian spirit.

The Golden Mount, Bangkok, peripheral to the city's royal complex at the center of the city.

Sukhothai could not compete with the Khmer god-king, and Sukhothai's symbiotic relation between ruler and the monkhood, on which its political viability depended, faltered (Gosling, 1991: 63-76). In 1438, Sukhothai was incorporated within the Ayutthaya kingdom. In spite of the defeat, however, the Tai presence survived. Theravada Buddhism, now supported by god-king concepts, gave rise to bell-shape stupas, which had been produced in great profusion at Sukhothai and now began to appear alongside Ayutthaya's *prang*. Sukhothai's distinctive sculptural style made its mark alongside Phimai-derived images, and Tai eventually supplanted Mon and Khmer as the country's first language. Although most old ethnic Tai traditions were soon enveloped in or supplanted by Khmer and Buddhist practices and ideologies, the pre-Indian also left its mark. Mountain-like structures, unlike Khmer temple-mountains that were built to mark the center of a royal city, the kingdom and the cosmos, were now built outside Thailand's city walls. Sukhothai's 'Phra Kaphung' south of the city was apparently such a structure, not unlike the square stepped earth altars erected outside ancient Chinese cities (Wechsler, 1985: 109-13; Gosling, 1991: 23-6; 1996: 22, 219-34). And a man-made mountain, Phu Khao Thong, or Golden Mount, was built outside Ayutthaya. Like Sukhothai's Phra Kaphung, Phu Khao Thong is said to have been the abode of a tutelary deity (Wales, 1931: 301). The tradition of building an artificial mountain outside the city walls would

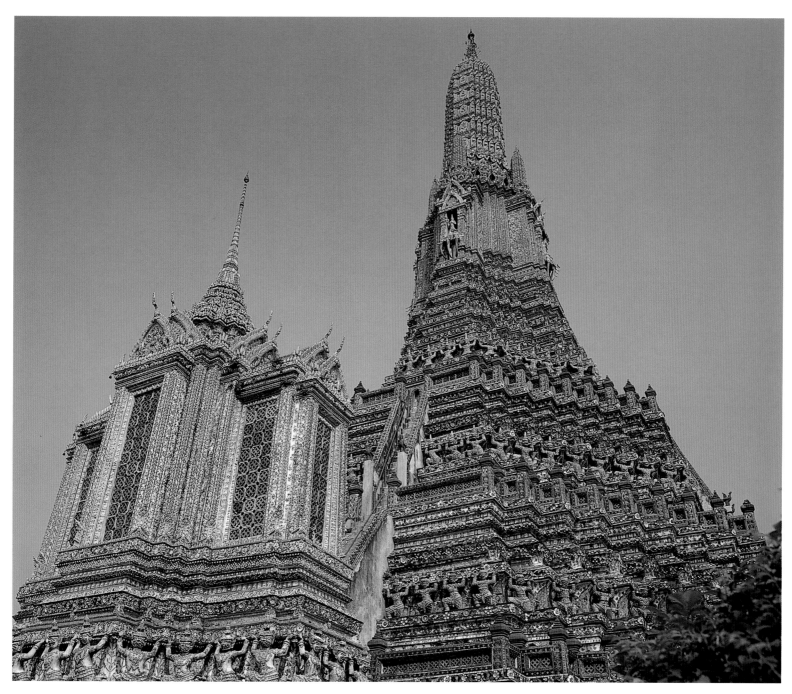

Prang *at Wat Arun, Bangkok. Here a soaring, highly decorative base visually surpasses the superstructure,*
which in early prang *were the monuments' most defining component. Nonetheless, the basic* prang *design is evident.*

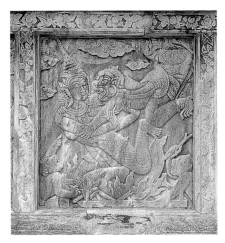

Bas reliefs, Wat Pho, Bangkok, depicting the adventures of Rama. As in past centuries, the Rama stories, as told in the Ramayana, *are royal adjuncts, and here define Wat Pho as a* wat luang, *or royal monastery.*

later be manifest in the Golden Mount at Bangkok (Smithies, 1986: 44). In the nineteenth century, Bangkok's historians, basing their concept of Thai history on dozens of newly discovered inscriptions and an abundance of archaeological remains at Sukhothai, began to trace their national heritage to the Tai. By the nineteenth century, Phimai had been largely forgotten, and Sukhothai began to be touted as the cradle of Thai culture. The Chao Phraya River, which linked Sukhothai with Ayutthaya and Thailand's newer capital, Bangkok, symbolically replaced the old Mun-Pasak artery as the country's topographical backbone. 'Khmer' became equated with 'Angkor' (not Phimai or Lopburi), and 'Tai' (the ethnic group) came to be equated with 'Thai', which included the country's entire multiethnic population.

In spite of these new historical and ethnic associations, however, much of Thailand's pre-Tai art survived to evidence the country's pre-Sukhothai, pre-Tai past. Most obvious are the Phimai-derived *prang*, which, reinterpreted as Theravada stupas with god-king connotations, were to become hallmarks of Lower Central Plains *wat luang*, that is, monasteries built and maintained by royal support. Thus, the *prang* became the country's most conspicuous emblem of the symbiotic relation between Thai royalty and Buddhism (Chapter 9). Bangkok's *prang* were taller and more ornate than earlier ones, and towering bases increased in visual importance. The *prang* at Bangkok's Wat Arun includes a base that is about half the height of the 240 foot monument. During the Ayutthaya period some Sinhalese bell-shape stupas, derived from Sukhothai prototypes, had also acquired royal symbolism, and they too were embellished with prominent vertical redentions and high

bases that replicated those on the *prang*. Redented bell-shape stupas abound at Bangkok's most important temple, Wat Phra Kaeo, and at another *wat luang*, Wat Pho, panels depicting scenes from the mythological Rama stories, though rendered Bangkok period style, reinforce the country's politico-religious alliance as they had at Phimai.

The local styles of pre-Tai monuments in various sections of the country have been preserved. Nakhon Si Thammarat's Srivijayan stupa-*prasat* (Chapter 6) was eventually rebuilt in the Sinhalese Theravada style, but a replica of the original Srivijayan monument was constructed in the temple courtyard. At the turn of the twentieth century, the old Mahayana stupa-*prasat* at Chaiya, which had also been built during the Srivijaya period, was redesigned by Bangkok's royal architect, Prince Naris. But although Bangkok-style embellishments are obvious in the reconstructed monument, the basic stupa-*prasat* design was retained (Joti, 1977: 115). Myriad images of the Buddha meshed traditional iconographic features that had been established in the early centuries AD with royal attributes introduced at Phimai in the eleventh century. Perhaps most notable was elaborate ornamentation, a hallmark of the Bangkok period.

Efforts by the Thai government to preserve its pre-Tai architectural and sculptural traditions have been prodigious. In the mid-nineteenth century Bangkok's King Mongkut, Rama IV, began to collect what he considered to be important antiquities from both the pre-Tai and later periods that were found in areas throughout the country. In 1855 he installed them in a small private museum in the royal palace. In 1874, his collection was moved to a building that was open to the public and

Row of Bangkok-style prang *at Wat Phra Kaeo, Bangkok's foremost royal monastery.*

Srivijaya stupa-prasat at left, Wat Mahathat, Chaiya, as redesigned in the nineteenth century by the royal architect Prince Naris.

Model of the Srivijayan stupa-prasat (lower right-hand corner). The original is encased in the huge Sinhalese-style bell-shape stupa at Wat Mahathat, Nakhon Si Thammarat.

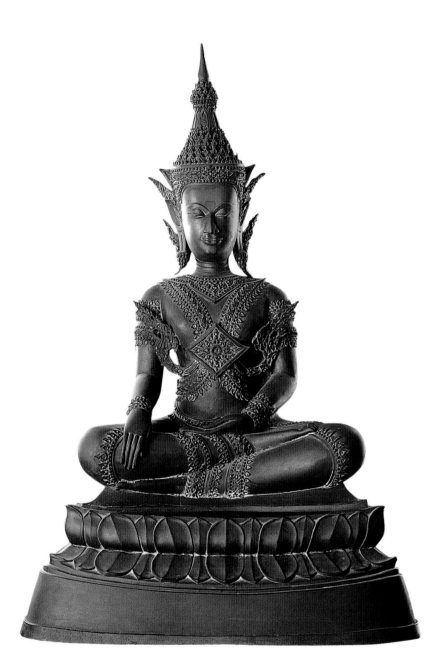

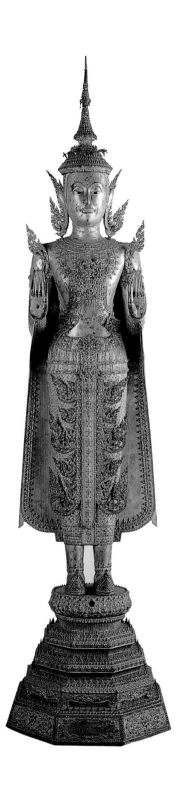

Late-Ayutthaya- and Bangkok-style Buddha images. In spite of their attenuation, very high bases, and decorative qualities, Bangkok images nonetheless retain attributes established centuries earlier. The crowns and royal attire have roots at Phimai, while the double mudra *dates back to the Dvaravati period. (Bangkok National Museum)*

King Rama VII and Queen Rambhai Barni at the opening of the National Museum in 1926.

The National Museum at the time it was first opened.

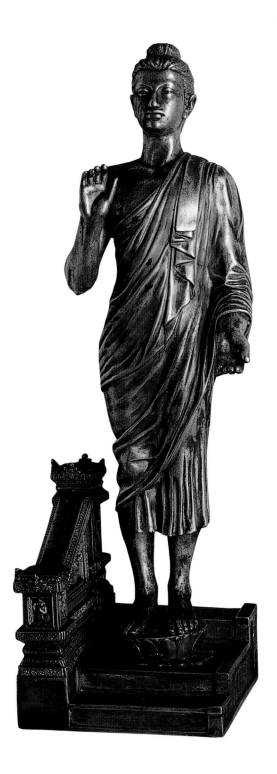

Twentieth-century Buddha image. This sculpture combines the Roman toga-like robes and hair style typical of Gandharan art of the early centuries AD with naturalistic body molding typical of European art. (Bangkok National Museum)

provided the nucleus of a collection which in 1926 was housed in the Bangkok National Museum (Coedès, 1928: 7-8; Development: 1965: 5-6). Today, besides the Bangkok National Museum, the Thai government supports several dozen regional museums with local collections throughout the country. Designated according to various classification systems, pre-Tai art, whether Mon, Khmer, or Srivijayan, finds a conspicuous place in the ancient tradition of Thailand's artistic works.

With the establishment of a government archaeological department in 1925, the clearing, preservation, and restoration of many of Thailand's pre-Tai architectural monuments were undertaken. Phra Prang Sam Yot and Wat Mahathat (Lopburi), Phra Phai Luang (Sukhothai), and numerous structures at Muang Singh and Khu Bua have been excavated or have undergone various degrees of restoration. Under the auspices of Thailand's Fine Arts Department, special care has been given to skillful restorations of the Khmer Mahidharapura sites on the Khorat Plateau. Restoration of Prasat Phimai began in 1964, and Phnom Rung underwent a seventeen-year restoration from 1971 to 1988. At both sites, the stones of the monuments were removed one by one, numbered, and tested for authenticity before they were replaced in their original places. Phimai and Phnom Rung are now designated Fine Arts Department Historical Parks and are popular tourist attractions for Thai and foreigners alike. Although Phimai is no longer accorded its historical significance as the country's major political center (its distinctive art is referred to even by ardent Thai nationalists as `Angkor Wat style'), both Prasat Phimai and Phnom Rung are renowned as two of Thailand's most noteworthy architectural works.

In contrast to the all but forgotten Mahidharapura dynasty, Dvaravati has been accorded a very special role in Thai history. Even though Dvaravati's history is obscure, its Buddhist traditions and its

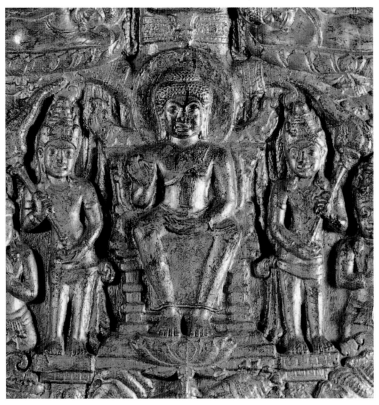

Above: *Dvaravati period stone carving of the Great Miracle at Sravasti, eighth century (detail at right). This piece now occupies a central location at Bangkok's Wat Suthat. The plaque was gilded, Bangkok fashion, in the nineteenth century.*

Far right: *Mural at Wat Mahasamanaram, Phetburi, by Khrua In-Khong depicting Phra Pathom stupa, renovated in nineteenth-century style, as an important pilgrimage site.*

location in what would become Thailand's political and cultural heartland, link past and present both ideologically and topographically as the Plateau sites have failed to do. The archaic design of Dvaravati's *dharmacakra* allows erroneous connections with India's great Buddhist emperor Asoka (Chapter 4; Charnvit, 1976: 17), and Dvaravati Buddhist images and architecture provide tangible links with the Theravada tradition as it developed later in Thailand. As early as the fifteenth century, Northern Thai chronicles were tracing the founding of Haripunchai to a seventh-century Dvaravati queen, Camadevi, who was said to have migrated from Lopburi, bringing with her Buddhist monks, scribes, and sculptors. Although this traditional belief is supported by neither archaeological, historical, nor artistic evidence, Camadevi's legendary endeavor is considered by some to have been `one of the major historical events in Thai Buddhism' (Charnvit, 1976: 18). The name Dvaravati appears in the official names of both Ayutthaya and its political successor, Bangkok, and masterpieces of classic Dvaravati art now occupy places of special importance in active Buddhist temples.

In the mid-nineteenth century King Mongkut, Rama IV, decreed that Nakhon Pathom's seventh-century Phra Pathom stupa be enlarged. Unlike U Thong, Khu Bua, and other notable Dvaravati sites, Nakhon Pathom had never been abandoned, and reconstructions of the ancient Dvaravati monument had probably been undertaken many times. The stupa was believed to be the oldest in Thailand, thus the Thai name 'Pathom' (first), and ancient legends declared that it occupied a spot that had once been visited by the Buddha. Although King Mongkut understood that these stories were legends without historical basis, he felt certain that there was a genuine relic of the Buddha enshrined. And because of its legendary renown, he recognized that it was an important cultural symbol that linked Dvaravati with the Lower Central Plains and helped to establish it as the Thai heartland (Thiphakorawong, 1966: 496-518). The king chose to reconstruct the then-dilapidated monument in contemporary Bangkok style while a model of a previous restoration that included a round stupa surmounted by a *prang* was built in the temple courtyard. Thereby, the monument acquired a shape and size much like what one sees today. Still, the stupa's appearance was embellished once again when it was restored in the mid-twentieth century. Today the Phra Pathom Chedi is the largest stupa in all Thailand, Theravada Buddhism is active there, and the stupa is a fitting monument to the continuity of the country's past and present.

With less fanfare, many Khmer temples have become Theravada monasteries. Judging from the style of numerous Buddha images that were placed in Phnom Wan's cella, it was converted to a Buddhist temple sometime during the Ayutthaya period. The Angkorean Phra Prang Sam Yot had a Theravada assembly hall built in front of it in the seventeenth century, and Lopburi's Wat Mahathat was a living Theravada monastery until the end of the eighteenth century (Woodward, 1975; Vol. 1: 108, 114). A Theravada shrine and modern Buddha image at Phnom Rung attract hundreds of Buddhist pilgrims each year (Smitthi and Moore, 1992: 271). Amalgamation of past and present extends even to the pre-Khmer era. At the Plateau's most

Detail of a mural illustrating the Buddha's victory over Mara, Wat Suwannaram, Thonburi. Here, an iconographic representation that dates back to Gandhara in the early centuries AD and introduced to Thailand in the late eleventh century, depicts Europeans and other foreigners as Mara's host of warriors.

Above Right: Wood-carving depicting a purnaghata, *or ever-blossoming flower pot, an auspicious Buddhist symbol introduced into Thailand around the third century AD. (Wat Phra That Lampang Luang, northern Thailand)*

important Theravada temple, Phra That Phanom, visited by thousands of pilgrims each year, the design of the stupa combines carved Khmer-style bricks dating from the ninth or tenth century (Boisselier, 1975: 60) with a Lao type stupa embellished with twentieth-century foliate designs. But venerated along with a relic of the Buddha thought to be enshrined within the stupa, an ancient menhir also inspires ardent Buddhist devotion. The engaging scrolls and swirls that typify Ban Chiang ceramics are sometimes reinterpreted as incipient Buddhist symbols (Phillips, 1992: 18).

Since the thirteenth century, when the Tai began to transform the country's cultural infrastructure, the country has seen increasingly numerous foreign intrusions – from Sri Lanka, Myanmar, India, China, and the Middle East. In the seventeenth century, isolated depictions of Europeans sometimes appeared among iconographic elements traditional to Thai Buddhist painting, and in the nineteenth century, European techniques would alter the way Thai painters perceived the natural world. Chinese decorative motifs interspersed with traditional Theravada iconographic details rendered in traditional styles became common. While, as in Neolithic times, some foreign introductions would remain 'foreign', valued for their exotic appeal, others were positioned within a Thai context 'to enhance and illuminate [the Thai] vision of the world' (Phillips, 1992: 5, 8). As in the Dvaravati and

Sukhothai periods, there would be trips abroad 'in search of symbols' to express the essence of Thainess, and those too would become part of the Thai artistic vocabulary. Among these foreign intrusions, however, traditional icons such as the *purnaghata*, the eternally flowering vase of plenty, which found acceptance during the Dvaravati period (Chapters 3, 4) endure.

As in every period of Thai history, the process of assimilation has been selective. Prince Damrong Rajanubhab, the most respected early twentieth-century Thai historian, coined the phrase *prasan prayot* (literally, 'to link to be beneficial'), meaning the ability to draw what is good and useful from a variety of dissimilar sources and cause them to unite (Sulak, 1991: 44-5). Whether referring to Thailand's pre-Tai era or modern times, the concept well describes the Thainess of its art forms, derived from multitudinous sources. While Thailand's geographical boundaries have fluctuated and its shifting populations and peoples continue to generate heterogeneity, there is also a national identity in which its art plays a major role. One could even suggest that the country's kaleidoscopic history is exemplified most overtly in its multicultural art. And because of that diversity, not despite it (as some might suggest), Thai culture and Thai art displays *khwam pen thai* (the 'substance that is Thai'), prevailing amidst the changes that proliferate in an ever-fluctuating world.

Above left: *Detail of a mural at Wat Suthat, Bangkok. Here Bangkok-style figures attired in Thai clothing are embedded in a Chinese style landscape. Chinese themes were particular popular in Bangkok in the early nineteenth century.*

Above: *Stupa dome, Wat Phra That Phanom, on the far eastern Khorat Plateau. This ancient monument has been rebuilt numerous times. Its present form includes a traditional Lao-style dome and a twentieth-century foliate motif that recalls the time-honored* purnaghata.

GLOSSARY

Abhaya mudra. The gesture of assurance or dispelling fear, in which one or both hands of a Buddha image are held at waist or chest level with palms facing outward.

Ajanta. Buddhist cave temples in western India. Recent evidence suggests that the Mahayana caves were constructed between 460 and 480 AD. Ajanta's Mahayana art provided prototypes for both Sinhalese and Thai art.

Amaravati. City on the southeastern coast of India known for its maritime connections and as an important Buddhist center in the early centuries AD. It was apparently from the Amaravati region that Buddhism was introduced to Thailand.

Amitabha. In Mahayana Buddhism, the Buddha who resides in the heavenly realm and is noted for his compassion. Images of the compassionate *bodhisattva* Avalokitesvara often show a figure of Amitabha in his headdress.

Angkor. Religious and political center of the Khmer Empire from AD 800 to the fourteenth century, when it was conquered by Thai forces. Angkor consists of several royal cities each built by a different king, the most prominent of which is Angkor Thom, built by Jayavarman VII in the late twelfth and early thirteenth centuries.

Angkor Wat. Temple-mountain at Angkor built by Suryavarman II in the first half of the twelfth century. Dedicated to Vishnu, Angkor Wat represents the peak of Khmer architectural design.

Antarala. Building that connects the cella and the *mandapa* of Khmer-style temples.

Antefix. Upright ornament placed at the edges of Khmer *sikhara*. In the Thai *prang*, antefixes were designed so that they rounded out the edges of the tower to produce an overall smoothly contoured shape.

Apsaras. Heavenly maiden often portrayed in late Angkorean art, less frequently in Thai art.

Ariya. A nontraditional sect of Buddhism that flourished in Myanmar and northern Thailand in the thirteenth century.

Asana. Seating position. In Buddhist art, different positions indicate different Buddhist concepts or events in the Buddha's life.

Asoka. Powerful king who ruled a large portion of India in the third century BC and who is renowned for his dissemination of Buddhism to southern India and Sri Lanka.

Asokan pillar. One of many lofty pillars erected along India's highways to proclaim both the Buddhist faith and the power of the Mauryan Empire.

Avalokitesvara. The *bodhisattva* of compassion. One of a triad of divinities that included Prajnaparamita and a *naga*-protected Buddha in late eleventh- and twelfth-century Thai art.

Avatar. Descent or incarnation, often applied to Vishnu in his incarnation as Rama.

Ayutthaya. Capital of Thailand from 1350 until it was sacked by Burmese forces in 1767.

Bangkok. Capital of Thailand from 1782 until the present.

Bayon. Temple-mountain built by Jayavarman VII at the center of his royal city, Angkor Thom, part of the Angkor complex.

Bell-shape stupa. Stupa type introduced to Thailand from Sri Lanka in the fourteenth century. The domes of early stupas were hemispherical, but by the time this form reached Thailand, in the fourteenth century, encircling rings around the base of the dome resulted in a bell-shape.

Bhavavarman. Khmer king who ruled from the lower Mekong region in the seventh century AD but extended his kingdom onto Thailand's Khorat Plateau and perhaps farther west.

Bhumisparsa mudra. The earth-touching gesture. In Buddhist art the *bhumisparsa mudra* is used to indicate the Buddha's victory over worldly desires, often depicted in the form of the evil king Mara. The gesture can also indicate the Buddha's enlightenment.

Bodhisattva. In Mahayana Buddhism, a person who is capable of achieving Buddhahood, but postpones his enlightenment so that he can help those who are still trying to find their way.

Bodhi tree. The tree under which the Buddha sat when he overcame the forces of worldly desire and attained enlightenment.

Brahman. A person of the Hindu priestly caste.

Caitya. Type of Buddhist stupa in which a square tower is punctuated with niches for images. This type of stupa originated in northern India and was one of the earliest stupa types in Thailand.

Cakra. Wheel. A Buddhist symbol often representing the dharma, or Buddhist doctrine.

Cella-*sikhara.* Composite architectural form in which the lower and upper portions of a Khmer-style tower that had been previously conceived as two architectural entities were blended so as to give the appearance of a unified whole. Also known as *prang.*

Chattra. Parasol, a symbol of royalty.

Chiefdom. Early form of political unit in which a small number of settlements were under loose political control of a ruler, or chief, who lived in the strongest and most affluent of the communities.

Chiefdom network. A loose association of chiefdoms which shared allegiance to a primary chiefdom.

Concentric temple plan. An architectural plan in which a temple, either Hindu or Buddhist, could be approached from the cardinal directions. The central buildings are usually surrounded by concentric galleries and moats.

Dharmacakra. The Wheel of the Law, a symbol indicating the Buddha's first sermon at Sarnath; symbol of the Buddhist doctrine.

Dharmacakra mudra. In Buddhist imagery, a gesture in which both hands, fingers curved, touch as if turning a *dharmacakra.* In Theravada Buddhism, this *mudra* signifies the preaching the Buddha's First Sermon.

Dharmasala. Rest house for travelers that Jayavarman VII had built along highways in Cambodia and Thailand during his reign in the late twelfth and early thirteenth century.

Dharmacakrastambha. A wheel, or *cakra,* supported on a post, or *stambha.*

Dhyana mudra. Gesture of meditation in which both hands of a Buddha image, one above the other, palms upward, are held in the lap.

Double *mudra (vitarka, abhaya)*. Identical gestures performed by both hands of a Buddha image. Found almost exclusively in the Buddhist art of Thailand.

Erawan. Thai name for Airavata, the multi-headed elephant that is Indra's mount. Airavata is said to have had numerous heads, but only three are usually shown.

First Sermon. The Buddha's sermon in the Deer Park, near Sarnath, by means of which Buddhism is said to have been founded.

Gandharva. Heavenly musician that may accompany both Hindu gods and the Buddha.

Gaya. Also Bodh Gaya. Site of the Buddha's enlightenment beneath the Bodhi tree.

Genre scenes. Depictions of daily life. In Thai art, genre scenes are sometimes found in conjunction with religious themes.

God-king. A king whose inner nature is believed to be intimately associated with that of a god.

Gopura. The gateway or building through which one approaches Indian and Khmer-style temples, typically surmounted by a tall, ornate superstructure.

Gupta. Dynasty that ruled a large part of India from the fourth to the sixth century. The art style of that period and of the centuries immediately following. The latter is sometimes referred to as post-Gupta.

Harihara. Khmer image in which the Hindu gods Vishnu and Shiva are combined. These images are identifiable by *kiritamukuta*, the two sides of which are unalike.

Harmika. A railing or box-like structure surmounting the dome of round and bell-shape stupas.

Hevajra. A multi-headed, multi-armed Tantric tutelary deity.

Hinayana. Branch of Buddhism that encompasses a number of conservative Buddhist sects, the best known of which today is Theravada.

Hsuan-tsang, Chinese Buddhist pilgrim who traveled to India in the seventh century AD to visit Buddhist holy sites and to obtain Buddhist texts to take back to China.

Iconography. A set of symbols that represent conventionally recognized religious attributes.

Indianization. Term commonly used to denote a transformation of Southeast Asia through the introduction of Indian culture. Because of Southeast Asia's unique nature, distinct from that of India, the term is falling out of favor.

Isvara. Lord or god. The suffix *-isvara* was added to the names of Khmer rulers, thereby signifying their lordly or godly status.

Jambupati. Mythical king in Burmese and Thai texts who is noted for his conversion to Buddhism.

Jataka. Birth story. Indian folk tales reinterpreted to tell stories of the Buddha's previous lives in which he appears in both animal and human form.

Jayabuddhamahanatha. One of eighteen Buddha images symbolizing the Buddha as the Great Lord of Victory that Jayavarman VII placed at temples throughout his kingdom. Once thought to be the King's portrait statues that have been found in a number of places in Thailand, it is now thought that the Jayabuddhamahanatha were 'radiating Avalokitesvara' images.

Jayavarman VI. Khmer ruler of the Khorat Plateau's Mahidharapura dynasty, 1080-1107.

Jayavarman VII. The last great king of the Angkorean Empire who ruled at Angkor between 1181 and the early thirteenth century. During his reign Angkor controlled much of western Thailand.

Kettle drum. Distinctive type of bronze drums that originated perhaps in Vietnam and then spread to many parts of both mainland and island Southeast Asia. In the west, these drums are commonly known (incorrectly) as rain drums.

Khmer. One of the largest ethnic and linguistic groups in Southeast Asia. Centered originally in the area that is now Cambodia, by the eleventh century the Khmer made up a large portion of Thailand's population.

Khmer Empire. Empire ruled from Angkor between the ninth and thirteenth centuries.

Khrua In-Khong. Nineteenth-century Bangkok artist noted for his Europeans style paintings and subject matter, which nonetheless are essentially Buddhist and are found in Thai monasteries.

Kinnari. A bird-woman creature. In both Indian and Southeast Asian art, *kinnari* were sometimes depicted with the Buddha and at other times appeared alone as auspicious Buddhist symbols.

Kiritamukuta. The tall, miter-like hat on Vishnu images.

Krishna. One of the major avatars or Vishnu.

Laterite. Crumbly, porous stone that is formed by leaching tropical soils. It may be quarried either in soft or hardened form, but in either case. it is too rough to be finely carved. Laterite temples often have stucco applied for decoration.

Later Amaravati. Art style of the Amaravati area in the eighth century, by which time the classic Amaravati style had been somewhat transformed by Gupta influences.

Linear temple design. Ground plan in which Buddhist temples, typically located on the tops of hills or mountains, are approached from a single side. Entrance to the temple proper is usually by way of a *mandapa* and *antarala*. The linear temple design was typical of early Khmer temples on the Khorat Plateau.

Linga. Phallic representation of the Hindu god Shiva.

Magadhi. The Prakrit language in which the Buddha is thought to have taught.

Mahabodhi temple. One of the great stupas of northern India, built at Gaya in the early centuries AD. The temple has had many reconstructions and its original form must be conjectured from comparisons with other temples. An important Buddhist pilgrimage site.

Mahayana. A branch of Buddhism that developed some centuries after the Buddha's death and espoused concepts that were different from those of earlier sects. Mahayana Buddhism used Sanskrit rather than Pali as its language and is characterized by its numerous *bodhisattva*.

Maitreya. Most important of the future Buddhas who reside in heaven until they are reborn on earth.

Makara. Mythological crocodile or sea monster, often depicted with a trunk. Associated with the waters, the *makara* it is an auspicious symbol that appears in both Hindu and Buddhist art.

Malay. Ethnic and linguistic group found primarily in what is now Malaysia and Indonesia.

Mandala. Name sometimes used to denote the type of political association that in these pages is called a chiefdom network.

Mandapa. Building that acts as an entryway to the major part of an Indian or Khmer-style temple.

Mara. In Buddhist thought, the personification of evil, overcome by the Buddha prior to his enlightenment.

Meru, Mount. In both Hindu and Buddhist thought, the cosmic mountain that marks the center of the universe.

Mon. One of the large linguistic and ethnic groups in early Southeast Asia. The Mon lived mostly in western Thailand and Myanmar.

Mongkut, King Rama IV. One of Thailand's greatest and best-known monarchs who ruled in Bangkok between 1851 and 1868.

Mucalinda. *Naga* king who spread his seven heads over the Buddha as he sat meditating during a violent rainstorm.

Mudra. The position of the hands in images of the Buddha. In Theravada Buddhism, different *mudra* designate different events in the Buddha's life or different Buddhist concepts.

Naga. A snake-deity, auspicious because of its association with life-sustaining water.

Naga-protected Buddha. An image of the Buddha seated beneath the seven-headed naga-king, Mucalinda, who was thought to have protected the Buddha from a storm as he sat meditating.

Pali. Language derived from several local Indian languages, especially Magadhi, in which the Buddha is thought to have preached. The language of the Theravada texts.

Pallava. Name given a south Indian script, a modification of which was used in early Southeast Asian inscriptions.

Pathom thetsana. Thai name for the *dharmacakra* and *vitarka mudra,* both of which indicate teaching or exposition. The gesture was originally associated with the Buddha's First Sermon at Sarnath.

Phimai Black. A type of burnished decorated black pottery which began to be produced at an Upper Mun site around 200 BC. Phimai Black ware was traded throughout the area.

Phra Kaphung. Inscriptional name for a high altar south of Sukhothai where the country's tutelary deity was honored. Today, Phra Kaphung is identified with a step pyramid at a site known today as Wat Kon Laeng.

Post-and-lintel construction. Architectural design based on the use of beams and lintels supported by perpendicular posts or pillars. Typical of wooden secular architecture and stone religious buildings in Cambodia and Thailand.

Prajnaparamita. In Mahayana and Tantric Buddhism, the goddess who symbolizes ultimate wisdom.

Prakhonchai. Located on the southern Khorat Plateau, this site lends its name to a style of ninth-century bronze sculpture produced in neighboring areas.

Prakrit. Term applied to a number of early Indian languages that were spoken locally. The Buddha is thought to have preached in one such languages known as Magadhi, spoken in northern India.

Pralambapadasana. The position of images of the Buddha in which the Buddha is seated 'European style' on some sort of platform.

Prang. Term sometimes applied to any Khmer-like tower, *prang* refers specifically to the Thai version of such a tower in which the lower part, or cella is visually integrated with its superstructure in composite 'cella-sikhara' form. The *prang* is associated especially with *wat luang,* or royal Buddhist temples.

Prasat. Temple or palace. A term that is commonly used to precede the names of Khmer temples in Cambodia and Thailand.

Pre-Indian. Term used to denote Southeast Asian cultural traits that had been established before the introduction of Indian ones.

Pre-Tai. Period of Thai history before the arrival of the Tai in the latter centuries of the first millennium AD. In art historical terms, the pre-Tai era did not end until the thirteenth century AD.

Purnaghata. Auspicious Buddhist symbol depicting a vase or flower pot; the vase of abundance.

Quincunx. Arrangement of five objects in which one is centered among the remaining four which are located in the subcardinal directions. The quincunx is the typical arrangement of towers that surmount Khmer temple-mountains but is found only occasionally in Thailand.

Radiating Avalokitesvara. Image of the *bodhisattva* of compassion with a multitude of small Buddhas images emanating from the pores of his body. The Jayabuddhamahanatha statues that Jayavarman VII was said to have distributed throughout his realm are considered to have been radiating Avalokitesvara.

Rama. Avatar of Vishnu who appears frequently in Thai art as a warrior conqueror and as such supports the institution of Thai royalty.

Ramayana, Indian epic poem describing the adventures of Rama.

Redention. Architectural motif by means of which the corners of a building are eaten away by a series of vertical right-angled indentions.

Relics. Bodily parts, clothing, or belongings of the Buddha, which were distributed to his followers after his cremation. Relics were often enshrined in stupas, which were thereby provided Buddhist legitimacy.

Rsi A Hindu holy person.

Saivite. Pertaining to the god Shiva

Sampot. Traditional Khmer garment composed of a wide piece of cloth tucked between the legs, forming a long pleat in front.

Sanchi. Early Buddhist site in northern India noted for its domed stupa design, elaborate stone reliefs, and its role in the transmission of Theravada Buddhism to southern India and Sri Lanka.

Sanskrit. The classical language of India, used in Khmer inscriptions and some early Thai inscriptions with political content.

Sarvastivada. One of the conservative Hinayana Buddhist sects, which differed from the Theravada sect most ostensibly by the use of Sanskrit rather than Pali for its texts.

Shang Dynasty. Chinese dynasty between the eighteenth and twelfth century BC. Art historically, the Shang is known especially for its magnificent bronze vessels.

Shiva. One of the most important Hindu gods, notable for both his destructive and regenerative powers.

Siam. The name of Thailand before it was changed to Thailand in 1939.

Sikhara. The tall superstructure representing Mount Meru that appears over Hindu temples

Sima. Buddhist boundary stone.

Sinhalese. Pertaining to Sri Lanka, formerly Ceylon.

Sravasti. City in India where the Buddha was miraculously multiplied into many replications of himself. The miracle is known as the Sravasti Miracle or Great Miracle.

Srivijaya. Maritime kingdom with bases throughout the coastal and hinterland areas of much of Southeast Asia in the ninth century AD.

Stambha. Post. The supporting element of a Buddhist *cakra*, or Wheel of the Law.

Sthaviravada. Sanskrit name for the Buddhist sect known in Pali as Theravada.

Stupa. Buddhist monument with any one of a variety of shapes. Stupas are revered as one of the most important, and certainly the most visible, of all Buddhist symbols. Stupas often hold relics of the Buddha or those of respected Buddhist followers.

Stupa-*prasat*. Architectural type in which a square cella (the *prasat)* is surmounted by a bell-shape stupa.

Sui Dynasty. Dynasty that ruled in China between 581 and 618.

Superstructure. The upper portion of a building, often ornamental or symbolic, that surmounts the major portion of a religious structure.

Suryavarman II. Angkorean king who ruled form 1113 to 1350.

Tai. Widely dispersed linguistic group with many sub-branches living in many parts of south China and Southeast Asia. The Tai who settled in what is now Thailand in the latter centuries AD established many of the cultural traits for which the country is still known today, and 'Tai' is often equated with 'Thai', which refers to Thailand's multiethnic population.

T'ang Dynasty. Chinese dynasty that ruled between 618 and 906.

Tantrism (Tantric Buddhism). A late, complex type of Buddhism that incorporated a multitude of ferocious, magical deities depicted with multiple arms and heads. Tantric elements appeared in Thailand in the late eleventh century, but never became part of the country's mainstream religious traditions.

Temple-mountain. Angkorean monument composed of a high man-made 'mountain' surmounted by towers. Each of Angkor's kings had his royal temple-mountain, typically located at the center of his own royal city, most often located in the Angkor complex. Although temple-mountains were not built in Thailand, the Thai *prang* incorporated the temple-mountain's royal connotations.

Thai. Pertaining to the modern country of Thailand and its citizenry.

Thai art. Often used to refer to the arts of Thailand that were made after the Tai began to produce their art in the thirteenth century AD. More generally, the term refers to art of whatever ethnic origin that has been localized to become an integral part of Thai culture. It is the latter definition that applies in these pages.

Theravada. The most conservative of several Hinayana Buddhist sects, characterized by its adherence to strict rules of ordination and behavior, the teachings of elder monks, and the use of the Pali language.

Thonburi. Briefly the capital of Thailand between 1767 and 1782. Located across the Chao Phraya River from Bangkok, it is considered to be part of Bangkok's metropolitan complex.

Trailokyavijaya. Powerful Mahayana god, or 'Lord of the Three Worlds' usually depicted with multiple arms and heads.

Tribhanga. Bodily pose in which a sway of the torso and head results in three bends of the body.

Tutelary deities. Supernatural territorial guardians.

Urna. Mole between the eyebrows, a sign of a great man, sometimes appearing on images of the Buddha, more often in Indian than Thai art.

Usnisa. Protuberance denoting supernatural wisdom that surmounts the heads of Buddha images.

Vishnu. Major Hindu god who was particularly popular in the Thai Peninsula in the fifth and sixth centuries AD.

Vitarka mudra. Hand gesture in which one or both hands of a Buddha image are raised at chest level with the thumb and forefinger touching. The gesture of teaching, a variation of the *dharmacakra mudra*.

Votive tablet. A small terracotta or metal tablet imprinted with Buddhist symbols. Votive tablets were often acquired by pilgrims at Buddhist holy sites and some were enshrined in stupas.

Wat. Thai word for monastery.

Wat luang. Royally supported Thai monastery.

Yaksa. Indian demon that appears in Buddhist and Hindu art.

Yasti. Spire of a Buddhist stupa.

BIBLIOGRAPHY

Aasen, Clarence (1998), *Architecture of Siam: A Cultural History Interpretation*. Singapore, Oxford, and New York: Oxford University Press.

Anuwit Charoensuphakhun (1979), 'Dating the Two Brick Monuments at Muang Si Thep: A Style Analysis', *Muang Boran Journal*, 5 (4): 85-104.

Aung Thaw (1972), *Historical Sites in Burma*. Ministry of Union Culture, Government of the Union of Burma.

Aung-Thwin, Michael (1985), *Pagan: The Origins of Modern Burma*. Honolulu: University of Hawaii Press.

Bareau, André (1955), *Les Sectes bouddhiques du Petit Véhicule. Publications de l'École Française d'Extrême-Orient*, Vol. 38. Saigon.

Basa, Kishor K. (1992), 'Early Historic Glass Beads in Thailand and Peninsular Malaysia'. In Glover, Ian, ed., *Southeast Asian Archeology 1990*, 85-101. Hull: Centre for South-East Asian Studies, University of Hull.

Basham, A. L. (1954), *The Wonder that Was India: A Survey of the Culture of the Indian Sub-continent before the Coming of the Muslims*. London: Sidgwick and Jackson.

Bennett, Anna (1990), 'Prehistoric Copper Smelting in Central Thailand'. In Glover, Ian, and Glover, Emily, eds., *Southeast Asian Archaeology 1986, Proceedings of the First Conference of the Association of Southeast Asian Archaeologists in Western Europe*, 109-19. Oxford: British Archaeological Reports, International Series, 561.

Bennett, Anna, and Glover, Ian (1992), 'Decorated High-tin Bronze Bowls from Thailand's Prehistory'. In Glover, Ian, ed., *Southeast Asian Archaeology 1990*; 187-208. Hull: Centre for South-East Asian Studies, University of Hull.

Boisselier, Jean (1965), 'Rapport de Mission (25 juillet-28 novembre 1964)', *Silpakorn*, 9 (2): 35-60.

_____ (1966), *Le Cambodge. Manuel d'archéologie d'Extrême-Orient*, Part 1, Asie du Sud-Est, Vol. 1. Paris: A. et J. Picard.

_____ (1975), *The Heritage of Thai Sculpture*. New York and Tokyo: Weatherhill.

Bowie, Theodore, ed. (1960),: *The Arts of Thailand: A Handbook of the Architecture, Sculpture and Painting of Thailand (Siam), and a Catalogue of the Exhibition in the United States in 1960-61-62*. Bloomington, (Indiana): Indiana University.

Briggs, Lawrence Palmer (1951), *The Ancient Khmer Empire*. Transactions of the American Philosophical Society, New series, 41, (1). Philadelphia: American Philosophical Society.

Bronson, Bennet (1979), 'The Late Prehistory and Early History of Central Thailand with Special Reference to Chansen'. In Smith, R. B. and Watson, W., eds., *Early South East Asia: Essays in Archaeology, History and Historical Geography*, 315-336. New York and Kuala Lumpur: Oxford University Press.

Bronson, Bennet and Dales, George F. (1970), 'Excavations at Chansen, 1968-1969', *Silpakorn*, 14 (1): 41-58.

Brown, Robert L. (1984), 'The Sravasti Miracles in the Art of India and Dvaravati', *Archives of Asian Art*, no. 37: 79-95.

_____ (1992), 'Indian Art Transformed: The Earliest Sculptural Styles of Southeast Asia'. In Raven, Ellen M. and Van Kooij, Karel R., eds., *Indian Art and Archaeology*, 40-53. Leiden and New York: E. J. Brill.

_____ (1994), '"Rules" for Change in the Transfer of Indian Art to Southeast Asia'. In Klokke, Marijke J. and Scheurleer, Pauline Lunsingh, eds. *Ancient Indonesian Sculpture*, 10-32. Leiden: KITLV Press.

_____ (1996), *The Dvaravati Wheels of the Law and the Indianization of South East Asia. Studies in Asian Art and Archaeology*, Vol. 18, Fontein, Jan, ed. Leiden and New York: E. J. Brill.

_____, ed. (1999), *Art from Thailand*. Mumbai: Marg Publications.

_____ (2000), 'The Early Visnu Images from Southeast Asia and their Indian Relationships'. Paper presented at 'Crossroads and Commodifications: A Symposium on Southeast Asian Art', March 25-26. Ann Arbor: University of Michigan.

Brown, Robert L. and Macdonnell, Anna M. (1989), 'The Pong Tuk Lamp: A Reconsideration', *Journal of the Siam Society*, 77 (2): 8-20.

Chamberlain, James R., ed. (1991). *The Ram Khamhaeng Controversy: Collected Papers*. Bangkok: Siam Society.

Chandler, David P. (1983), *A History of Cambodia*. Boulder (Colorado): Westview Press.

Charnvit Kasetsiri (1976), *The Rise of Ayudhya: A History of Siam in the Fourteenth and Fifteenth Centuries*. East Asian Historical Monographs. Kuala Lumpur, Oxford, and New York: Oxford University Press.

Chira Chongkol and Woodward, Hiram W., Jr. (1966), *Guide to the U-Thong National Museum, Suphanburi*. Bangkok: Fine Arts Department.

Chirapat Prapandvidya (1990), 'The Sab Bak Inscription: Evidence of an Early Vajrayana Buddhist Presence in Thailand'. *Journal of the Siam Society*, 78 (2): 11-14.

Christie, A. H. (1979), 'The Megalith Problem in South East Asia'. In Smith, R. B. and Watson, W., eds., *Early South East Asia: Essays in Archaeology, History and Historical Geography*, 242-52. New York and Kuala Lumpur: Oxford University Press.

Ciarla, Roberto (1992), 'The Thai-Italian Lopburi Regional Archaeological Project: Preliminary Results'. In Glover, Ian, ed., *Southeast Asian Archaeology 1990*, 111-28. Hull: Centre for South-East Asian Studies, University of Hull.

Coedès, George (1926), 'Siamese Votive Tablets', *Journal of the Siam Society*, 20 (1): 1-23.

_____ (1928 a), 'Les Collections archéologiques du Musée National de Bangkok', *Ars Asiatica* (12): 7-36.

_____ (1928 b), 'The Excavations at P'ong Tuk and Their Importance for the Ancient History of Siam', *Journal of the Siam Society*, 21 (3): 195-209.

_____ (1952), 'Le Culte de la royauté divinisée, source d'inspiration des grands monuments du Cambodge ancien', *Serie Orientale Roma*, (5): 1-23.

_____ (1963), *Angkor: An Introduction*, Emily Floyd Gardiner, tr. and ed. Hong Kong, London, New York: Oxford University Press.

_____ (1968), *The Indianized States of Southeast Asia,* Walter F. Vella, ed., Susan Brown Cowing, tr. Honolulu: East-West Center Press.

Coral-Rémusat, Gilberte de (1934), 'De l'origine commune des linteaux de l'Inde pallava et des linteaux khmérs pré-angkoriens', *Revue des Arts Asiatiques,* 8 (4): 242-50.

_____ (1951), *L'Art khmér: Les grandes étapes de son évolution. Études d'Art et d'Ethnologie Asiatiques,* 2nd ed. Paris: Vanoest, Les Editions d'Art et d'Histoire.

Damrong Rajanubhab, Prince (1926), *A History of Buddhist Monuments in Siam.* Bangkok.

_____(1973), *Monuments of the Buddha in Siam,* Sulak Sivaraksa and A. B.Griswold, trs. Bangkok: Siam Society.

The Development of Museums and Archaeological Activities in Thailand under the Control of the Fine Arts Department. Museums in Thailand, Vol. 1 (1965). Bangkok: Fine Arts Department.

Dhanit Yupho (1965), *Dharmacakra, or the Wheel of the Law.* Bangkok: Fine Arts Department.

_____ (1967), *Quartzite Buddha Images of the Dvaravati Period.* Bangkok: Fine Arts Department.

Dofflemyer, Virginia (1999), 'Vishnu Images from Ancient Thailand and the Concept of Kingship'. In Robert. L., Brown, ed. *Art from Thailand.* Mumbai: Marg Publications.

Dupont, Pierre (1959), *L'Archéologie mône de Dvaravati,* 2 vols. Paris: Publications de l'École Française d'Extrême-Orient. no. 41.

Eilenberg, Natasha; Subhadradis Diskul, M.C.; and Robert L. Brown, eds. (1997), *Living a Life in Accord with Dhamma: Papers in Honor of Professor Jean Boisselier on His Eightieth Birthday.* Bangkok: Silpakorn University.

Felten, Wolfgang and Lerner, Martin (1989), *Thai and Cambodian Sculpture.* London: Philip Wilson.

Fickle, Dorothy H. (1989), *Images of the Buddha in Thailand.* Singapore, Oxford, and New York: Oxford University Press.

_____ (1997), 'The Pointed-Crown Buddhas of Thirteenth-Century Central Thailand'. In *Living a Life in Accord with Dhamma: Papers in Honor of Professor Jean Boisselier on His Eightieth Birthday;* 176-90. Eilenberg, Natasha; Subhadradis Diskul, M.C.; and Brown, Robert L., eds. Bangkok: Silpakorn University.

Fine Arts Department (1987), *Muang Singh and Prasat Muang Singh: Changwat Kanchanaburi.* Bangkok.

Geiger, Wilhelm (1943), *Pali Literature and Language.* Calcutta: University of Calcutta.

Giteau, Madeleine (1965), *Khmer Sculpture and the Angkor Civilization.* London: Thames and Hudson.

Glover, I. C. (1989), *Early Trade between India and Southeast Asia: A Link in the Development of a World Trading System.* Hull: University of Hull Centre for Southeast Asian Studies Occasional Paper no. 16.

_____ (1990), 'Ban Don Ta Phet: The 1984-85 Excavation'. In Glover, Ian and Glover, Emily, eds., *Southeast Asian Archaeology 1986. Proceedings of the First Conference of the Association of Southeast Asian Archaeologists in Western Europe,* 139-83. Oxford: British Archaeological Reports (International Series 561).

Glover, I. C., Bronson, B., and Bayard, D. T. (1979), 'Comments on "Megaliths" in South East Asia'. In Smith, R. B. and Watson, W., eds. *Early South East Asia: Essays in Archaeology, History and Historical Geography,* 253-4. New York and Kuala Lumpur: Oxford University Press.

Glover, Ian (1999), Review of Charles Higham [sic] and Rachanie Thosarat, *Prehistoric Thailand: From Early Settlement to Sukhothai. Journal of the Siam Society,* 87 (1 and 2): 125-7.

Glover, Ian and Henderson, Julian (1995), 'Early Glass in South and South East Asia and China'. In Scott, Rosemary and Guy, John, *South East Asia and China: Art, Interaction and Commerce. Colloquies on Art and Archaeology in Asia,* no. 17: 141-70. London: Percival David Foundation of Chinese Art, School of Oriental and African Studies, University of London.

Gosling, Betty (1991), *Sukhothai: Its History, Culture, and Art.* Singapore, Oxford, and New York: Oxford University Press.

_____ (1996), *A Chronology of Religious Architecture at Sukhothai, Late Thirteenth to Early Fifteenth Century.* Ann Arbor: Association for Asian Studies. Reprinted, Chiang Mai: Silkworm Books, 1998.

Griswold, Alexander B. (1960), In *The Arts of Thailand: A Handbook of the Architecture, Sculpture and Painting of Thailand (Siam), and a Catalogue of the Exhibition in the United States in 1960-61-62.* Bloomington (Indiana): Indiana University.

_____ (1967), *Towards a History of Sukhodaya Art.* Bangkok: Fine Arts Department.

Griswold, A. B. and Prasert na Nagara (1969), 'The Pact between Sukhodaya and Nan: Epigraphic and Historical Studies, No. 3', *Journal of the Siam Society,* 57 (1): 57-107.

_____ (1971), 'The Inscription of King Rama Gamheng of Sukhodaya (1292 A.D.): Epigraphic and Historical Studies No 9', *Journal of the Siam Society,* 59 (2): 179-228.

Groslier, George (1925), La Sculpture khmére ancieane. Collection Française des Arts Orientaux. Paris: Editions G. Cres.

_____ (1931), *Les Collections khméres du Musée Albert Sarraut a Phnom-Penh, Arts Asiatica,* no. 16. Paris: Les Editions G. van Oest.

Guide to Antiquities found at Koo Bua, Ratburi (1963). Bangkok.

Guy, John (1995), 'The Avalokitesvara of Yunnan and Some South East Asian Connections'. In Scott, Rosemary and Guy, John, *South East Asia and China: Art, Interaction and Commerce. Colloquies on Art and Archaeology in Asia,* no. 17, 64-83. London: Percival David Foundation of Chinese Art, School of Oriental and African Studies, University of London.

Hall, Kenneth R. (1985), *Maritime Trade and State Development in Early Southeast Asia.* Honolulu: University of Hawaii Press.

Hazra, Kanai Lal (1994), *Pali Language and Literature: A Systematic Survey and Historical Study,* 2 vols. New Delhi: D.K. Printworld (P) Ltd.

Heine-Geldern, Robert (1956), *Conceptions of State and Kingship in Southeast Asia,* Southeast Asia Data Paper No. 18. Ithaca: Department of Asian Studies, Cornell University.

Higham, Charles (1989), *The Archaeology of Mainland Southeast Asia: From 10,000 B.C. to the Fall of Angkor,* Cambridge World Archaeology Series. Cambridge: Cambridge University Press.

_____ (1996), *The Bronze Age of Southeast Asia,* Cambridge World Archaeology Series. Cambridge: Cambridge University Press.

Higham, Charles and Rachanie Thosarat (1998), *Prehistoric Thailand: From Early Settlement to Sukhothai.* Bangkok: River Books.

Jacques, Claude, (1997), Tom White, tr., *Angkor: Cities and Temples.* Bangkok: River Books.

Joti Kalyanamitra (1977), *Six Hundred Years of Work by Thai Artists and Architects.* Bangkok: Fine Arts Commission of the Association of Siamese Architects.

Klokke, Marijke J., and Scheurleer, Pauline Lunsingh, eds. (1994), *Ancient Indonesian Sculpture.* Leiden: KITLV Press.

Knox, Robert, (1992), *Amaravati, Buddhist Sculpture from the Great Stupa*. London: British Museum Press.

Kramrisch, Stella (1946), *The Hindu Temple*. Calcutta: University of Calcutta.

Krom, N. J. [1938?], *De Tempels van Angkor*. Amsterdam, N. V. Van Munster's.

Loofs, H. H. E. (1979), 'Problems of Continuity between the Pre-Buddhist and Buddhist Periods in Central Thailand, with Special Reference to U-Thong'. In Smith, R. B. and Watson, W., eds. *Early South East Asia: Essays in Archaeology, History and Historical Geography*, 342-351. New York and Kuala Lumpur: Oxford University Press.

Luce, Gordon H. (1969), *Old Burma-Early Pagan*, 3 vols. *Artibus Asiae Supplementum*, no. 25. Locust Valley, New York: J. J. Augustin.

Lyons, Elizabeth (1965), 'The Traders of Ku Bua', *Archives of the Chinese Art Society of America*, 19: 52-6.

Mabbett, I. W. (1978), 'Kingship in Angkor', *Journal of the Siam Society*, 66 (2): 1-58.

Mabbett, Ian, and Chandler, David (1995), *The Khmers*. Oxford (UK) and Cambridge (USA): Blackwell.

Manit Vallibhotama, (1962), M. C. Subhadradis Diskul, tr. and ed., *Guide to Pimai and Antiquities in the Province of Nagara Rajasima (Khorat)*. Bangkok: Fine Arts Department.

Mannikka, Eleanor (1996), *Angkor Wat: Time, Space, and Kingship*. Honolulu: University of Hawaii Press.

Moore, Elizabeth (1988), 'Notes on Two Types of Moated Settlement in Northeast Thailand', *Journal of the Siam Society*, 76: 275-287.

Nandana Chutiwongs (1978), 'On the Jataka Reliefs at Cula Pathon Cetiya', *Journal of the Siam Society*, 66 (1): 133-51.

No Na Paknam (1981), *The Buddhist Boundary Markers of Thailand*. Bangkok: Muang Boran Publishing House.

O'Connor, Stanley J., Jr. (1972), *Hindu Gods of Peninsular Siam*. Ascona (Switzerland): Artibus Asiae Publishers.

Parmentier, H. (1937), 'L'Art pseudo-khmér au Siam et la prang', parts 1 and 2, *Journal of the Greater India Society*, 4 (1): 1-25; 4 (2): 97-116.

Pattaratorn Chirapravati, M. L. (2000), 'Development of Buddhist Traditions in Peninsular Thailand: A Study Based on Votive Tablets (Seventh to Eleventh Centuries)'. In *Studies in Southeast Asian Art: Essays in Honor of Stanley J. O'Connor*, Nora A. Taylor, ed. Ithaca: Southeast Asia Program Publications, Cornell University.

Paul, Debjani (1995), *The Art of Nalanda, Development of Buddhist Sculpture AD 600-1200*. New Delhi: Munshiram Manoharlal Publishers.

Phillips, Herbert P. (1992), *The Integrative Art of Modern Thailand*. Berkeley: University of California.

Piriya Krairiksh (1974 a), *Buddhist Folk Tales Depicted at Chula Pathon Cedi*. Bangkok.

_____ (1974 b), *Semas With Scenes From the Mahanipata-Jatakas in the National Museum at Khon Kaen*. In *Art and Archaeology in Thailand*, 35-64. Bangkok: Fine Arts Department.

_____ (1977), *Art Styles in Thailand, a Selection from National Provincial Museums*. Bangkok: Department of Fine Art.

_____ (1979), *The Sacred Image: Sculpture from Thailand*. Cologne: Museum of East Asian Art.

_____ (1980), *Art in Peninsular Thailand Prior to the Fourteenth Century A.D.* Bangkok: Fine Arts Department.

Plan and Report of the Survey and Excavations of Ancient Monuments in North-Eastern Thailand, 1959 (nd). Bangkok: Fine Arts Department.

Rahula, Walpola (1956), *History of Buddhism in Ceylon, the Anuradhapura Period, 3rd Century BC-10th Century A.D.* Colombo: M. D. Gunasena.

Report of the Survey and Excavations of Ancient Monuments in North-Eastern Thailand, part 2, 1960-61. 1967. Bangkok: Fine Arts Department.

Reynolds, Craig J., ed. (1991), *National Identity and Its Defenders: Thailand, 1939-1989*, Monash. Papers on Southeast Asia, no. 25. Clayton (Victoria): Centre of Southeast Asian Studies, Monash University.

Rhys Davids, T. W., tr., (1881). *Buddhist Suttas: The Sacred Books of the East*, Vol. 11. Oxford: Clarendon Press. Reprinted, New York, Dover Publications, 1969.

Rispoli, Fiorella (1992), 'Preliminary Report on the Pottery from Tha Kae, Lopburi, Central Thailand'. In Glover, Ian, ed., *Southeast Asian Archaeology 1990*, 129-42. Hull: Centre for South-East Asian Studies, University of Hull.

Rowland, Benjamin (1953), *The Art and Architecture of India, Buddhist, Hindu, Jain, the Pelican History of Art*, Pevsner, Nikolaus, ed. Melbourne, London, and Baltimore: Penguin Books.

Santi Leksukhum (1979), *The Evolution of Stucco Decorative Motifs of Early Ayudhya Period*. Bangkok.

Schastok, Sara (1994), 'Bronzes in the Amaravati Style: Their Role in the Writing of Southeast Asian History'. In Klokke, Marijke J. and Scheurleer, Pauline Lunsingh, *Ancient Indonesian Sculpture*, 33-56. Leiden: KITLV Press.

Scott, Rosemary and Guy, John (1995), *South East Asia and China: Art, Interaction and Commerce, Colloquies on Art and Archaeology in Asia*, no. 17. London: Percival David Foundation of Chinese Art, School of Oriental and African Studies, University of London.

Shakur, M. A. (1963), *Gandhara Sculpture in Pakistan*. Bangkok: South-East Asia Treaty Organization Office of Public Information.

Smith, R. B. and Watson, W., eds. (1979), *Early South East Asia: Essays in Archaeology, History and Historical Geography*. New York and Kuala Lumpur: Oxford University Press.

Smithies, Michael (1986), *Old Bangkok*. Singapore, Oxford, and New York: Oxford University Press.

Smitthi Siribhadra and Moore, Elizabeth (1992), *Palaces of the Gods: Khmer Art and Architecture in Thailand*. Bangkok: River Books.

Snellgrove, David L., ed. (1978), *The Image of the Buddha*. Paris and Tokyo: Kodansha International/Unesco.

Sørensen, Per, ed. (1988), *Archaeological Excavations in Thailand: Surface Finds and Minor Excavations*, Scandinavian Institute of Asian Studies Occasional Papers no. 1. London: Curzon Press.

_____ (1990), 'Kettle drums of Heger Type 1: Some Observations', *Southeast Asian Archaeology 1986, Proceedings of the First Conference of the Association of Southeast Asian Archaeologists in Western Europe*, 195-200. Oxford: British Archaeological Reports (International Series 561).

Spink, Walter M. (n.d.), *Ajanta: A Brief History and Guide*. Ann Arbor: Asian Art Archives, University of Michigan.

_____ (1992), 'The End of Imagery at Ajanta'. Unpublished paper.

Stone, Elizabeth Rosen (1994), *The Buddhist Art of Nagarjunakonda,* Buddhist Tradition Series, Vol. 25, Alex Wayman, ed. Delhi: Motilal Banarsidass.

Subhadradis Diskul, M. C. (1970), *Art in Thailand: A Brief History.* Bangkok.: Silpakorn University.

Subhadradis Diskul, M. C. (1972). In Theodore Bowie, ed., *The Sculpture of Thailand.* New York: Asia Society.

_____ (1978), 'Notes on Recent Excavations at Prasat Muang Singh', *Journal of the Siam Society,* 66 (1): 109-111.

_____ (1981), 'Further Notes on Prasat Muang Singh, Kanchanaburi Province', *Journal of the Siam Society,* 69: 164-8.

Sulak Sivaraksa (1991), 'The Crisis of Siamese Identity'. In *National Identity and Its Defenders: Thailand, 1939-1989,* Craig J. Reynolds ed., Monash Papers on Southeast Asia, no. 25: 41-58. Clayton (Victoria): Centre of Southeast Asian Studies, Monash University.

Suraphon Damrikun (1978), 'Prehistoric Rock Paintings in Udon Thani', *Muang Boran Journal,* 4 (4): 27-53.

Taylor, Nora A. (2000) *Studies in Southeast Asian Art: Essays in Honor of Stanley J. O'Connor.* Ithaca: Southeast Asia Program Publications, Cornell University.

Thiphakorawong, Chao Phraya (1966), *The Dynastic Chronicles, Bangkok Era, the Fourth Reign, B.E. 2394-2411 (A.D. 1851-1868),* Vol. 2, Chadin (Kanjanavanit) Flood, tr. Tokyo: Centre for East Asian Cultural Studies.

Thongchai Winichakul (1994), *Siam Mapped: A History of the Geo-Body of a Nation.* Honolulu: University of Hawaii Press.

Vickery, Michael (1979), 'A New Tamnan about Ayudhya' (review article), *Journal of the Siam Society,* 67 (2): 123-86.

_____ (1998), *Society, Economics, and Politics in Pre-Angkor Cambodia, the 7th-8th Centuries.* Tokyo: Centre for East Asian Cultural Studies for Unesco, Toyo Bunko.

Wales, H. G. Quaritch (1931), *Siamese State Ceremonies.* London: Bernard Quaritch, Ltd.

_____ (1936), 'The Exploration of Sri Deva, an Ancient Indian City in Indochina', *Indian Art and Letters,* New Series, 10 (2).: 61-99.

_____ (1961), *The Making of Greater India,* second edition. London: Bernard Quaritch.

_____ (1969), *Dvaravati: The Earliest Kingdom of Siam (6th-11th Century A.D).* London: Bernard Quaritch, Ltd.

Watson, W. (1979), 'Kok Charoen and the Early Metal Age of Central Thailand'. In Smith, R. B. and Watson, W., eds. *Early South East Asia: Essays in Archaeology, History and Historical Geography,* 53-62. New York and Kuala Lumpur: Oxford University Press.

Wechsler, Howard J. (1985), *Offerings of Jade and Silk: Ritual and Symbol in the Legitimation of the T'ang Dynasty.* New Haven and London: Yale University Press.

Welch, D. J., and NcNeill, J. R. (1991), 'Settlement, Agriculture and Population Changes in the Phimai Region, Thailand', *Bulletin of the Indo-Pacific Prehistory Association,* 11: 210-28.

Wells, Kenneth E. (1960), *Thai Buddhism: Its Rites and Activities.* Bangkok.

Wheatley, Paul (1961), *The Golden Khersonese: Studies in the Historical Geography of the Malay Peninsula to A.D. 1500.* Kuala Lumpur: University of Malaysia.

White, Joyce C. (1982), *Discovery of a Lost Bronze Age, Ban Chiang.* Philadelphia: University Museum, University of Pennyslvania, and Smithsonian Institution.

_____ (2000), Review of Charles Higham and Rachanie Thorsarat [sic], *Prehistoric Thailand: From Early Settlement to Sukhothai. Journal of Asian Studies,* 59, (4): 1093-4.

Wicks, Robert S. (1999), 'Indian Symbols in a Southeast Asian Setting: Coins and Medals of Ancient Dvaravati'. In Brown, Robert L., ed., *Art from Thailand.* Mumbai: Marg Publications.

Willetts, William (1965), *Foundations of Chinese Art: From Neolithic Pottery to Modern Architecture.* New York, Toronto, and London: McGraw-Hill.

Williams-Hunt, P. (1950), 'Irregular Earthworks in Eastern Siam: An Air Survey', *Antiquity,* 24: 30-7.

Wiyada Thongmitr and Bang-on Karakovida (1979), 'Prehistoric Rock Paintings in Uthai Thani', *Muang Boran Journal,* 5 (5): 5-18.

Wiyada Thongmitr (1979), *Khrua In Khong's Westernized School of Thai Painting.* Bangkok: Cultural Data Center.

Wolters, O. W. (1979), 'Khmer "Hinduism" in the Seventh Century'. In Smith, R. B. and Watson, W., eds. *Early South East Asia: Essays in Archaeology, History and Historical Geography,* 427-42. New York and Kuala Lumpur: Oxford University Press, 1979.

_____ (1982), *History, Culture, and Region in Southeast Asian Perspectives.* Singapore: Institute of Southeast Asian Studies.

Woodward, Hiram W., Jr. (1966), 'Some Examples of Thai Stucco Decoration'. In *Warasan borankhadi chabap pathomruk,* 34-40. Bangkok.

_____ (1971), 'The Art and Architecture of the Ayudhya Period'. In *Silpakorn nai Ayutthaya,* 61-6. Bangkok: Fine Arts Department.

_____ (1975), 'Studies in the Art of Central Siam, 950-1350 A.D.' 3 volumes. Ph.D. dissertation, Yale University.

_____ (1979), 'The Bayon-Period Buddha Image in the Kimbell Art Museum', *Archives of Asian Art,* 32: 72-83.

_____ (1980), 'Some Buddha Images and the Cultural Developments of the Late Angkorean Period', *Artibus Asiae,* 42 (2 and 3): 155-174.

_____ (1983), 'Interrelations in a Group of South-East Asian Sculptures', *Apollo,* 118: Vol. 118. no. 261: 379-83.

_____ (1994-1995), 'The Jayabuddha- mahanatha Images of Cambodia', *Journal of the Walters Art Gallery,* 52-53: 105-110.

_____ (1995), 'Thailand and Cambodia: The Thirteenth and Fourteenth Centuries'. In *Studies and Reflections on Asian Art History and Archaeology: Essays in Honour of HSH Professor Subhadradis Diskul,* 335-42. Bangkok: Silpakorn University.

_____ (1997), *The Sacred Sculpture of Thailand: The Alexander B. Griswold Collection, the Walters Art Gallery.* Baltimore: Walters Art Gallery.

Wu, Nelson I. (Wu No-Sun) (1963), *Chinese and Indian Architecture: The City of Man, the Mountain of God, and the Realm of the Immortals.* New York, George Braziller.

Wyatt, David K. (1984), *Thailand: A Short History.* New Haven and London: Yale University Press.

_____ (2001), 'Relics, Oaths and Politics in Thirteenth-Century Siam', *Journal of Southeast Asian Studies,* 32, (l): 3-64.

*Note: References in italic refer to illustrations;
those in bold to the Glossary.*